Lecture Notes in Morphogenesis

Series Editor

Alessandro Sarti, CAMS Center for Mathematics, CNRS-EHESS, Paris, France

More information about this series at http://www.springer.com/series/11247

Maria Giulia Dondero

The Language of Images

The Forms and the Forces

Foreword by Virginia Kuhn

 Springer

Maria Giulia Dondero
FNRS—National Fund for Scientific
Research
University of Liège
Liège, Belgium

ISSN 2195-1934 ISSN 2195-1942 (electronic)
Lecture Notes in Morphogenesis
ISBN 978-3-030-52622-1 ISBN 978-3-030-52620-7 (eBook)
https://doi.org/10.1007/978-3-030-52620-7

This Springer imprint is published by the registered company Springer Nature Switzerland AG
The registered company address is: Gewerbestrasse 11, 6330 Cham, Switzerland

Foreword

It was my great pleasure to work with Maria Giulia Dondero during the time she was finalizing this translation of this, her most recent book. Over the course of the six weeks spent as a visiting researcher at the University of Southern California's School of Cinematic Arts, my home institution, we enjoyed many long conversations about a range of topics associated with visual studies, semiotics, academic disciplinarity and the odd trajectory by which certain theories take hold while others are left to obscurity. These conversations highlighted many convergences in Dondero's work and my own, or rather parallel efforts, each one deviating slightly but always productively. Examining a few of the more salient overlaps is a useful demonstration of the ways in which this book may form a bridge of sorts, one that spans the francophone and anglophone worlds and connects Dondero's enhanced semiotic theory with the algorithmic processes for image examination that links our current efforts. Here I focus on some of the most germane areas in this connecting effort, and I do so with some liberties taken in order to open this text to a more general audience.

Sketching her argument for a theory of 'uttered enunciation' with regard to the language of images, Dondero remarks, almost in passing, that narrativity in still images has seldom been considered by visual semioticians, due to the 'cumbersome opposition, inherited by the contemporary world, between the spatial arts and the temporal arts'.[1] Although for many years I have argued that current academic disciplines, having coalesced during the era of print literacy, need rethinking for a digital era, I had not thought of the rift in this way. It certainly rings true in my own trajectory as I moved from art history (spatial art) to language and cinema (temporal arts). Indeed, in the early 1980s as an undergraduate, I co-wrote a gallery catalog for an exhibition titled 'French Master Caricaturists: Daumier and Gavarni,' which featured a fairly extensive corpus of the work of these two political satirists. The extensive research that my co-author and I undertook for the project was written mostly in French, with a few relevant books in German. We each had some serious translation to do. Two things about that experience are relevant here: First, the

[1]Page 26.

images that I glossed in the catalog—I handled the Daumier work, my colleague wrote about Gavarni—were done in a purely formal way, or what Dondero refers to as a plastic way. History was considered of course, but no overarching theory or methodology was outlined, at least explicitly. Years later, when I returned to academia and pursued a doctorate in rhetoric and cinema with a heavy emphasis on the digital, I was somehow lulled into the false notion that all scholarship is now translated into English. Arrogant as this may sound, in all fairness, I was in a department of English and the structuralists and poststructuralists we were studying, many or most of whom were French such as Jean-Francois Lyotard, Michel Foucault, Gilles Deleuze, Jacques Derrida, Jean Baudrillard, Julia Kristeva and Roland Barthes *were* translated into English.

I belabor my own story as a way of suggesting the extent to which disciplinary divides are both productive and problematic. In fact, in my work with graduate students over the last decade, I find that a multi-disciplinary approach like my own is more the rule than the exception, potentially further separating the spatial and temporal arts, or at least creating gaps in what is considered pertinent scholarship. Thus, while I was not conversant with the francophone school of semiotics before, I now appreciate its path and I understand Dondero's foundations in the work of Greimas and Focillon but also her frustration with the reliance on verbal language as the 'global interpreter' of all other semiotic systems. Indeed, for at least the last two decades, my work has been premised on the fact that digital technologies are nearly as amenable to images as they are to words. As such, we have an expanded semiotic palette from which to make meaning, and, by extension, we must be able to both interpret and produce the language of images. Put another way, critical engagement must include the ability to 'read' as well as to 'write' with this emergent language. For me, this is a matter of large-scale literacy, but it is also an analytical stumbling block since a word cannot adequately account for the 'excess' of meaning in an image; it cannot be that 'global interpreter' of all semiotic systems.

The question then becomes, how do we establish both a theory and a notation system that will allow the examination of vast corpora of the images that bombard us in the contemporary world? This is where I believe Dondero's theory of 'uttered enunciation' may hold most promise. While the technology needed to mediate among human and computer vision is not yet able to handle this challenge, a solid methodology will be vital to its anticipation. Computer vision algorithms are necessary to filter visuals and subject them to human analysis, much of which will require words and non-digital intervention. One of the main difficulties of discussing an image-based system on its own terms is that we have no native way of communicating (native to our bodies) except in gestures and vocal tonality (once we get devices implanted in our bodies, perhaps we will be able to talk in pictographs and memes). Human gestures, however, do have representation and building on Aby Warburg, Dondero argues for a system that accounts for the forces that animate the form, those that result in gestures, even in the face of the inherently static nature of an image. Isolating and labeling the forces in these forms will be massively helpful in training computerized processes.

Further, as Dondero admits, for a purely image-based system to work, it must allow for an image to comment upon another image, and she builds a compelling overview of the way this interaction works since images frequently do refer to each other. In addition, I suggest that an image can be 'cited' when part of it is pulled from the whole in order to say something new. This is most easily demonstrated in John Berger's *Ways of Seeing*, a 1972 BBC television series that explores the impact of mechanical reproduction of paintings from the past.[2] Berger shows, for instance, the ways in which a portion of Bruegel's *The Road to Calvary* can be isolated, shifting its meaning accordingly; highlighting one area, it becomes a 'straightforward devotional image' while another detail suggests a simple land-scape, or perhaps a history of costuming.[3] This relationship is consonant with Dondero's 'mereological' connection. It is an association of the part to the whole, what I refer to as a metonymical relationship. It is also a one-way street in that the part can never stand in for the whole; if one isolates a face from a painting of allegorical depiction, it becomes merely a portrait and will not refer back to the allegorical representation.

This brings me to another feature of Dondero's approach which I find useful and as such attractive: her schema does not foreclose other interpretive strategies, since it is not based solely in a universal language of images, but rather one that rec-ognizes generalized imagistic connotations but also appreciates the particular 'status' of an image, or what I refer to as its placement in a discourse community. This opens a space for cultural analyses that can add another layer of meaning. For instance, in an excellent overview of Tintoretto's *Susanna and the Elders,* Dondero demonstrates the ways in which irreducible forces animate this painting, directing the gaze in several and often conflicting ways both within and outside of the frame. Here the convincing argument is enhanced, in my view, by the larger economy of images of its time and the cultural work they perform. Here again, I refer to *Ways of Seeing* and Berger's discussion of the difference between nakedness and nudity. Noting that *Susanna and the Elders* are a frequent subject in European oil painting of the Renaissance, Berger argues that this is an example of the latter: the nude. The woman depicted is simply a trope, an object. Since the subject matter is religious, this trope allows the patron to display a nude freely and without rebuke. It becomes an alibi, in essence. Older versions of this topic do not include the mirror that Tintoretto adds, thus implicating the woman herself as she becomes both subject and object of the gaze. The addition of the mirror becomes more frequent as it both allows the pleasure of the male gaze, while it also serves to show women as vain.

[2]This impressive series was based on the work of Walter Benjamin and was later turned into a book. Unsurprisingly, it is the book form which has been a staple in many visual studies classes, while the original filmic version is largely neglected but accessible since its digitization. The filmic version instantiates many of the ideas in my own, as well as Dondero's conception of a language (both langue and parole) of images.

[3]*Ways of Seeing*, episode 1, 13:50 to 15:50. 1972.

This reading does nothing to violate Dondero's method; rather it enhances it (and vice versa), adding evidence for the 'irreducible forces' identified within her reading.

The final aspect of productive alignment between our work concerns processes of production and versioning: Dondero calls for the inclusion of multiple versions of an image, whether they be different formats of the same digital image, or the sketches and studies conducted as preparation for painting. Ultimately, these 'paratexts' can inform and add nuance to the study of images, regardless of their era or genre. In my work, this is mainly an issue of archival practices—especially as digital formats change and platforms become obsolete in a short space of time— these paratexts can act as clues to the original functioning of an inexecutable computer program. Multiple versions are useful for providing training data for computer vision algorithms even as they can also function as metadata that aids the potential recreation of an image that is no longer accessible. Until computer vision algorithms are better trained at image detection, this metadata can also provide a useful layer of meaning, enhancing the strictly formal processes carried out by computers.

For all of these reasons, the schema outlined in *The Language of Images: The Forms and the Forces* is quite compelling and can open up new avenues of exploration for large corpora of image-based media, in the current state of things even as it anticipates a future of ever larger and more numerous databases and the enhanced algorithmic processes that are sure to come in the near future.

<div align="right">

Virginia Kuhn
University of Southern California
Los Angeles, USA

</div>

Acknowledgements

I would like to make a few acknowledgments. Firstly, I would like to thank my first reviewers, Marion Colas-Blaise, Pierluigi Basso Fossali, Jean-Pierre Bertrand and Jean-François Bordron. A special thanks go to Virginia Kuhn who kindly did me the honor of writing the foreword to this book.

The initial idea of this book came to Jean Cristtus Portela, on the occasion of two classes I taught ('*Questions d'énonciation: de la linguistique à la sémiotique visuelle*') at the Faculdade de Ciências e Letras de l'Universidade Estadual Paulista (UNESP), in Araraquara (Sao Paulo), in September 2014 and in March 2016. His friendly encouragements provided me with the impetus to initiate the writing of this book. My thanks also extend to my two dear colleagues, Sémir Badir and François Provenzano, members of the Centre de Sémiotique et Rhétorique of the University of Liège to which I am honored to belong. Additionally, I would like to thank Cédric Honba Honba and Enzo D'Armenio for their invaluable technical help.

I also wish to thank my students in visual semiotics at the University of Liège, before whom I have defended some of the theses presented herein.

I am also very grateful to my colleague and dear friend Thomas Broden for his invaluable help with the translations from French to English, especially as far as bibliographical references, technical expressions and idiomatic forms are concerned.

Last but not least, I wish to thank Alessandro Sarti, with whom I have discussed a preliminary version of this manuscript and who encouraged me to pursue in greater depths the examination of the relation between forms and forces initiated by Gilles Deleuze in his book *Francis Bacon: The Logic of Sensation*, which proved to be one of the most important books during my training at the University of Bologna. Many thanks to Mrs. Françoise Peyrot-Roche and Mrs. Catherine Derioz from the Galerie Le Réverbère in Lyon for making it possible to reproduce Denis Roche's photos in this book and in my previous publications.

Finally, a small geographical note. This book was conceived in Brazil, then written and rewritten in Liège, Paris, Lavagna, as well as in London, Sao Paulo and Rio de Janeiro. It was then reshaped and rewritten in order to adapt it to the English-speaking scholarly culture and was then translated from French to English

by Lila Roussel, whom I thank warmly. The translation was funded by the F.R.S.—
Fonds National de la Recherche Scientifique whom I also thank (Research project
title: 'Big Visual Data. A Semiotic Approach to Indexing and Visualizing Image
Archives' 2018–2021). My gratitude also extends to the other institutions having
provided me with funding for this lengthy research endeavor and for the necessary
travels, namely the aforementioned FNRS, the University of Liège and the
Universidade Estadual Paulista-Araraquara.

Contents

Chapter 1
Introduction

How are images to be studied, described, and analyzed given the current state of semiotic knowledge? Should we focus on a single image or should we select a series of images in order for each to become comprehensible? May this be done by identifying affinities in terms of genre, status, filiation, or should this rather be done on the basis of form and composition, as seen in the past in the traditions of Warburg and of French semiotic structuralism? The latter had notably sought to identify "shared diagrams"[1] within visual productions which stemmed from highly diverse traditions using a wide variety of mediums. Today, these shared diagrams are sought to be identified within large collections of images ("big visual data"[2] or "big image data,"[3] depending on the author), and this search is carried out using the tools built in the field of computer vision which will be addressed in this book.

A very rich debate has long concerned the role of images in society and vice versa. Is it a matter of understanding images through the study of audiences, of interest groups, and of cultural institutions? Or is it a matter of understanding society itself through images, as proposed by visual ethnography and anthropology, and as proposed by Lev Manovich's cultural analytics in the field of computer science? Such are the numerous questions this work seeks to address, by arguing for levels of mediation between the structures which organize and shape images and the social statuses which overlie and orient their interpretation. The image corpora analyses presented here aim to understand not only the specificity of *visual grammar*, but also the social *statuses* and the interpretive frameworks which govern the functioning of the images. To this end, it is necessary to start with a methodology for the observation

[1] Fabbri (1998).
[2] Dondero (2018).
[3] Klinke (2017).

© Springer Nature Switzerland AG 2020
M. G. Dondero, *The Language of Images*, Lecture Notes in Morphogenesis,
https://doi.org/10.1007/978-3-030-52620-7_1

of images by means of which to analyze their identifying and distinguishing compositional features, but also to identify all the affinities which may help to understand the images thanks to the relations they establish between one another within social domains such as art, science, politics, and advertising.

This book bases its methodology upon multiple levels of analytical pertinence which are interrelated and stratified. We will thus focus in turn upon the *substrate* carrying the forms (the canvas, the photochemical paper, the software, the screen), upon the *genre* (namely the portrait genre), and upon the *status* of the images (artistic, scientific, or other). These issues have remained relatively unaddressed to this day, research in visual semiotics having only seldom devoted attention to these three parameters. Prior research has rather attended, on the one hand, to general issues pertaining to visual perception (Groupe μ 1992), and on the other hand, to issues pertaining to the description of forms (Floch 1985).

It is to an introduction to the semiotics of images that the following chapters invite, as well as to a critique of the analytical methodology of semiotics and of its general theory of meaning. More specifically, our proposals develop three major areas of reflection: 1. Enunciation in the context of visual language, that is, the observational system which may be associated with images; 2. The associated notions of metaimage and of metavisual; and 3. The question of the medium, or of the substance of the image's plane of expression as substrate, application, and gestural act of inscription. It is the attention devoted to the substance of expression, and not only to the form of expression, which will enable us to illustrate the relationships between the forms and the forces, between the stabilization of the visual features and of the productive gestures, and between the setting of the image's composition and its narrativity.

1.1 How Does One Look at an Image?

The objective of this book is to address images by means of a renewed semiotic perspective. This is a perspective which seeks to be complementary to the one adopted by French semiotician Floch (1985, 1986). In his works, Floch mainly devoted himself to the plastic and figurative analysis of images, leaving aside the truly *dialogical* aspect of the relation between the image and the space of the observer. We will therefore investigate the transposition of the theory of enunciation, formulated in linguistics, into the field of visual discourse.

The question of enunciation, and namely the relationship between the image and its observer as inscribed within the image itself (*uttered enunciation*), appeared to constitute the issue which, in semiotics, governs all others, namely the relations between both the plastic and figurative dimensions, as well as the relations between

expression and content (semi-symbolism[4]). Indeed, as we will see, the theory of enunciation is also useful for examining the process by which the image's planes of expression and of content are established[5] (enunciative act[6]).

Using the analysis of the theory of enunciation as foundation, an attempt will first be made to address a central question raised by several disciplines and fields of investigation: How does one look at an image?[7] The question may be broken down as follows: By what means, by which compositional strategies, and by which manners of topological organization can the image predispose/configure a *model observer*?[8] If, as asserted by Marin (1993) and by other historians of art following him, the image configures, by means of its spatial strategies, a model observer, or *a simulacrum of the ideal gaze*, wouldn't the empirical observer, made of flesh and bones, be free in his or her act of gazing? Does the image pre-configure a cognitive and passional position for the observer to which the spectator must adhere and conform, or, conversely, may he or she elect to deviate from the observational simulacrum provided by the image, and if so, in what way?[9]

The sciences of language provide answers to these questions through the theory of enunciation, such theory constituting the tool for analyzing the *simulacra* of communication. In this respect, it is useful to stress from the onset that the goal of the semiotic approach is not to interpret the image, but to analyze it, that is, to shed light upon what is *commensurable* among all possible interpretations. According to the perspective of Algirdas Julien Greimas and the School of Paris,[10] what determines the commensurability of interpretations is the discursive organization of the image, which provides reading *constraints*. In counterpoint to this conception of the analysis of images, interpretation would rather be understood as an appropriation of historically and

[4]Semi-symbolism concerns the relation between categorial oppositions, including the homologation between oppositions on the plane of expression and on the plane of content. For example: "above: below = celestial: terrestrial.".

[5]This is in following with the works of Jacques Fontanille on the semiotics of imprint and namely Fontanille (2004, 2011) where the enunciation's reference position ensures the distinction between expression and content.

[6]On the notion of "enunciative act" in semiotics, see Fontanille (1998), as well as this book's last chapter which addresses the notions of substrate and application.

[7]It is a question which has also been posed several times in art history. This text will limit itself to citing Fried (1980) and Arasse (1996).

[8]Regarding the notion of "model reader" in the context of literature, please refer to Eco (1979). As concerns images, it is necessary to distinguish between the "delegate observer" directly represented within the image (Thürlemann 1980) and the types of perspective which open various routes into the painting for the penetration of the spectator's gaze.

[9]In this respect, it would be fruitful to apply Michel de Certeau's theories regarding consumer cultures to the field of visual artifacts. As concerns visual semiotics and the theory of enunciation as the subversion of a totalitarian strategy, see Dondero (2015b).

[10]For a clear, complete and updated overview on Greimasian semiotics, see Broden (2017).

culturally attested discursivity,[11] which would require the integration, within semiotics, of analysis methods proceeding from other disciplinary horizons, namely from field observation.[12]

Devoting attention to the issue of enunciation within the visual domain appears necessary today for yet other reasons. Some are internal to the discipline and to the sciences of language, such as the legitimacy of the visual as language as well as the dialog between semiotics, linguistics, and discourse analysis. Others are extradisciplinary and concern namely information and communication sciences,[13] art history,[14] philosophy of art and of images,[15] as well as visual studies,[16] and *Bildwissenschaft*.[17] In all of these cases, it is a matter of giving a new impetus to interdisciplinary dialog in view of the development of specific methodologies which would be capable of explaining the functioning of contemporary images.

[11] On this matter, see Fossali (2013).

[12] Concerning field observation as a method for the analysis of practices which may be integrated with Greimas' theory, see Dondero (2014c).

[13] In what concerns ICS, collaborations with semioticians have always been oriented towards questions regarding the interpretation of texts and namely of syncretic texts (Badir, Dondero, & Provenzano, Eds. 2019). While ICS have explored the circulation of verbo-visual texts in society and through various media (Jeanneret 2008, 2014), semiotics has favored the analysis of texts as systems of relations.

[14] A lot of research on visual metalanguage conducted in the field of semiotics (see the third section of this book) is inspired by the work of art historians such as Victor Stoichita and Hubert Damisch. See namely the notions of framing and of meta-painting (Stoichita 2015 and 1995), and the notions of "thought of the painting" and of "theoretical object" (Damisch 2000, 2008). For a summary, see Damisch et al. (2013)

[15] Consider, for instance, the legacy which the works of Nelson Goodman have left on the semiotics of art and of images (Fossali 2002; Dondero and Fontanille 2014; Sonesson 1989), as well as the legacy left by the works of Deleuze (2003) on the theory of diagrams (Dondero 2008; Basso Fossali 2013). We may also recall that themes such as *mise-en-abyme* and image montages—starting with the works of Warburg—have been the object of work in semiotics (Caliandro 2008, 2019).

[16] We could compare the trajectory between a discursive semiotics (Greimas) and a semiotics of practices (Fontanille) to the trajectory extending from art history (focused on artworks and masterpieces) to visual studies (focused on image statuses other than artistic). This connection has never been made due to a certain distance between contemporary semiotics and visual studies. Some dialogs have, however, been established between Peircean semiotics and art history (Bal and Bryson 1991; Krauss 1985), which have also been rather criticized by Elkins (2003). Other connections could be made concerning the theories of montage and of metavisuality. In this regard, see, in the field of visual studies, Mitchell (1994), and in the field of art history, see Elkins (2008). In the field of visual semiotics, see Caliandro (2008, 2013), Le Guern (2013), and Dondero (2016a).

[17] Concerning the relations between French visual semiotics and the *Bildwissenschaft* conceived by G. Boehm, see Mengoni (2018). The article also reviews the relation between the *Bildwissenschaft* and visual studies, by remarking that the semiotics of Greimas is closer to the iconic turn of Boehm, which is devoted to the relations internal to images (Boehm 2004), than it is to the pictorial turn of W. J. T. Mitchell, which is more preoccupied with the social circulation of images.

1.2 The Substrates of the Inscription of Images

In semiotics, plastic and figurative analyses have enabled the conjoint study of the expression and content of images via the semi-symbolic relation, that is, via the relation between categories pertaining to the form of expression and those pertaining to the form of content.[18] However, these categories do not take into account the relevance of that which pertains to the processes of image production (the techniques and material substrates). How was the image produced? How does the substrate of the pictorial (or photographic) inscription endow the image with its specificity? How does the image bear testimony to its technique and to the material substrate's reaction and resistance to the strategies of inscription? The production techniques and methods evidenced by the image have often been partially integrated within the concept of plasticity but have never been directly addressed by Greimasian semiotics as elements contributing to a study of the substance of the plane of expression.[19]

However, material substrates have been taken into account in semiotics by post-Greimasian theories, namely in the works by Fontanille on Berber pottery (Fontanille 1998), on the bodily dimension of enunciation (Fontanille 2004), and on writings (Fontanille 2005). Works stemming from this approach have attempted to apply these proposals to the theory of photography and to its methodology (Basso Fossali and Dondero 2011) as well as to contemporary scientific imagery (Dondero and Fontanille 2014) and digital images (Dondero and Reyes-Garcia 2016).

[18] Semi-symbolism has marked a very important moment in the history of the semiotics of images and of semiotics in general. Namely in the context of image analysis, semi-symbolism enabled, among other things, a distancing from the distinction, very widespread in visual studies (Mitchell 1986), between the arbitrary verbal sign and the motivated visual sign. Semi-symbolism has also offered a solution with respect to the analysis of images via iconographic symbolism. Regarding the process which led to the formulation of semi-symbolism, see the fundamental text by Valenti (1991).

[19] The semiotics of Groupe μ (1992) tackled the question of techniques in a more explicit manner, by attending not only to the notion of texture, but also to the notions of optical, analytical, and kinetic transformations, which made it possible to address the issue of the establishment of artworks. For a comparison between Greimasian semiotics and the semiotics of Groupe μ with respect to this matter, see Dondero (2010c). Regarding the material component of the signifier—the stimulus—see Klinkenberg (2000).

Bordron (2016) also addressed the problem of the substrate as part of his reflections regarding the relation between purport,[20] substance, and form:

> Purport becomes substance when it encounters a screen, be it a cinema screen, a painter's canvas, a wall, or a three-dimensional device. The screen has a stoppage function, but also the power to arrange lights as per ever-changing morphologies. [...] The analogy with the geographical landscape is justified by the fact that the latter also constitutes a morphological arrangement (mountain, valley, river, etc.) of fundamental material elements (sand, clay, rock, etc.). *But this morphological level, that of substance, is quite distinct from what we designate as the level of form.* (p. 237, our translation and emphasis)

Bordron continues by listing a great variety of substrates, these ranging from frescoes to stained glass and cinema screen. In the above excerpt, we can appreciate the distinction between the morphology of substance and form. By pursuing and enhancing the tripartition between purport, substance, and form, Bordron distinguishes between *form understood as symbolic structure*, made of rules and codes, and what he calls the *morphology of substance*,[21] that is, the encounter, on the one hand, of the luminous qualities stemming from the coloring materials (*tempera*, oil paint, watercolor, photographic emulsion, etc.), and, on the other hand, of the manner of disposing them (of "landscaping them") depending on the various substrates which serve a "receptive" function. The three elements constantly intermingle, because the purport subsists inasmuch as it bears the traces of the materials employed and of the resistance of the substrate, while the symbolic form emerges from the progressive work of morphological selection operated upon the substance.

This book intends to pursue the work regarding substrates initiated by Fontanille and Bordron so as to address the substance of the plane of expression in various types of images, including digital images. While Greimas' theory and Floch's analyses limited themselves to making the generative trajectory of content operational, the aim pursued here is to construct a semiotics of images integrating the analysis of the plane of expression of images as part of the semiotic theoretical project. To this end, we will base ourselves on the recent proposals which Jacques Fontanille devoted to the generative trajectory of expression (Fontanille 2008), and namely to

[20]The author discussed at length with the translator, Lila Roussel, and with her preface writer, Virginia Kuhn, the possibility of rendering such usage of the term "*matière*" (in French) by "matter," but finally preferred to maintain the term from the Hjelmslevian tradition, which warrants the translation of the Danish "*mening*" by "purport," for the sake of upholding the technicality of the semiotic metalanguage by virtue of which "*mening*" denotes: "the factor that is common ... to all languages," namely, "the amorphous thought-mass" (Hjelmslev 1963: 52) which to a certain extent is external to language as such. "In itself," Hjelmslev says, "purport is unformed, not in itself subjected to formation but simply susceptible to formation" (Hjelmslev 1963: 76). For a discussion about the terminology and the metalanguage of Greimasian Semiotics, see Broden (2020) who explains the problems of translation from French to English of some terms such as "énoncé", "langue", etc.

[21]On the distinction between symbolic form and morphology of substance, also see Bordron (2019, p. 6): "In the terminology of Hjelmslev, the second level has the name 'substance.' The word is misleading because it leaves one to imagine purport without a particular form. In reality, substance possesses a form or, maybe more exactly, a morphology. It is important to terminologically distinguish what we call 'morphology,' which is the form of substance, and 'form' in the traditional sense, which refers to the symbolic or semiotic form" (our translation).

the interface between text and object. This interface points towards the core of the relations between the image as an *application* (of light, of colors, etc.), and the image as a surface of inscription, that is, as a "receptive" *substrate* to which the inscription is applied and which then makes the inscription available to both the body of the observer/user and to the various mediums which diffuse it (the paper used by printed media, museum walls, screens, etc.). Working on images from the perspective of the substrate/application pair will enable us to problematize and to specify the notion of medium and the relationships between forms and forces.[22]

These issues will be addressed throughout the three sections of this book.

In the first part (Chap. 2), we will start by accounting for the developments in the theory of enunciation since the works of Louis Marin who was the first to apply the notion of "uttered enunciation" to the visual domain. We will consider afresh the possibility for conceiving of truly visual *langue* (language) and *parole* (speaking), by revisiting the debate formerly driven by Roland Barthes and Emile Benveniste regarding the minimal units of language systems.[23] Furthermore, the opposition between *langue* and *parole* will be called into question through the notion of "enunciative *praxis*"[24] and its articulation into modes of existence (virtualization, actualization, realization, and potentialization).

While it is difficult to conceive of *langue*, in the sense of Saussure, in the visual domain—a domain where there is no universal reservoir of distinct elements forming a system—we will hypothesize that there are, conversely, *sub-langues* that are dependent upon the social domains and institutions where the images are produced and interpreted (art, science, politics, religion, etc.). We will call these *image statuses,* and they will be attributed the same role as the "domains of validity" of sign systems as understood by Benveniste.

We will then test an approach to the study of visual enunciation which emphasizes a relation of conflict between the enunciator and the enunciatee (Fontanille 1989), that is, between the simulacrum of the image's producer and the simulacrum of its

[22]In this work, a distinction is made between medium and media. By "medium," we mean the set of components involved in the process by which a discourse is made to be carried by an object (which may be a picture, a photograph, or writing), components such as the substrates, what is applied to them (the application), and the gestures of inscription. On the other hand, by "media," we mean a communicational device which is both stabilized in its usage and fully institutionalized, such as television.

[23]See on this matter Benveniste (1974 and especially 1981). Regarding the semiotics of Benveniste and Barthes in comparison to the semiotics of Greimas, see Dondero (2017a, b). For a reflection on elementary units in the visual and verbal domains, see Colas-Blaise (2017).

[24]The enunciative *praxis* aims not to account for the *conditions of possibility* of communication, nor for the *possible* intersubjective relations generated by an utterance as in the case of the uttered enunciation (see note 76), but for the communications *realized* in and by cultural practices. As stated by Fontanille and Zilberberg (1998), within a same discourse, different magnitudes of discursive presence cohabit while pertaining to differing modes of existence: All discourses are characterized by various equilibria between modes of existence—the virtualized, the actualized, the realized, and the potentialized. These modes constitute the discursive thickness enabling one to describe each utterance in relation to cultural practices that are undergoing transformations and being translated into one another.

spectator. This perspective will enable us to define the image as a non-irenic locus where the figures of enunciator and enunciatee may compete with respect to visibility and knowledge through a conflict of perspectives. This will enable us to show that the image consists not only in presenting something to the eyes, but that it can also argument, for example by denying what it showcases. To support this position, we will return to one of the foundations of visual rhetoric (Groupe μ 1992) according to which, in order to understand an image, it is necessary to account not only for what is offered to vision, but also for what lies beyond the frame of the image, that is, what has been excluded. Proposals regarding the rhetorical enunciation of negation will be put to the test of various mediums such as painting (*Susanna and the Elders* by Tintoretto), contemporary artistic photography, and scientific images.

The second part (Chap. 3) will be devoted to the forces at play in portraits. Maintaining enunciation as a common thread, an illustration will be made of the modes of functioning of this genre of which the specificity consists in making identity present. We will first see what are the characteristics of the form of expression having defined the portrait genre which showcases both identity and dialogs with alterity. Secondly, we will explore some cases of deviation from the portrait's type—namely cases of negation, withdrawal, or multiplication of presence by chromatic or topological means. Presence will be addressed from the standpoint of tensive semiotics which will enable us to study the relations between ground and figure, these being governed by competing forces. From the standpoint of morphogenesis as inspired by the works of René Thom,[25] we will see cases where the ground exceeds the area assigned to the figure and where it tends to reduce its preponderance through compression and/or spillover, reminiscent of the struggle of forces described by Deleuze regarding the work of Francis Bacon.

In what concerns the analytical component, we will first review the photographic productions of several contemporary artists and then focus our attention on a very particular case of portraits—the portrayal of monological acts as appear in Sam Taylor-Wood's photographic series *Soliloquy*—while considering whether it is still possible to designate as a "portrait" an image in which the represented subject precludes his or her availability to enter into a dialog with the observer.

The third part (Chap. 4) of the book will address the delicate question of metalanguage in the visual domain, which is strictly dependent upon the notion of enunciation. According to Fontanille, "[E]nunciation is a 'descriptive' metalanguage because, by predicating the utterance, it displays its own activity, codes it, and makes of it a sensible or observable event" (Fontanille 2006, p. 195). The theory of visual enunciation, by exploring the spatial simulacra of production and observation, makes it possible to take account of the self-reflective activity at work within the image. A first question then arises: Is it a matter of a diffuse and generalized reflectivity— as has been advocated by some art historians and from within the field of visual

[25]See namely the works by Thom devoted to the work of art (Thom 1983).

studies[26]—or may we truly speak of a metalanguage as regards the visual domain, as per the parameters set by the sciences of language?

Since Benveniste's fundamental 1969 article *"Sémiologie de la langue"* (Semiology of Language) published in the journal *Semiotica* (1981, pp. 43–78), questions have arisen regarding the existence of units of signification in the visual system, that is, regarding the possibility of identifying *disjoint and recombinable signs* following the model of verbal language. Semiotics has attempted to respond to this challenge by proposing other types of organization of the visual domain than by means of distinct units: mereological composition and tension between opposing forces.[27] The problem of the lack of units in systems of signs other than verbal systems had already been linked to the issue of metalanguage by Benveniste (ibid.): According to him, systems which do not have units and rules to govern their relations would be dependent upon natural language for any description or for any "interpretance." In short, in his view, when there are no elementary units, there can be no metalinguistic function.

Indeed, while the question of units has been addressed by several researchers in semiotics—who have also observed that units can only result from analysis and never be a priori, as is the case with verbal language (Rastier 2001, 2011)—the issue of the metalanguage of images remains unsettled. This work aims to counter the affirmation according to which there would be no metalanguage without an alphabet constituted of discrete units having a fixed meaning and being combinable within grammatical constraints.

In order to address the issue of visual metalanguage while avoiding entangling ourselves with the question of a priori units, we will concentrate on two problems:

1. Is metalanguage conceivable when dealing with a single image which would comment itself? How, within an image, is it possible to distinguish the areas governed by object language and those governed by metalanguage? Finally, is it necessary to postulate a hierarchy between object language and metalanguage?
2. Does the image contain its own metalanguage, or does it need another image in order to be interpreted by virtue of the latter's signifying structures—another image within a series, an intertext, a chain of citations, or even a system of transformations?[28]

Greimasian semiotics distinguishes itself from the semiolinguistic theories of Benveniste and of Barthes inasmuch as it does not conceive of verbal language as being the global interpreter of other systems of signs. An image can therefore interpret another image without necessitating recourse to the system of verbal language.[29] In this scenario and especially in the field of art, each image could be envisioned as a rereading/translation of another. Any image selected within an intertext should

[26]See in this respect the chapter "Metapictures" in Mitchell (1994).

[27]Concerning mereology in the field of the semiotics of images, see Bordron (2010, 2011, 2013); concerning the tension between forces in conflict within an image, see Dondero (2016c).

[28]We are thinking here of the works, inspired by Lévi-Strauss, by Hubert Damisch on clouds (Damisch 2008) and on *Las Meninas* (Damisch 2008).

[29]In this respect, see Fabbri (1998) and, in art history, see Focillon (1992) and Warburg (2012).

hence be regarded as a platform for rereading other images,[30] following the model of *interferences* proposed by Michel Serres,[31] which excludes any hierarchy between object language and metalanguage to the benefit of the concept of translation.

The examples which will enable us to test the hypotheses proposed here include modern painting, contemporary artistic photography, fashion advertising photography, as well as image visualizations produced by the Cultural Analytics Lab using the media visualization techniques developed by Lev Manovich.

The main objective being here to test the effectiveness and the heuristicity of the theory of enunciation in the visual domain by developing its various associated problematics (such as the capacity of images to negate or the metavisual), the third part will develop the issue of enunciation from the perspective of the medium—more specifically, from the perspective of the substance of the plane of expression—and will focus on the substrates, on that which is applied to them, and on the gestural acts of inscribing the forms. As indicated at the beginning of this introduction, we will focus on the notion of *uttered enunciation* which concerns the representation of the acts of production and of observation in the image via simulacra (perspective, delegated observers, etc.), but we will also focus on the memory of the forces and gesturalities which established the image (*enunciative act*). In order to study this memory of the forces involved, our attention will shift from the sole forms of expression (for example, perspective) towards the substance of expression, that is, towards what we could call a "memory of the gestures and materials serving to establish the image."

To conclude this introduction, it must be stressed that the challenges facing visual semiotics since its inception at the end of the 1970s have been numerous. If it was for a long time limited[32] to the study of images as visual enunciations, this is because one of its first concerns was to demonstrate that visual enunciations are as much articulated by means of a linear syntax as are verbal enunciations, in addition to being articulated by means of a tabular syntax, the latter being specific to the topology of images.[33] Following this, it became necessary to demonstrate that visual enunciations possess a double articulation of expression/content (Groupe μ 1992) and that there exists "plastic content" (Basso Fossali 2004). More specifically, the challenge was

[30]See in this respect Rastier's concept of the metastability of artworks (Rastier 2016). According to this view, each form entails and supports a *family of transformations*: "The assumption of a form and metamorphosis are two moments of a same process: this transformation is diachronically oriented in the time of the text and of tradition" (p. 203, our translation). In this sense, any form would have a value of prefiguration as well as a value of conserving the old.

[31]Regarding the different manners of understanding the concept of metalanguage, including that of Serres, see Bouquiaux et al. (2013).

[32]For a brief history of the semiotic theories devoted to the analysis of images, see Dondero, Klinkenberg (2018–2019).

[33]On tabular reading, see Greimas (1989) who describes it as more complex than linear reading, which is accomplished from top to bottom and from left to right. Tabular reading is pluri-oriented— accomplished from bottom to top, right to left, diagonally, and can also include anaphoric jumps between similar features as well as the simultaneous grasping of opposite features.

to demonstrate that visual enunciations contain the means required for their own analysis (Dondero et al. 2017) and that they have the power to negate—not only to assert (Badir and Dondero 2016).[34]

Busy with these challenges internal to the sciences of language, semiotics, contrarily to the information and communication sciences, took only a slight interest in technological evolutions and in the circulation of enunciations. However, the practices of circulation and of interpretation are directly linked to the matter of the substrates underlying the signs.[35] The final pages of this book will endeavor to address the issue of the substrates of visual forms, by also taking into account the complexities presented by digital media. We will return to the significance of both the form and the substance of the plane of expression of images, while trying to provide, via the notions of *material substrate* and of *formal substrate* (Klock-Fontanille 2005; Fontanille 2005), instruments for the study of images in their full mediatic complexity. The intent is therefore to go beyond semi-symbolic analysis which relegates the image to a relation between form of expression and form of content so as to give precedence to the forces having constituted the forms of expression "in the making" (the substance).

References

Arasse, D.: Vermeer. Faith in Painting. Princeton University Press, Princeton (1996)
Badir, S., Dondero, M.G. (eds.): L'image peut-elle nier?. Presses universitaires de Liège, Liège (2016)
Badir, S., Dondero, M.G., Provenzano. F. (eds.): Les Discours syncrétiques. Poésie visuelle, BD, graffitis. Presses universitaires de Liège, Liège. (2019)
Bal, M., Bryson, N.: Semiotics and Art History. Art. Bulletin **73**(2), 174–208 (1991)
Basso Fossali, P.: Il dominio dell'arte. Semiotica e teorie estetiche. Meltemi, Rome (2002)
Basso Fossali, P.: Protonarratività e lettura figurativa dell'enunciazione plastica. Versus **98–99**, 163–190 (2004)
Basso Fossali, P.: Il trittico 1976 di Francis Bacon. Con Note sulla semiotica della pittura. ETS, Pise (2013)
Basso Fossali, P., Dondero, M.G.: Sémiotique de la photographie. Pulim, Limoges (2011)
Benveniste, E.: Problèmes de linguistique générale 2. Gallimard, Paris (1974)
Benveniste, E.: The semiology of language. Semiotica **37**, 5–23 (1981)
Boehm, G.: Jenseits der Sprache? Anmerkungen zur Logik der Bilder. In: Maar, C., Burda, H. (eds.), Iconic Turn. Die neue Macht der Bilder, pp. 40–42. DuMont, Köln (2004)
Bordron, J.-F.: Rhétorique et économie des images. Protée **38**(1), 27–40 (2010)

[34]This work is to be read in contrast to the affirmations of Mitchell (2005) regarding the impossibility for the image to negate.

[35]On the rediscovery of image substrates and of the dynamics of forces as a response to the predominance of the symbolics of forms, see Didi-Huberman (2005): "There is a work of the negative in the image, a 'dark' efficiency which, to put it as such, hollows out the visible (the disposition of the represented aspects) and corrodes the readable (the disposition of significatory devices). [...] This work or constraint may be considered as a regression, since they bring us back [...] to a lower level, towards something that the symbolic elaboration of the works had indeed masked or remodeled" (pp. 174–175, our translation).

Bordron, J.-F.: L'iconicité et ses images. Études sémiotiques. Presses Universitaires de France, Paris (2011)

Bordron, J.-F.: Dynamique des images. Signata Annals of Semiotics **10**. https://journals.opened ition.org/signata/2267 (2019). Accessed 7 September 2019

Bordron, J.-F.: Image et vérité. Essais sur les dimensions iconiques de la connaissance. Presses universitaires de Liège, Liège (2013)

Bordron, J.-F.: L'énonciation en image : quelques points de repère. In: Colas-Blaise, M. Perrin, L., Tore, G.M. (eds.) L'énonciation aujourd'hui. Un concept clé des sciences du langage, pp. 227-239. Lambert-Lucas, Limoges (2016)

Bouquiaux, L., Dubuisson, F., Leclercq, B.: Modèles épistémologiques pour le métalangage. Signata Annals of Semiotics 4. https://journals.openedition.org/signata/544. (2013). Accessed 27 March 2018

Broden, T.: A. J. Greimas in English Translation: Style and Terminology, Chronology and Cultural Context. In: Bertrand, D., Darrault-Harris, I. (eds), Le sens à même le corps. Formes sémiotiques de la créativité incarnée. Lambert Lucas, Limoges (2020, in press)

Broden, T.: Introduction: From A.J. Greimas to romance semiotics today. Semiotica **219**, 3–12 (2017)

Caliandro, S.: Images d'images. Le métavisuel dans l'art visuel. L'Harmattan, Paris (2008)

Caliandro, S.: Morphodynamics in Aesthetics. Essays on the Singularity of the Work of Art. Springer, Berlin (2019)

Caliandro, S.: Métavisuel et perception: Une investigation sur la définition d'une fonction sémiotique en art. Signata Annals of Semiotics 4. https://journals.openedition.org/signata/990. (2013). Accessed 13 October 2017

Colas-Blaise, M.: Questions de sémiotique visuelle. Énonciation énoncée et expérience de l'œuvre d'art. In: Dondero, M.G., Beyaert-Geslin, A., Moutat, A. (eds.) Les plis du visuel. Énonciation et réflexivité dans l'image, pp. 85-99. Limoges, Lambert-Lucas (2017)

Damisch, H.: The Origin of Perspective. MIT Press, Cambridge (2000)

Damisch, H.: A Theory of Cloud: Toward a History of Painting. Stanford University Press, Stanford (2008)

Damisch, H., Careri, G., Vouilloux, B.: Hors cadre: entretien avec Hubert Damisch. Perspective. https://journals.openedition.org/perspective/1670. (2013). Accessed 17 Feb 2017

Deleuze, G.: Francis Bacon: The Logic of Sensation. Continuum, London (2003)

Didi-Huberman, G.: Confronting Images: Questioning the Ends of a Certain History of Art. Penn State Press (2005)

Dondero, M.G.: Il diagramma di Foucault. Visible **4**, 71–93 (2008)

Dondero, M.G.: La sémiotique visuelle entre principes généraux et spécificités. À partir du Groupe μ. Actes Sémiotiques Website. http://epublications.unilim.fr/revues/as/3084. (2010c). Accessed 29 Jan 2018

Dondero, M.G.: Voir en art, voir en sciences. Nouvelle Revue d'Esthétique **17**(1), 139–159 (2016a)

Dondero, M.G.: La négation dans l'image: pour une approche énonciative. In: Badir, S., Dondero, M.G. (eds.) L'image peut-elle nier?, pp. 19–37. Presses universitaires de Liège, Liège (2016b)

Dondero, M.G.: Barthes entre sémiologie et sémiotique: le cas de la photographie. In: Bertrand, J.-P. (ed.) Roland Barthes: Continuités, pp. 365–393. Christian Bourgois, Paris (2017)

Dondero, M.G.: La remédiation d'archives visuelles en vue de nouvelles iconographies: le cas de la Media Visualization de Lev Manovich. Interin **1**(23), 85–107. https://seer.utp.br/index.php/i/issue/view/41. (2018). Accessed 3 November 2018

Dondero, M.G.: Sémiotique de l'action: textualisation et notation. CASA—Cadernos de Semiótica Aplicada **12**(1). http://seer.fclar.unesp.br/casa/article/view/7117. (2014c). Accessed 2 November 2018

Dondero, M.G.: The Semiotics of Design in Media Visualization: Mereology and Observation Strategies. Inf. Design J. **23**(2), 208–218 (2017c). https://www.academia.edu/35306814/The_semiotics_of_design_in_media_visualization._Mereology_and_observation_strategies_Info

rmation_Design_Journal_2017_Farias_and_Queiroz_eds_FULL_TEXT. Accessed 10 January 2019

Dondero, M.G., Beyaert-Geslin, A., Moutat, A. (eds.): Les plis du visuel. Énonciation et réflexivité dans l'image. Lambert Lucas, Limoges (2017)

Dondero, M.G., Fontanille, J.: The Semiotic Challenge of Scientific Images. A Test Case for Visual Meaning. Legas Publishing, Ottawa (2014). https://www.academia.edu/19799510/The_Sem iotic_Challenge_of_Scientific_Images._A_Test_Case_for_Visual_Meaning_with_Jacques_F ontanille_FULL_TEXTE.Accessed 5 November 2018

Dondero, M.G., Reyes Garcia, E.: Les supports des images: photographie et images numériques. Revue Française des Sciences de l'Information et de la Communication 9 (2016). http://rfsic.rev ues.org/2124. Accessed 10 May 2018

Eco, U.: Lector in fabula. La cooperazione interpretativa nei testi narrativi. Bompiani, Milan (1979)

Elkins, J.: What does Peirce's sign theory have to say to art history? Culture, Theory and Critique **44**(1), 5–22 (2003)

Elkins, J.: Six Histories from the End of Representation. Images in Painting, Photography, Astronomy, Microscopy, Particle Physics and Quantum Mechanics, 1980–2000. Stanford University Press, Redwood City (2008)

Fabbri, P.: La svolta semiotica. Laterza, Rome-Bari (1998)

Floch, J.-M.: Petites mythologies de l'œil et de l'esprit. Pour une sémiotique plastique. Hadès-Benjamins, Paris-Amsterdam (1985)

Floch, J.-M.: Les formes de l'empreinte: Brandt, Cartier-Bresson, Doisneau, Stieglitz, Strandt. Fanlac, Périgueux (1986)

Focillon, H.: The Life of Forms in Art. Zone Books, New York (1992)

Fontanille, J.: Les espaces subjectifs. Introduction à la sémiotique de l'observateur. Hachette, Paris (1989)

Fontanille, J.: Soma et séma. Figures du corps. Maisonneuve et Larose, Paris (2004)

Fontanille, J.: Du support matériel au support formel. In: Arabyan, M., Klock-Fontanille, I. (eds.) L'Écriture entre support et surface, pp. 183–200. L'Harmattan, Paris (2005)

Fontanille, J.: The Semiotics of Discourse. P. Lang, New York (2006)

Fontanille, J.: Pratiques sémiotiques. Presses universitaires de France, Paris (2008)

Fontanille, J.: Corps et sens. Presses universitaires de France, Paris (2011)

Fontanille, J.: Décoratif, iconicité et écriture. Geste, rythme et figurativité: à propos de la poterie berbère. University of Limoges Website, Visio. http://www.unilim.fr/pages_perso/jacques.fontan ille/articles_pdf/visuel/decoratifberbere.pdf. (1998). Accessed 24 Dec 2018

Fontanille, J., Zilberberg, C.: Tension et signification. Mardaga, Liège (1998)

Fried, M.: Absorption and Theatricality. Painting and Beholder in the Age of Diderot. Chicago University Press, Chicago (1980)

Greimas, A.J.: Figurative Semiotics and the Semiotics of the Plastic Arts. New Lit Hist **20**(3), 627–649 (1989)

Groupe μ.: Traité du signe visuel. Pour une rhétorique de l'image. Seuil, Paris (1992)

Hjelmslev, L.: Prolegomena to a Theory of Language. University of Wisconsin Press, Madison (1963)

Jeanneret, Y.: Penser la trivialité 1. La vie triviale des êtres culturels. Hermès-Lavoisier, Paris (2008)

Jeanneret, Y.: Critique de la trivialité. Les médiations de la communication, enjeu de pouvoir. Éditions non Standard, Paris (2014)

Klinke, H.: Big Image Data within the Big Picture of Art History. Int J Digital Art Hist **2**, 15–36 (2017)

Klinkenberg, J.-M.: Précis de sémiotique générale. Seuil, Paris (2000)

Klock-Fontanille, I.: L'écriture entre support ct surface: l'exemple des sceaux et des tablettes hittites. In: Arabyan, M., Klock-Fontanille, I. (eds.) L'écriture entre support et surface, pp. 29–52. L'Harmattan, Paris (2005)

Krauss, R.: The Originality of the Avant-Garde and Other Modernist Myths. MIT Press, Cambridge (1985)

Le Guern, O.: Métalangage iconique et attitude métadiscursive. Signata Annals of Semiotics 4. https://journals.openedition.org/signata/1000. (2013). Accessed 20 May 2018

Marin, L.: De la représentation. Seuil, Paris (1993)

Mengoni, A.: Le tournant iconique de Gottfried Boehm et la sémiotique plastique de Greimas. La Part de l'Œil **32**, 331–341 (2018)

Mitchell, W.J.T.: Picture Theory. Essays on Verbal and Visual Representation. University of Chicago Press, Chicago (1994)

Mitchell, W.J.T.: What do Pictures Want? The Lives and Loves of Images. University of Chicago Press, Chicago (2005)

Mitchell, W.J.T.: Iconology. Image, Text, Ideology. University of Chicago Press, Chicago (1986)

Rastier, F.: Arts et sciences du texte. Presses universitaires de France, Paris (2001)

Rastier, F.: La Mesure et le Grain—Sémantique de corpus. Champion, Paris (2011)

Rastier, F.: Créer: Image, Langage, Virtuel. Casimiro, Paris-Madrid (2016)

Sonesson, G.: Pictorial Concepts. Inquiries into the semiotic heritage and its relevance for the analysis of the visual world. ARIS Nova Series. Lund University Press, Lund (1989)

Stoichita, V.: Visionary Experience in the Golden Age of Spanish Art. Reaktion Books, London (1995)

Stoichita, V.: The Self-Aware Image: An Insight into Early Modern Metapainting. Harvey Miller, London (2015)

Thom, R.: Local et global dans l'œuvre d'art. Le Débat **2**(24), 73–89 (1983)

Thürlemann, F.: Fonctions cognitives d'une figure de perspective picturale: à propos du Christ en raccourci de Mantegna. Le Bulletin **15**, 37–47 (1980)

Valenti, M. Dal figurativo all'astratto. In: Corrain, L., Valenti, M. (eds.) Leggere l'opera d'arte. Dal figurativo all'astratto, pp. 7-30. Esculapio, Bologna (1991)

Warburg, A.: L'Atlas mnémosyne. Éditions Atelier de l'écarquillé, Paris (2012)

Chapter 2
The Theory of Enunciation: From Linguistics to Visual Semiotics

2.1 Foreword

Although semiotics of the structuralist tradition, which devoted itself to the theorization and analysis of visual language in the 1980s and 1990s, did not directly address the issue of enunciation,[1] a second and third generation of semioticians gave due consideration to this concept, developing it and legitimizing its use in an extra-verbal context.

Thirty years ago, the 1989 book by Jacques Fontanille, *Les Espaces subjectifs. Introduction à la sémiotique de l'observateur (discours, peinture, cinéma)*, set the challenge of transposing the concept of enunciation into the visual domain and into the field of the audiovisual arts (painting and cinema), and remains the starting point for any contemporary reflection on the matter, namely in what concerns enunciation in the still image.[2] While the corpora favored by School of Paris researchers were artistic images—entailing a certain tendency to assimilate visual enunciation with artistic

[1]See in this respect Greimas (1989), Floch (1985, 1986, 2005), Thürlemann (1982), and Silva (2004). For an enlightening history and analysis of the term "enunciation," please refer to Badir et al. (2012).

[2]While cognitivist visual semiotics such as that of Groupe μ never posed the question of visuality in terms of enunciation, all the works on frames and framing carried out by Groupe μ developed, from an "indexical" standpoint, the enunciative problematics which interest us here. See in this respect Groupe μ (1992) and Klinkenberg (2016).

enunciation—enunciative analysis concerning images belonging to other domains,[3] namely the sciences, recently appeared in semiotics.[4]

In following with past and present research, this first part will address the simulacra of communication and, more specifically, the intersubjective relations *inscribed* within the image. The enunciative analysis of visual enunciations aims as such to describe "the position and manner of the gaze," that is, to study the points of view from which the image was conceived and which are required for its apprehension through the observer's gaze. Enunciative analysis hence constitutes a tool enabling one to study the ways in which values, passions, and ideologies are embodied within visual enunciations. Such analysis is made possible thanks to the notion of *uttered enunciation*, described as follows in Greimas and Courtés' *Dictionary* (1982):

> An unfortunate confusion is often encountered between enunciation properly speaking, the mode of existence of which is that of being what is logically presupposed by the utterance, and the *uttered* (or reported) *enunciation* which is only the simulacrum within the discourse imitative of the *enunciative* doing: the "I," "here," and "now" that we encountered in uttered discourse in no way represents the subject, space or time of the enunciation. ("Enunciation" entry, p. 105)

The actions of both the producer and the spectator of the image are meant to be "imitated" within the utterance itself by simulacra which are actorial (I-you/he-she), spatial (here/there), and temporal (now/then). We will return to these different types of simulacra in greater detail; for the moment, it may be pointed out that *actorial simulacra* can be identified with characters who have a role of observer within the image (and who may be admirative, nonchalant, indifferent, etc.)—roles to which the spectator may or may not conform. *Spatial simulacra* concern the various types of perspective (geometrical, atmospheric, reverse, etc.) and indicate from which distance (spatial distance but also passional distance) the spectator is to grasp the image. *Temporal simulacra*, for their part, concern the trajectories produced by simultaneous actions within the scene, but also plastic transformations (in chromaticity, luminosity, etc.) which exceed the sphere of human action. In general, actorial simulacra concern the figurative formants of the image[5] (everything that can be identified

[3]See the work by Beyaert-Geslin (2009) on enunciative authenticity in the context of war reporting and photography, as well as Dondero (2014a, b) on enunciation in fashion advertising photography and in the project of public architecture, respectively. See also Beyaert-Geslin (2017) on portraits in the worlds of art and of the press, as well as the work by Basso Fossali and Dondero (2011) which proposes a reflection on the specificity of photographic enunciation, applied to artistic and scientific statuses.

[4]For a problematization of scientific images with respect to artistic ones, see Beyaert-Geslin and Dondero Eds. (2014), Bordron (2013), Dondero and Fontanille (4).

[5]By "figurative formant" we mean packets of visual features, of varying density, which the reading grid, of a semantic nature, constitutes into units endowed with meaning; in other words, we pass from visual figures to object-signs: "A more attentive examination of the act of semiosis would show that the principal operation constituting it is the selection of a certain number of visual features and their subsequent globalization. This is a simultaneous grasping that transforms the bundle of heterogeneous features into a format, that is, into a unit of the signifier. This unit is recognizable, when it is framed by the grid of the signified, as the partial representation of an object from the natural world. [...] We can see that the formation of formants, at the time of semiosis, in no more than

and lexicalized), whereas spatial and temporal simulacra are constructed upon plastic relations and oppositions (topological, chromatic, eidetic).

Before detailing the actorial and spatio-temporal configurations of uttered enunciations, let's look at enunciation as mediation between *langue* and *parole* and at the manner in which it may be understood within the visual framework. We will address this question through the perspective of the School of Paris, which illustrates it as follows:

> Emile Benveniste gave the first formulation of enunciation as process by which natural language (Saussure's *langue*) is turned into discourse. In between language (conceived as a paradigmatic system) and speech—already interpreted by Hjelmslev as a syntagmatic system and now specified in its status as discourse—it is indeed necessary to supply mediating structures and to imagine how it is that language as social system can be assumed by the individual realm without as a result being scattered into an infinite number of examples of speech (Saussure's *parole*), outside all scientific cognizance. (Greimas and Courtés 1982, "Enunciation" entry, p. 103)

In this passage, it is question of both "mediating structures" and of "assum[ing] by [an] individual [instance]." The *individual* realization of the system of *virtualities* is accomplished by the *taking of an initiative*: It is the enunciative act producing the utterance. There is no utterance without an enunciative act, as there exists no utterance devoid of an instituting standpoint or of an *axis of reference* serving as *generative* and *regulating center* for the interpreter's access to meaning.

In the terms of A. J. Greimas' theory, enunciation concerns the appropriation of semio-narrative structures (deep structures of semiotic *competence*) by an individual who selects, from a particular standpoint, the linguistic virtualities and realizes them through discourse (discursive structures of semiotic *performance*). This act of individual appropriation enables a conception of enunciation not only as a theory of mediation between *langue* and *parole*, but also as a theory of the insertion of the subject and his or her perspective into language. We will address, firstly, the conception of enunciation as mediation between *langue* and *parole* and, following that, the conception giving precedence to matters of point of view and of intersubjectivity.[6]

2.2 *Enunciation as a Mediation Between* Langue *and* Parole

The first conception of enunciation has to do with the mediation between system and process, between *langue* and *parole*.[7] Firstly, a question arises: Is it possible to conceive of such a thing as language in the visual domain?

an articulation of the planar signifier, its *segmentation* into legible discrete units. This segmentation is done with a view to a certain kind of reading of the visual object, but [...] it does not exclude other possible segmentations of the signifier" (Greimas 1989, p. 633).

[6]For a history of the linguistic and semiotic theories of the viewpoint, see Rabatel (1997).

[7]TN: Throughout this book, the French terms *langue* and *parole* will be employed in accordance with their usages as established by Saussurean linguistics and Greimasian semiotics.

In order to analyze a visual utterance and in order to understand the way in which it signifies with respect to other visual utterances, it is necessary to take into account the collective repertory of forms stabilized though usage, that is, the totality of combinations of elements and forms which are available to the producer as *possibilities* at the moment of producing the image. But is there such a thing as a true visual grammar by which to combine visual elements, which functions in the manner of a system of rules? Is it possible to conceive of a single and universal grammar for the combination of colors, lines, and shapes, as proposed in 1992 by the members of Groupe μ in their *Traité du signe visuel. Pour une rhétorique de l'image*? As asserted by Jacques Fontanille, "in what concerns images, the system— as a schematic virtuality independent from any singular utterance—remains forever elusive" (Fontanille 1996, p. 48, our translation).

"Liberty," or the lack of a code, being that which characterizes visual language according to Benveniste (1974), is not, however, a defining characteristic. Diachronic research on images shows that each act of image production is confronted with several constraints, be they pertaining to genre, intertext, status, tradition, available materials, etc. It is precisely at levels of immanence which are higher than the level of the image (considered as an utterance), such as the levels of genre and status,[8] that it is possible to locate codes of sorts—and not at inferior levels such as the level of signs, understood here as minimal units. For example, at the morphological level, it should be stressed that, contrarily to the notational systems of natural languages where each marking forms a unit that is easily distinguishable from another (the grapheme *g* as opposed to the letter *c*, for instance), with images, we are always dealing with elements which cannot be assimilated to classes of stable-value elements. There are indeed no fixed and bounded classes of topological, chromatic, and eidetic elements,[9] and this requires that the units be constructed and reconstructed in each image, the units obtained resulting from a stance taken by the analyst. In other words, there exists no limited reservoir of distinctive and recombinable markings akin to the graphemes found in notational systems of which the value would be fixed within a system of possibilities prior to their being "put" into an image.[10]

The question also stands regarding syntax: What could, within the visual domain, be analogous to syntactic rules, namely rules which would allow or prohibit the combination of minimal visual units as occurs in natural languages?[11] If there are no

[8]On the relation between utterances, genres, and statuses in the visual field, see Basso Fossali and Dondero (2011).

[9]See in this respect the analysis of Paul Klee's painting *Blumen-Mythos* by Thürlemann (1982), where the researcher attempts to identify classes of surface elements and linear elements which however can only be located within the painting itself and are not generalizable to other pictorial productions.

[10]A counterexample can be found with Paul Klee (1964) who constructed a sort of pictorial alphabet. We will return to this in the third part of the book.

[11]For example, we can find a *langue* characterizing each painter, as did Jean-Marie Floch in *Petites mythologies de l'œil et de l'esprit: Pour une sémiotique plastique* (*Eye on mind; a collection of short*

universal rules for the combination of elements (the elements only being the result of an interpretive stance renewed at each analysis), one may, however, mention the physiological constraints, namely the chromatic ones, imposed by the distinction between primary and secondary colors, or compositional rules (re)defined by the pictorial tradition, by artistic movements, and by schools of thought.[12]

It is therefore difficult to maintain the two following (extreme) postulates: on the one hand, the existence of a universal visual *langue* and, on the other, the idea according to which each painting may constitute a system in itself, by instituting its own *microlangue*. In the latter case, there would be a coincidence between *langue* and *parole*, between system and process, and between types and tokens. If we were to follow this path, each visual utterance would deploy, within itself, the very tools for its own comprehension, and it would have its own specific grammar, a grammar which would be both autonomous and unique. From such a conception, it would follow that each pictorial *langue* would be fully independent from images instantiating the *langue* of other painters, which would render incomprehensible, unintelligible, and incommensurable any filiation between different artistic productions.

We will rather look at a *median* position between the option conceiving of a universal visual *langue*—a conception which was in part proposed by Groupe μ (1992)—and the one which considers each image as a micro-code endowed with its own grammar, hence the one excluding any sort of grammatical commensurability with other images[13]—an option which was attractive to a number of semioticians of the Greimasian school during the 1980s.[14]

mythologies: Towards a theory of plastic semiotics) (1985) regarding Kandinsky's production. This approach enabled him to emit hypotheses on the meaning of *Composition IV*, the painting at the center of his analysis, by starting with several comparisons with earlier paintings by the Russian artist. In order to understand abstract paintings such as *Composition IV*, Floch started from the more figurative paintings of Kandinsky's early production where the composition of colors and lines resembles those of *Composition IV*. Floch reconstructed a *local* and *historically attested* microsystem which shows within which configurations Kandinsky's trajectory may be observed. This valuable analysis problematizes the difficulties in locating general grammatical rules for visual *langue* and shows a possible solution: finding local and historically attested microsystems which regulate liberty in composing and interpreting.

[12] See Basso Fossali (2014).

[13] It is important to keep in mind that *langue* has a translational function: It is the function of the system to make various discourses commensurable. See in this respect Benveniste (1974, 1981), when he describes the difference between verbal signs and visual signs, while denying the existence of visual *langue*: "Therefore, the meaning of art may never be reduced to a convention accepted by two partners. New terms must always be found, since they are *unlimited* in number and *unpredictable* in nature; thus they must be redevised for each work and, in short, prove unsuitable as an institution. On the other hand, the meaning of language is meaning itself, establishing the possibility of all exchange and of all communication, and thus of all culture" (1981, p. 12, emphasis added).

[14] Several disciples of Greimas have indeed followed Benveniste when he asserted that the antidote against the liberty of visual signs is to concentrate on a sole image as a closed system of signification. See Benveniste on the issue of colors, for example: "The artist chooses them, blends them, and arranges them on the canvas according to his taste; finally, it is in composition alone that, technically speaking, they assume a 'signification' through selection and arrangement. Thus the artist creates his own semiotics; he sets up his own oppositions in features which he renders significant in their

Greimas himself, in "Figurative Semiotics and the Semiotics of the Plastic Arts," went a step further than Benveniste who did not acknowledge the existence of a system of visual language:

Such a system, which is said to exist but which is unknown to us, can have a chance of being grasped and made explicit only through an examination of the *semiotic processes*—that is, of the "visual texts"—by which it realizes itself. Knowledge of particular planar objects can lead to knowledge of the system which underlies them. This means that if the processes are grasped in their realized form, they presuppose the system as a virtual one, and thus as one that can be represented only through an ad hoc, constructed language. (Greimas 1984, p. 637)

It is clear that Greimas does not renounce conceiving of a visual system, though he is aware that such a system is not universal and that it does not depend upon a "general" perception. If it is indeed a matter of system, it would be so under the condition of it being reconstructed a posteriori through the analysis of relations of kinship between the various images.

Such virtual system may now be envisioned thanks to computational instruments developed for the purpose of plastic feature extraction (Nixon and Aguado 2012) and which are capable of classifying sets of images by means of similarities and differences within very large collections (big visual data). This would provide a solution to the *langue-parole* problem which may be defined as exclusively "internal," that is, as strictly dependent upon the internal features of images; we will return to this in the third section of this book. If, conversely, we were to consider a more complex solution that would not solely depend upon the plastic features of images but also upon their content, their mediums and their usages—which would then limit us to small corpora and to a purely qualitative approach—it would be necessary to hypothesize the universal visual language as making way to sub-*langues* which are dependent upon the images' statuses (art, science, law, religion, etc.). This is what we call a *median* option between a universal visual *langue* and *langue* as instituted by each visual utterance. Between the two extreme options, median levels of discursive organization may be envisioned between the system and a single utterance—those pertaining to statuses, genres, series, and filiations. The relation between *langue* and *parole* can thus be reviewed firstly in the light of image statuses: Each of these, or each valorization the image receives within a *given social domain* (artistic, scientific, religious, advertising, political, etc.),[15] is determined by a specific type of enunciation which depends upon the institutions through which these images are diffused

order. Therefore, he does not acquire a repertory of signs, recognized as such, nor does he establish one? Color, the material, comprises an unlimited variety of gradations in shade, of which none is equivalent to the linguistic sign. […] The signifying relationships of any artistic language are to be found within the compositions that make us aware of it" (1974, p. 12, our translation). According to Benveniste, only verbal language is analyzable as a stable system of significations because it depends upon a general system which sets the rules of comprehension for specific processes.

[15]Concerning domains and enunciation, see Bordron (2016). What we call "status" includes what Bordron refers to with the notion of the "economy" of images. "Economy" designates the ordering which founds the possibilities of values and their eventual circulation. For Bordron, interrogating the economy of an image amounts to wondering within what global order it is inscribed, which fundamental articulation it presupposes in order for it to be understood. Regarding the status of

(museum, laboratory, cathedral, press, etc.) and through which they are rendered intelligible. Secondly, other criteria for interpretive selection can be activated in order to identify the trajectories which are more or less constrained by the repertories of forms available to image producers: These are genres (which we will address in the second section of this book), series, genealogies,[16] and intertexts.[17]

2.3 Enunciation as an Appropriation: Production and Observation

The second conception of enunciation concerns the act of appropriating a *langue* via an *individual selection* resulting in a bounded and accomplished linguistic output (*parole*) we call *utterance*. The utterance is the result of an enunciative act having been *objectified* onto a substrate.

The utterance, be it verbal, pictorial, photographic, or filmic, is understood as a *signifying totality*: The different types of utterances share the feature of having been produced by an enunciative act, and, more specifically, by an act of *disengagement*.[18] An utterance is characterized by the fact that it was produced by an act having provided it with limits and boundaries (a frame in the case of paintings,[19] a front and back cover in the case of novels, opening and ending credits in the case of films…).

photographic images, and namely regarding the religious, scientific (biology and astrophysics), and political statuses of images, see Basso Fossali and Dondero (2011).

[16]We will return in this regard to the works of Warburg and Focillon from the contemporary perspective of computational and quantitative (distant reading) analyses which aim to identify the degrees of visual similarity within large collections of images.

[17]In the case of art, for example, and especially in painting, the exceeding of rules (in the sense of conventions which exist in each era) is exactly what benefits the artist in view of surprising/decompetentializing the spectator and for sparking the search for new configurations and new conceptions of space. What is prohibited, in art, is rather of the order of "doing what has already been done": The rule is therefore not internal to a stable grammar, but depends on local usages. On matters of negation of tradition and of renewal in the field of the plastic arts, see Beyaert-Geslin (2012).

[18]See Greimas and Courtés (1982, "Disengagement" (*débrayage*) and "Engagement" (*embrayage*) entries): "We can try to define disengagement as the operation by which the domain of the enunciation disjuncts and projects forth from itself, at the moment of the language act and in view of manifestation, certain terms bound to its base structure, so as thereby to constitute the foundational elements of the discursive utterance. For example, if we take the domain of the enunciation as a syncretism of "I-here-now," disengagement […] will consist in inaugurating the utterance […]. Actantial disengagement, then, in its first steps, will consist in disjuncting a "not-I" from the subject of the enunciation and projecting it into the utterance, temporal disengagement in postulating a "not-now" distinct from the time of the enunciation, spatial disengagement in opposing a "not-here' to the place of enunciation" ("Disengagement" entry, pp. 87–88). Engagement is defined in opposition and in complementarity to disengagement: Disengagement "is the effect of the expulsion from the domain of the enunciation of the category terms which serve as support for the utterance, whereas engagement designates the effect of a return to the enunciation" ("Engagement" entry, p. 100).

[19]In painting, it is the enclosure ensured by the frame which allows us to postulate that the painting functions as a semiotic microsystem enabling us to identify centers of attention, relations between

Greimasian semiotics postulates that visual utterances may be analyzed as systems of signification on the basis of differential relations between forms, colors, and positions.[20] These differential relations provide the basis for understanding the construction of a point of view and the position the observer is meant to occupy—spatially, pragmatically, cognitively, and passionally. As already outlined above, the utterance prefigures the assumption of a position, trajectories of the gaze, as well as a set of values to be shared with the observer.

Whereas in verbal language, enunciation concerns the manner of asserting something (disengagement) and of taking responsibility with respect to that which has been uttered (engagement), in the case of images,[21] it rather concerns *corporeal action*, which coextensively articulates a *productive act* (painting, photographing, drawing, etc.), and an *observational act* (contemplating, looking, grasping, etc.). As already mentioned, semiotics is devoted to the study of the simulacra of production and of observation carried by the enunciator and enunciatee. These simulacra play the same roles as the pronouns *I* and *you* employed in everyday discourse. These are simulacra of subjectivity in the forms of *taking an initiative* (the *I*) and of *addressal* (the *you*) within the discursive construction of the dialog. The enunciator and the enunciatee are in fact identifiable by means of the *discursive configurations which stand for them* and which offer the flesh and blood interpreter *possible* models for reading trajectories: This is what we have called the *uttered enunciation*.

The enunciator and the enunciatee form a pair of *discursive simulacra* and their relation is characterized by a form of reciprocality. The enunciator is constituted at the same time as the enunciatee. Of course, they are both subjects of the enunciation who may fail to correspond to any character represented within the image or to the empirical producer/spectator pair; they may be found however in the *various configurations of space*, in the perspectives employed, in the intersections of viewpoints, and in the rhythms of the phenomena represented.[22]

Let's examine this point. Enunciation as a semiotic instance that is logically presupposed by the utterance is to be distinguished from enunciation as a non-linguistic, referential act related to the communication situation[23] *in praesentia*. Classical semiotics does not endeavor to analyze the *act of enunciation* itself, that is, the acts of speaking, painting, photographing—understood as *processes taking*

center and periphery, equilibria between planes at various depths, the economy of the directional forces of the lighting, etc. See in this respect Thom (1983). Concerning picture frames and statue bases from a Peircean and diagrammatical perspective, see Dondero (2014d).

[20]With respect to the three plastic categories (topological, chromatic, and eidetic), see Greimas (1989) and Floch (1985). For another, more cognitivist perspective, see Groupe μ (1992).

[21]Concerning the relation between assertion and assumption, see Fontanille (2006). Assertion, which can be assimilated to disengagement, concerns making the content of an utterance present in the discourse's field of presence, whereas assumption, which can be assimilated with engagement, concerns the appropriation of the content of the utterance by the subject of the enunciation.

[22]The term "observer" is used here as a synonym of "enunciatee," which is to be taken as the simulacrum of a real, flesh and blood spectator.

[23]For a critique of this theory of enunciation as a theory of simulacra constructed on the model of the *conversation in presence*, hence on an extralinguistic basis, see Paolucci (2021).

place within practices—but to study the uttered enunciation, that is, the *enunciative markings of subjectivity and intersubjectivity deposited into discourse*.[24] We have already indicated that the simulacra of the producer and receptor of an utterance do not coincide with the actions of the real, flesh and blood producers and receptors, but rather with the multiple strategies available to the subjects of the enunciation to position themselves with respect to the image, to construct a rhetoric of self and of others, and this, within variegated times and spaces. The subject is therefore a product of discourse, meaning that subjectivity and intersubjectivity may be studied from the standpoint of utterances and not the reverse.

A quite eloquent explanation of the notion of uttered enunciation in images has been provided by semiotician and art historian Louis Marin. In *Opacité de la peinture* (1989), he clarified the difference between uttered enunciation and enunciative act in situations of communication by drawing upon examples of religious paintings. The latter are useful to describe, in a manner other than that of linguistics, the distinction between "restricted enunciation" and "extended enunciation" to which we will later return.[25]

According to Marin,[26] Italian Annunciation scenes would symbolize a homology between the structure of communication of the Incarnation of God and the structure of the uttered enunciation. The idea that founds the analogy between the theory of the uttered enunciation and the representation of the Annunciation stems from the fact that, being at the basis of the singular event of the appearance of an utterance, enunciation as an *act* is "unknowable" to the sciences of language in the same way as the Incarnation of God is unknowable to manmade sciences. Both enunciation and Annunciation can only be approached *indirectly*, from markings, traces, or clues that the singular event (the enunciative act, the Annunciation) deposits within utterances: In a certain way, *the enunciation manifests itself as forever and irremediably concealed and ungraspable*, as is the secret of the Annunciation. The act of God's Incarnation and the act of enunciation would likewise be impossible to understand; all that would remain in our reach would be to study their residual discursive markings. To illustrate this, Marin uses the example provided by the *Annunciation* by Domenico Veneziano (1445–1450, Fitzwilliam Museum, Cambridge), which shows that the secret of the Annunciation is only *spoken about* along the *axis of history* (historical enunciation in the terms of Benveniste), from left to right, from a third-person perspective. Indeed, Angel Gabriel and Mary are portrayed in side view, and both the access to their gaze and the institution of an *I-you* dialog with the observer

[24]For a panoramic glimpse at the debates in enunciative linguistics and in Greimasian and post-Greimasian semiotics, see Colas-Blaise (2010).

[25]We here return to the famous distinction by Kerbrat-Orecchioni (1980). The debate concerning the "restricted" version of enunciation (the uttered enunciation) and its "extended" version (the referential enunciation) is still topical in the sciences of language. The extended version of this theory pushes back the limits of the explorations to the point of describing the communication situation, the enunciation scene, and its components—the protagonists of the discourse, the spatio-temporal circumstances, the conditions of production/reception, the historical and cultural setting, and the generic and sociolectal determinations. See Maingueneau (2012, 2014).

[26]We namely refer to Chapter Five, "Annonciations toscanes.".

(addressal) are precluded. It is therefore impossible to conceive of a dialog or to uncover the secret along the *axis of perspectivity* (discursive enunciation in the terms of Benveniste). The axis of perspectivity reveals itself through the act by which the observer's gaze penetrates the depths of the painting. Such penetration is prohibited, or in the very least obstructed by a closed door and hermetic lock blocking the observer along the axis of perspectivity. In the image, the mystery of the Annunciation is signified by the very negation of the ability to access revelation (forbidden entry).

Veneziano's *Annunciation* provides a valuable *exemplum* of the functioning of the uttered enunciation: The access to the act of enunciation/Annunciation is irremediably concealed and even forbidden—we can only analyze the *traces* of communication/revelation since the latter will remain forever unknowable.

2.4 Person/Time/Space in the Image

In verbal discourse, the enunciative marks of subjectivity and of intersubjectivity involve namely personal pronouns (*I, you, he/she/it, we*), verbal tenses (present and past), and adverbs in relation to the description or appropriation of a locus (here and there). Each act of enunciation thus involves a triple disengagement: actorial, temporal, and spatial. According to Benveniste, the *he/she/it* of the third person is associated with *another time and place* whereas the pronominal pair *I-you* is associated with a *here* and *now*. From this, Benveniste makes a distinction between *historical enunciation* and *discursive enunciation*.[27]

Within the context of the image, the disengagement of the person (*actantial disengagement*) mainly corresponds to the *system of gazes* which circulate within the painting. Side and frontal views constitute topological investments of the person and, more generally, configurations of what Benveniste respectively calls historical enunciation and discursive enunciation. The subjects painted or photographed in a side

[27]See on this matter (1966, pp. 206–207, our translation). The *historical* utterance, according to Benveniste, is characterized by the third person, the past tense (the *aorist*), and by a distant location. Events from the past which are over and done appear to tell their own story by themselves, *without any intervention of the speaker in the account. Discursive enunciation*, on the other hand, is characterized by any utterance supposing a speaker and auditor in the present, and by an intention of the former to influence the latter in some way. Benveniste asserts that it is mostly oral discourses or "the mass of writing that reproduces oral discourse or that borrows its manner of expression and its purposes: correspondence, memoirs, plays, didactic works, in short, all the genres in which someone addresses himself as the speaker, and organizes what he says in the category of person" (Benveniste 1966, p. 209, our translation). This fundamental distinction by Benveniste corresponds to what Greimas calls "utterative disengagement" ("*débrayage énoncif*") and "enunciative disengagement" ("*débrayage énonciatif*"). See in this respect Greimas and Courtés (1982, "Disengagement" entry, p. 88).

view have a "third person" attitude: This may be observed in paintings of the "histor-ical" genre, in which events unfold without beckoning the observer.[28] The historical scene establishes an asymmetrical relation between something belonging to the past and a spectator who observes from the present (time of enunciation/observation). The relation is therefore not dialogical, as it is in the case of portraits which propose a frontal "I-you" relation of exchange, conjugated in the present tense: In histor-ical painting, the event is conjugated in the third person, depicted as being "already brought to a close"—any direct communication between the enunciator and enunci-atee is precluded. Conversely, subjects painted in portraits address us by establishing a relation of the *I-you* type, or even a direct dialog, when they are portrayed frontally and when they cast their own searching gaze in the direction of the viewer. A subject represented so as to appear to look at the viewer from within the portrait functions as a mirror, one which interrogates, stares, and embraces. We will return to this in the second section of the book.

Temporal disengagement finds itself attested in the disposition of figures along the various planes of depth. We could assert that the foreground plane signifies the present and that recessive planes represent the past.[29] We could also conceive of the temporal question in a more dynamic manner: Forces may be identified in the image, for example, a trajectory (of light, of shapes, etc.) extending from the surface of the image towards its depths (from the present towards that which is far away in time), or a reverse trajectory extending from the depths towards the observer, that is, towards the *now* of the act of observation, as in still-life paintings where an object set on a table appears to be on the verge of falling towards the observer's location (Dondero 2012b).

The major challenge is to demonstrate that narrative transformation, which necessarily involves temporal extension, may be supported by a *single, isolated, discrete* image. Because if we multiply the images, as occurs in press reports and fashion photography series, we necessarily obtain an effect of sequentiality and of duration, where gaps between the images are filled and in which contiguity is established, thereby producing an effect of deployment.[30]

Temporal disengagement in the single-scene still image has only been rarely addressed by semiotic studies.[31] The narrativity internal to the image concerns not only the trajectory of the deicticization of the action in space, but also more abstract

[28]See Marin (1993). Concerning the paintings which exclude the role of the observer, see the reflections on non- theatricality in French painting of the eighteenth century by Fried (1980).

[29]See in this respect the analysis of some of Matisse's paintings by Beyaert-Geslin (2004) who main-tains that everything in the Frenchman's paintings unfolds in the present since all represented objects (carpets, tables, paintings, windows, wallpapers, etc.) are disposed in the foreground, presenting the observer with only a single plane of depth.

[30]Concerning internal narration as deployed by a sole image and external narration as supported by multiple images, see Vouilloux (2013) and namely, in what concerns internal narration, the relation between substrate, plane, and scene. According to the author, when the plane and the scene are not in a relation of homology, there occurs an opacification of narration which enables the image's reflective work to emerge.

[31]For an analysis of temporality within a spatial art (sculpture), please refer to the fundamental text by Petitot (2004), especially the first chapter ("*Goethe et le Laocoon ou l'acte de naissance*

cases where narrativity involves forces[32] affecting our perception, such as produc-
tion actions[33] (of tracing, englobing, causing to disappear, etc.). Consider for instance
the temporality of the face in a portrait: There are cases where the face advances front-
wards, and others where it retreats, hides, shuns, etc. Framing is indeed capable of
portraying the face through various rhythms of appearance/disappearance, which
would require an analysis of the spatial aspectuality.[34] We will examine the tempo-
rality of portraits in the second part of this work; for the time being, we shall address
in greater depths the question of narrativity as it appears in an exemplary spatial art
form, the still image.

2.4.1 Time and Narrativity in the Still Image

While studies on the various *historical temporalities* nested within images are being
developed under the impetus of several researchers building upon the work accom-
plished by Warburg and Didi-Huberman,[35] the question of narrativity within the
still image has, on the other hand, been given very little attention, likely due to the
cumbersome opposition, inherited by the contemporary world, between the spatial
arts and the temporal arts. A distinction is drawn between spatial syntax constituted
by magnitudes of extension, and temporal syntax constituted by intervals of dura-
tion. The former concerns the spatial juxtaposition of entities and their parts, the
latter concerns the organization of successions of events: The former would be the
privileged domain of the visual arts, while the latter would be that of the temporally
deployed arts, such as poetry and music.

Studies which address the temporal plurality *internal* to images, that is,
phenomena of transformations governed by visuality, often develop rather weak
arguments against the hypothesis of narrativity signified by the still image.

For instance, Jean-Marie Schaeffer, in his article *"Narrativité visuelle et inter-
prétation"* (2001), recognizes absolutely no autonomy and no linguistic articulation
for visual language: The image would, at most and in terms of narration, be no
more than the representation of a verbalization—the "visual equivalent of a narra-
tive verbalization" (p. 18). Schaeffer thus poses the distinction between narration

de l'analyse structurale") which will be discussed later. Other reference texts are Fontanille (1994)
and Beyaert-Geslin (2013).

[32]Concerning images, as a system of forces, see for example Deleuze (2003) to which we will later
return and, from a standpoint of art history and of the theory of images, see Acquarelli (2015).

[33]Concerning the issue of the formation of forms from a haptic force inherent to enunciative and
perceptual acts (disengagement/engagement) of painting, of looking at, and of reading the image,
see Estay Stange (2014).

[34]Concerning spatial aspectuality in the framework of tensive semiotics, see Badir (2017).

[35]See the issue of the journal *Carte semiotiche* directed by Mengoni (2013) regarding the
anachronism and plurality of temporalities traversing images.

and mimesis of action. The latter would characterize theater and images: *Mimesis* of action would concern, according to the author, representations of actions in which no narrator/enunciator would be involved. This is quite surprising: Schaeffer conceives of *mimesis* of action within images to be the unfolding of an action devoid of a point of view and hence, devoid of orientation. But how is it possible to conceive of a representation of an action which is not governed by a point of view?

Such a conception is in complete opposition to that of Groupe µ who on this matter maintain that: "Just as perceived space is constructed from a point of view, an optocenter, chronology also has a "point of view" or, to avoid the spatial metaphor, a point of apprehension: Just as there is an optocenter, there is a chronocenter" (Groupe µ 1998, p. 66, our translation).

Schaeffer thus recognizes no enunciative articulation in what concerns either perceptual experiences or images, which he also considers to be stable figurative blocks, characterized by immediacy. According to Schaeffer, the image would be unable to show the transformation from a state A to a state B—this being the minimal condition for displaying of a sequence of events. The co-spatial presence of certain actors within multiple-scene images would also, in his view, never be a matter of succession, but of spatial co-occurrence. In short, any opportunity for narrative organization internal to visual signs is precluded.

These considerations, which pertain more to deductive reasoning stemming from a verbal theory of language than to knowledge regarding the functioning of images, disregard the fact that all images and all perceptual trajectories are instituted by a point of view. They also disregard devices which create *spatial continuity* within images, such as blurrings and camera shakes (which pertain to the plastic features of images). The various forms of blurring employed since the experiments of physiologist Étienne-Jules Marey, inventor of chronophotography in the 1880s, are obvious examples of the ability to visually represent the successive stages of an action—in a single scene—such as the walk of a man or the flight of a bird.[36]

Semiotics has examined the question of the spatial and temporal arts, including by employing Lessing's distinction between the primary and secondary forms of intuition. Petitot (2004) furthered the reflections proposed by Lessing by considering a temporal dimension in the spatial arts and a spatial dimension in the temporal arts:

> Each art form (plastic arts or poetry) possesses a form of primary spatial or temporal intuition (in the Kantian sense) which constitutes a form of its expression (in the Hjelmslevian sense). It also possesses a form of secondary temporal or spatial intuition which, inasmuch as it is not constitutive of its essence, becomes an instance of *selection* for the composition. (Petitot 2004, p. 42, our translation and emphasis)

It is clear that temporality, for the plastic arts, involves a form of secondary intuition because its primary intuition indeed pertains to space: Temporality thus becomes an instance of *selection* as regards the image. This means that the arts can transgress their primary essence; for example, when painting expresses general ideas

[36]See Dondero (2009c).

(in painting, according to Lessing, through allegory), it transgresses its nature which is usually geared towards the singular and the particular. Descriptions in poetry also involve transgression when a poet paints forms by seeking to iconize the conventional signs of writing.[37]

In his analysis of *Laocoon*, Petitot recognizes within the work an immanent and systematic analysis solely founded upon relevant mereological relations (whole/parts), that is, upon sensible relations. He then asks what would become of meaning if it were no longer conceptual: "If a plastic work is originarily non conceptual (and only mediately conceptual), then what would the origin of its meaning be?" (idem, p. 54). For him as well as for Goethe, there exists a purely visual *comprehensibility* and *intelligibility* as regards sculpture and other plastic arts, which he calls a "sui generis *perceptual dimension* of *meaning*."

In exploring the question of meaning from the standpoint of space, that is, from a purely intuitive and not conceptual standpoint, Petitot reflects upon categorization as a mode of conceptual abstraction. It is categorization which, in the conceptual domain, resolves the problem regarding the passage from continuity to discreteness: "We categorize semantic continua by introducing qualitative discontinuities, but in the context of the plastic arts, *how may we extract a form of discrete expression from a form of continuous intuition?*" (Petitot 2004, p. 55, our translation and emphasis).

Petitot finds in non-genericity, that is, in non-predictability, the solution internal to the plastic arts and to the sensible enabling the expression of non-conceptual abstract meanings, such as through narration in the case of *Laocoon*. This requires the identification of a mechanism allowing the passage from a spatial *continuum* as pure intuition towards a non-conceptual and discrete meaning which can explain the sense and functioning of duration in images.

Petitot is not alone in addressing this important matter. Another semiotic current raised the issue of the construction of narration in the single-scene still image: the cognitive semiotics of Groupe µ. As with Petitot, before addressing the issue from the standpoint of content, Groupe µ declared it necessary to specify it from the standpoint of expression: How is the meaning of "movement" to be understood and explained in the case of still images? In other words, "how can an iconic utterance, which is in principle static—therefore without duration other than that of its production or of its contemplation—signify such duration?" (Groupe µ 1998, p. 41, our translation). This question begs another one: How to account for the fact that a static two-dimensional substrate is able to construct temporal effects of intersectings between two or more processes, as well as effects of sequentiality? How to go beyond the level of the materiality of the image's static substrate (the primary intuition to which Petitot refers) in order to grasp the meaning of the plastic dynamic (secondary intuition) of each work? Groupe µ asserts that "if it is possible to tabularize that which is linear, it is to be expected that it would, conversely, be possible to linearize the visual image, which is, nevertheless, tabular in nature" (1998, p. 45, our translation). From this, four manners of conceiving of the linearization of still images may be identified.

[37]On the iconization of writings, see Klinkenberg and Polis (2018).

We will only take into account the proposals concerning single-scene still images (leaving aside those pertaining to multiple-scene still images).

The first "technique" by means of which Groupe μ tries to resolve the issue of narration is by "importing the feature of 'duration.'" Such importation of the feature of "duration," which appertains to all process, into a discrete image, which by definition has the feature of "instantaneity," has the effect of making the image into a station or a stage within the process represented. This first proposal concerns features of the figurative type, and therefore encyclopedic knowledge about the processes which are likely to affect the referents of the iconic types represented. This is the case with all types corresponding to referents that the encyclopedia usually links to a process, either as a function or as a property: a ball implies rolling, a knife implies cutting. In other words, any representation of an object can communicate the operations linked to this object, that is, its affordances.

According to Groupe μ, such importation is achieved by means of a particular variety of "processes" (for example, "flight," "fall," "translation"), that is, by an inferential link. This is the case for example with a feature such as "human body" presenting the/oblique/ determinant which enables one to infer the process "fall"; the same "human body" presenting the/vertical/ determinant would, for its part, block any possibility of extracting a "fall" signified.

This conception nevertheless has the weakness of presupposing the necessity of having recourse to an interpretive tool transcending the image, the image being reduced to a status of mediator of a process unfolding elsewhere, beyond itself. Such conception indeed postulates the "injection" of duration from an external source, that is, from the encyclopedia, following a logic of cause and effect which does not involve a functioning specific to images.

Groupe μ also takes account of chronophotography in which several successive states of a same referent are simultaneously exhibited: for example, both a walker's positions of departure and of arrival. It is, according to Groupe μ, encyclopedic competence which again makes it possible to assert that it is the successive states of a same process which are shown. However, in the view defended here, there is a difference between an image which simply shows the successive states of an action and a chronophotograph which shows the *trailing of an object's movement*, the forces acting upon it. In Étienne-Jules Marey's seagull images,[38] for example, the trailing can even cause one to forget the form of the object in motion, to the benefit of the form of the motion itself. Although in the case of an image displaying the starting and finishing positions of a walker, we have a still image of which the functioning resembles that of a multiple-scene image, an image which shows the partly blurred trailing of the movement, as does Marey's capture of the flight of a seagull, requires a different manner of explanation because it assumes there to be, within the image itself, an immanent analytical function. It is no longer a matter of importing anything whatsoever from the outside into the image so as to explain the meaning of the movement it communicates. In chronophotography, the transformation of the form of the object by movement is gradual and extends into displaying the forces which

[38]Etienne-Jules Marey (1830–1904), *Vol du Goëland* (1887–1888).

determined and prepared *the transformation over time.* The object dissolves into movements, the memory of the movements becomes spatialized, and the object is expanded over the time span of its transformation. The movements then acquire a form of their own, causing one to forget the form of the "object" which, for its part, has become almost unrecognizable.

This process may be described as a passage from the dissolution of the figures into movements to the representation of the form of the movement by the trailing. From the *form of the object in motion* there is passage to the *form of the motion.*[39] The movement assumes a form in the sense that it gradually gains autonomy from the "remains" of the objects, inasmuch as the gradual differentiations triggered by the trailing end up constructing an iconic totality, in the sense of Bordron (2011). This iconic totality is not necessarily lexicalizable into a narrative, but showcases the transformation from a state A to a state B.

The phenomena of movements assuming a form and of constituting a totality from the structural correlations within an image would benefit from being described along the lines of a proposal advanced by Basso Fossali (2004). According to him, the plastic may be emancipated from any figurative content as a set of patterns and of chromatic, eidetic, and topological oppositions functioning as appearances/disappearances which would enunciate themselves in order to come into presence—this is what he calls the *plastic reading of the plastic enunciation.* Conversely, the plastic arts can also assume figurativity while emphasizing *discursive memory,* that is, a *signified and eventually fictive memory of the establishment of the image* (rather than its actual memory)[40]: This is what Basso Fossali refers to when he speaks of a *figurative reading of the plastic enunciation.* In the latter case, it is a matter of recovering the *inter-actantial dimension* of plasticity via a dramatization of the *establishment of the image,* which amounts to saying that features not having a stable figurative reference (recognizable objects) nevertheless shape a more abstract albeit more dynamic figurativity: The figuration of the gestures by which the image was *established.* We would thus pass from the conception of an "uttered" figurativity (object representation) to an alternative conception of figurativity, one which is enunciative and which concerns the gestures involved during production—these virtually underlying all visual productions.

[39]Didi-Huberman and Mannoni (2004) conclude their analysis of Marey's chronophotographs as follows: "introducing the notion of time into the image consists, here, in introducing discontinuity into the graphical curve and continuity into photographic instantaneity" (pp. 242–243, our translation). Regarding the continuous and discontinuous in Marey's work, see Dondero (2009c, 2010b).

[40]As explained by Basso Fossali (2013), "signified memory" pertains to the fact that the plastic form is constituted by signs which may simulate a gesture of production which does not necessarily occur during the practice of realization. In other words, the plastic form is semiotized because it can lie (Eco 1976) and display, for example, a material effect as if it were the result of the artist's intention, whereas this effect may have been naturally due to the characteristics of the raw materials. Basso Fossali insists on the fact that the plastic form attested in a painting does not necessarily coincide with the form of the real, actual, historically realized gesture.

Thus, a narrativization of the plastic discourse's process of constitution is activated, a process founded upon the attribution of a minimal actantial status (constitutive gesturality) to the plastic formants; this process is called "proto-narrativization" by Basso Fossali (ibid.) because it concerns the deployment of a narrative process from the perception of forms stabilized on a substrate. It is by attributing a minimum of corporeality to the plastic formants that the inter-actantiality between the plastic formants and the observer may be constituted as an *analogizing apprehension,* or even as a basis of commensurability between morphogenetic gestures and events. In other words, passing from a plastic reading to a figurative reading of the plastic enunciation would entail a transition from the object to action, that is, from the valorization of a simple play of lights or of reflections to the valorization of the *operations and forces applied to matter and to the substrate.*

This investigation of the establishment of the image enables us to attend to another technique, the forth one listed by Groupe μ (1998), by which movement and duration are incorporated into the still image, a technique which, in the view defended here, seems more decisive than the importation of iconic semantic (encyclopedic) features into the image.[41] It concerns the moment of elaboration which would enable one to narrativize the plastic formants by attributing them inter-actantiality—a solution we may deem close to the proposal by Basso Fossali concerning the figurative reading of the plastic enunciation.

Groupe μ refers to the case of layers of pigments, which are superimposed in numerous paintings belonging to both the abstract and figurative genres. Let there be two layers: A as the background and B as a superimposed layer. The chronological relation between these layers may be identified on the basis of various features and processes: the transparency of B (for example in the case of watercolor painting), the use of rubbing so as to let the texture of layer A show through layer B, the tracing of furrows in layer B using an instrument (a knife, the tip of the paintbrush's handle…), the visibility of layer B through layer A in gilt glass, etc. Temporality is thus made present in the utterance, as a trace of the act of establishment, even if such trace can be "misleading." Besides, the matter is not, for semiotics, of reconstructing each act

[41] The first strategy, the "encyclopedic" one, is followed by two others, which cannot be exhaustively commented here. They may be summarized as follows: The second strategy concerns the material features of the signifier of the iconic sign—the fact that certain features are interpreted as the products of a dynamic process arising over the course of the production of the sign. For example, the blurring of a cathedral would not elicit an encyclopedic hypothesis, but a stylistic one: The blur is either attributed to the observer or to the producer of the signifier, but in no case is it attributed to the object, the iconic type "cathedral" not possessing the feature of "mobility." The third strategy of temporalization of space concerns indexical signs, that is, arbitrary signs, such as speed lines in comics which signify "fast movement." These second and third strategies of comprehension of the production of movement in images seem less interesting than the two others which we comment in greater detail because they depend on figurative or logical elements which do not illustrate the specificity of the functioning of visual language. For an exhaustive panorama of the attempts made in art history to study temporality in paintings, in its various perspectives (time of the story, time of the artwork, movements, duration, and the issues of aspect, of cyclical temporality, of the spectator's time, of anachronicity, etc.), see Jollet (2012). For a panorama of the theories of narrativity and for analyses of images by Paul Klee, see Colas-Blaise (2019).

of tracing in its whole phenomenological proceeding, but rather of understanding the manner in which the act of establishment becomes significant within the visual utterance.[42]

Finally, it appears that the trajectory from the encyclopedia to the *signified* gesture of establishment (which is not necessarily consistent with the actual act of production itself) coincides with the conception of narrativity as being immanent to visual configurations, the latter proving to be fully autonomous with respect to verbal language and to the functioning of logical inference.

Thereby, another step is made towards acknowledging the visual as a language enabling the articulation of meaning without soliciting verbal language, it being governed by relations of stabilization of forces into forms and by relations of dissipation of forms into forces.

2.5 Conflicting Spaces

Spatial disengagement generally concerns matters of perspective, or of designating an *elsewhere* as opposed to a *here* conceived of as an axis of reference for the image. Conversely to temporal disengagement, it has been abundantly studied in art history. Here, it will be addressed from the standpoint of the proposals of Fontanille (1989), which are less familiar to image specialists.

Perspective, or the point of view from which a photograph is taken or from which something is drawn, always serves the *management of knowledge*, since it constitutes the point from which a particular view is cast and proposed to the spectator. It is in the construction of perspective, in the negotiation of the relation between enunciator and enunciatee, that knowledge and power are played out; within the selections, focalizations, and distortions in the topology of the image, the values of things are at stake, as well as the proposed viewpoint to which the spectator may adhere.

In his aforecited work of 1989, *Les espaces subjectifs. Introduction à une théorie de l'observateur*, Fontanille asserts that each visual utterance carries a questioning about knowing and knowledge: Knowing is an *object which circulates* between the simulacra of the producer and spectator *of* the image, that is, between the enunciator and enunciatee *in* the image. Subjectivity may thus be defined as *interactive* because the enunciative simulacra act upon one another within the spatial articulations of the image by means of their shared or disputed knowledge. Such knowing is not exclusively cognitive, but has passional and pragmatic determinations.

Enunciative analysis enables us to study the way in which the spectator is meant to position him or herself before the image given that it is the image itself which determines such position: The enunciatee, in the image, predisposes, "prepares" the

[42] See Dondero (2009b).

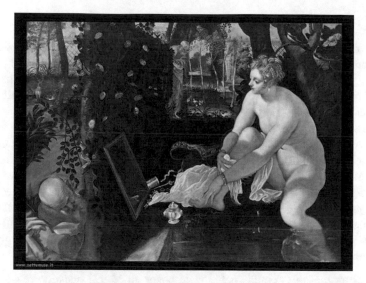

Fig. 2.1 Tintoretto, *Susanna and the Elders*, 1555–1556, Kunsthistorisches Museum, Vienna

position of the spectator who must occupy it if he or she wishes to reconstruct the trajectory of signification.[43]

In order to specify the roles of each, we may characterize the enunciator by his or her *expressive activity* and the enunciatee by his or her *desire for knowledge and for apprehending*. The enunciator and enunciatee may conflict with one another, they may deceive, they may conceal, or may compete to reveal or to dissimulate. Conversely to what is often believed, images are never irenic and are not necessarily articulated in a mode of affirmation or of full realization of the forms. To the contrary, images are capable of modulating the presence of forms, of denying it, or of removing from view objects which are nevertheless outlined in the representation.[44]

Images often confront us with situations that may be described as "struggles" over the vision of things. For instance, consider the case of *Susanna and the Elders* (Fig. 2.1), studied in other works[45] and to which we will return in greater detail later. It is a painting by Tintoretto which, in a very exemplary manner, is presented as a conflict between gazes and perspectives which construct an irreducible tension between the forces at work within the painting.

[43] As already outlined in the introduction, the spectator may of course abandon the place that was intended for him or her by the enunciator, or may even subvert it: This is what Certeau (2011) anticipated, from a more general perspective. This is also why each image embodies a *possible* intersubjective relation, semiotics being a discipline devoted to the *conditions of possibility* of meaning—and not to the actual, experienced meaning. On the relation between contemporary semiotics and the philosophy of Certeau, see Dondero (2015b).

[44] This is also what has been highlighted in the context of the rhetoric of images. See Groupe μ (1992) and Bordron (2010).

[45] See Dondero (2012a) and (2015a).

There are at least three forces at work which may be identified:

1. The direction of the gazes of the elders spying on beautiful Susanna while she bathes;
2. The gaze of Susanna, who shields herself from view by focusing on the mirror and by positioning herself between the trees and the hedge, these functioning as protective devices;
3. The simulacrum of our own spectatorial gaze, a gaze which hesitates between the view provided by the perspective upon Susanna's body, the latter being nude, illuminated and frontally exposed, and the model of gazing proposed by the elders as indiscreet onlookers who are a priori excluded from the spectacle of female nudity. The elders are indeed *delegate observers*, substitutes for the spectator in the painting,[46] although both the perspective which is offered to the flesh and bones observer and the arrangement of lights are rather welcoming and aid the observer's penetration into the scene. How is one to assume a position given the multiplication of the points of observation to be fulfilled?

It appears that this "conflictual" image poses an ethical question regarding the acts of seeing and looking: Susanna's nude body is exposed before our eyes, and at the same time, the delegate observers are portrayed as spies. The delegate observers have a status of model observers who shape the very manner in which we cast our own gaze. Thus, we find ourselves in the position of indiscreet onlookers, just like the elders: Like them, we are not seen by the young woman, but we see her. We hence assume the role of spies, of sorts: Our gaze is a betrayal of the intimacy to which the woman is entitled and which she could enjoy in the projective space of the mirror, a space bounded by the hedge.

Ultimately, this painting stages a negation of the free circulation of gazes between the image and its spectator: It either prohibits any possibility for dialog and presence, or it diffracts or displaces their occurrence. This serves as an illustration of the semiotic complexity of the uttered enunciation: *Susanna and the Elders* is an image which precludes any legitimacy for the gaze cast upon it, such legitimacy being nevertheless at the foundation of any relation with artistic images, these being the designated locus par excellence for visual contemplation.

There are other images which manifest a tension, that is, a struggle between orientational and directional forces taking place within the act of gazing itself. Take for instance Denis Roche's photograph *28 mai 1980 (Rome, «Pierluigi»)* (Fig. 2.2), analyzed by Pierluigi Basso Fossali in *Sémiotique de la photographie*,[47] who considers it to be a photograph exemplifying a "battle of devices."

The woman represented, who is the main object of the shot, rather than letting the photographer capture her gaze, occludes it using a mirror which enables her to generate an additional perspective, that is, another view (a view upon the act of

[46]On delegate observers as cognitively and passionally modalizing the spectator, see Thürlemann (1980).

[47]See Basso Fossali and Dondero (2011) and namely the last chapter, "*Photos en forme de 'nous'. L'éclipse représentationnelle d'un couple*.".

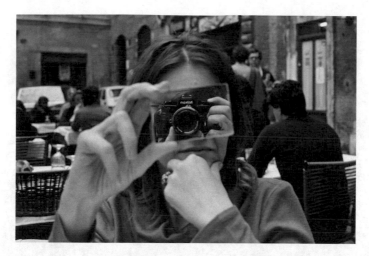

Fig. 2.2 ©Denis Roche, *28 mai 1980 Rome. "Pierluigi"*/Le Réverbère Gallery, Lyon

production), thereby making her a *co-author* of the photograph. Through this reversal of the viewpoint, a new perspective is made to compete with the main viewpoint which is that of the photographer. What is displayed is a true conflict of perspectives; the mirror is indeed used by the woman as a means of resistance against appearing in the photograph as a *model,* that is, as the shot's object. It is the mirror which enables the woman, beyond being only *looked at*, to perform an *action through her gaze*, while producing *another*, competing view.

Susanna and the Elders and *28 mai 1980* are images exemplary of the conflict between enunciator and enunciatee, both vying to "offer their own viewpoint." In the two cases examined, the struggle is played out by represented actors who are delegated in the form of human beings and of identifiable devices (the mirror, the hedge).

Indeed, it is possible to take a step further by considering an enunciative battle which is not conducted through represented devices and actors, but rather taking place solely between forces and plastic forms seeking to prevail over one another. The *blur effect* in photography is the best example of such a game of "hide-and-seek" and of the struggle to either impose a certain view or to make it inaccessible to others. Consider the example of a photograph by Isabelle Eshraghi (Fig. 2.3) that is part of a series called *Avoir 20 ans à Téhéran* (Eshraghi et al. 1999) which was analyzed by Shaïri and Fontanille (2001).

As demonstrated by the two semioticians, the blurring of the face of the woman in the picture is the result of her fleeing, of her seeking to avoid the space of enunciation. The woman dodges the photographer, causing her face to appear blurred and thereby marking her will to evade the gaze cast upon her. According to semi-symbolic encoding, such blur featured on the plane of expression is to be contrasted with the clear rendering of the representation of the man. This contrast corresponds to an opposition which occurs on the plane of content, one between the reserved and

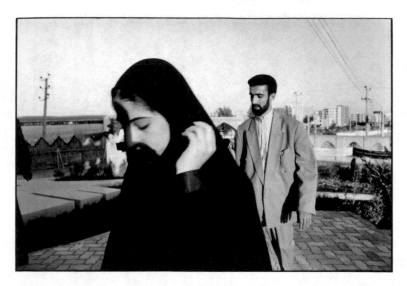

Fig. 2.3 Isabelle Eshraghi, *Iran, Bandar Abbas University*, 1999

demure figure of an Iranian woman in public space, who gives the impression of being on the verge of fleeing, and the attitude of Iranian men who everywhere are comfortable and self-assured.

We could call this example an *uttered blurring*, in the sense that it is not the photographer who produces a visual effect of instability, but indeed a character presented in the image who moves at the very instant the shot is taken, a movement which destabilizes the relation between the model (the object of the photograph) and the photographer. When viewing a blurred image, the first step is to identify who is "taking the initiative" of this steering away from the harmonization between the bodies represented in the image and the body of the photographer. In the case of Isabelle Eshraghi's photograph, it is the woman in the picture who takes the initiative of refusing the harmonization of bodies and who thereby prevents the shot from being sharp.

We may also consider the opposite case: a blur effect created by an unstable position of the photographer, as occurs in numerous war photographs. The blur that can be seen for instance in the famous *D-Day* picture by Robert Capa (*Normandy. June 6th, 1944. US troops assault Omaha Beach during the D-Day landings (first assault)*), results from an enunciator who "takes the initiative" of moving relatively to the events and objects of the world. We can call this type of figure an *enunciative blur*, because it stems from the instance of enunciation. The fact that the blurring is homogeneously distributed over the *whole surface* of the image emphasizes that the camera shake is determined by a movement belonging to the very act of photographing and not to the subject represented in the picture. It follows that two kinds of *blurs* may be distinguished: that produced by the movement of the subject represented, which always

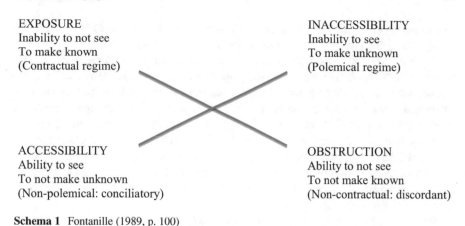

EXPOSURE
Inability to not see
To make known
(Contractual regime)

INACCESSIBILITY
Inability to see
To make unknown
(Polemical regime)

ACCESSIBILITY
Ability to see
To not make unknown
(Non-polemical: conciliatory)

OBSTRUCTION
Ability to not see
To not make known
(Non-contractual: discordant)

Schema 1 Fontanille (1989, p. 100)

leaves a *local* blur on the photographic imprint, and the movement belonging to the instance of enunciation which leaves a trace on the *global* extension of the imprint.

To summarize these reflections on the conflictual relation between the enunciator who evades and/or offers him or herself to the gaze and the observer who wants to see, let's return to the schema by Fontanille (1989) which, in the form of a semiotic square, explicates the *cognitive modalization of space*. According to Fontanille, the encounter between the simulacra of producer and spectator may manifest according to four regimes, articulated in Schema 1: *contractual, polemical, conciliatory*, or *discordant* regimes[48]:

Exposure (the contractual regime of vision) characterizes everything which offers itself to the gaze of the observer, who is presumed to want to look: The enunciator, in such case, has nothing to hide. An example of this would be a character appearing in the foreground and in frontal view, as may be seen for instance in most photographic portraits by Dutch artist Rineke Dijkstra, to which we will return later.[49]

The opposite position, that of *inaccessibility*, concerns the polemical regime of vision, whereby the enunciatee cannot see and the enunciator does not seek to reveal, or even forbids him or herself from doing so. We often find examples of this in religious paintings, in which the vision of God enjoyed by saints is concealed by the Divine Force itself.[50]

Obstruction characterizes the regime of discord and namely concerns everything which is masked, difficultly apprehensible, incomplete, and which functions as a negation of exposure. Cases of this may often be seen in images showing distant or decentered objects, or comprising characters seen from the back. An example of this

[48]This schema functions as a semiotic square through the relations of contradiction and conflict which can be read as both logical relations as well as relations of narrative transformation.

[49]Regarding the portraits produced by this artist, see Beyaert-Geslin and Lloveria (2013).

[50]See for example *The Ecstasy of St. Cecilia* by Raphael (1514–1515, National Art Gallery of Bologna).

visual strategy is present in the aforementioned photograph by Denis Roche, *28 mai 1980*, where the woman's face is obstructed from the observer's view.

Accessibility, for its part, pertains to the regime of conciliation characterized by the observer's "ability to see" and by a principle of "not making unknown" for the enunciator who, in a way, removes any obstacle so as to allow the free circulation of the gaze, and hence, the free circulation of knowledge. This regime of vision is encountered in anything that allows itself to be perceived or glimpsed at, that is, anything that extends the boundaries of the visual field (mirrors, reflections, open doors, shutters…). Good examples of this strategy may be found in seventeenth century Dutch paintings of scenes of interior domestic life inviting the gaze to follow a series of openings, doors, and entrance points enabling the observer to discover that which he or she wishes to see.

We will return to this typology of the cognitive modalization of space in the second part of the book, which is devoted to portraits.

2.6 From Conflicting Forces to Negation

Conceiving of the image's capacity to negate may be considered to represent a major challenge for any theory of the visual domain, namely in the context of research on the language of images and on the visual display of unrepresentability, of the transcendent, and of the divine.[51] While the problem of the unrepresentable has always mobilized research in the field of religious art, on the other hand, there is no tradition of research on the capacity of the image to negate what it represents.[52] As we shall see, far from limiting itself to affirmatively assuming what it displays, the image can modulate the degrees by which it assumes what it represents and present the observer with objects endowed with various degrees of presence: be it a *surplus of presence*, as is often the case in religious painting, a *deficit of presence*, or even a removal from presence.

In order to address the image's ability to negate, it is first necessary to take some distance from the classical conception of negation stemming from the field of logic. Two major reasons motivate conceiving of negation otherwise. The first concerns the fact that the logical approach to negation, with its principle of non-contradiction—according to which something cannot be simultaneously affirmed and negated—cannot function in language, be it verbal or visual.[53] Indeed, in language, every form of negation is a modulation of meaning, inscribed within operations of *expectation-protention* and of *memory-retention* which cannot be reduced to the categories of presence/absence, as is the case in formal language.

[51] We are thinking, for example, of the way in which this question was presented in the works of Belting (2005) and Stoichita (1995).

[52] Rare exceptions are Dondero (2012a) and Bordron (2010, 2013). Regarding negation in images from an art historical perspective, see De Koninck (2008).

[53] On the graduality of negation in verbal language, see Desclés (2014).

The second reason is that logic excludes the actants of enunciation from its operations, inverting truth values independently of the operators manipulating such values. Such a view is opposite to the one defended here, according to which negation is directly dependent upon the notion of enunciation and may be studied on the basis of a gradual and tensive conception of enunciation. Such a conception is the only one capable of addressing the topology of the image, which is constituted by a *continuum* of which the signs are never disjoint and do not possess a fixed value within a given repertoire. In other words, and following Goodman (1968), in autographical systems (systems which are semantically and syntactically dense) such as in painting, between one sign, line, or color and another, a *third term* is always present. It is there, *between a term and its opposite*, that our comprehension of negation, as articulated by the image, may develop. The condition enabling negation to emerge in the image and for it to be analyzable consists in renouncing to seek an *opposition* between terms and in rather considering *relations of graduality*[54] between them. Images indeed appear to be characterized by gradual oppositions, organized by a *more/less* tensive relation rather than by categorial *yes/no* relations. We are thus quite far from the univocality of negation of classical logic, which deploys itself within a binary universe, where negation of the one is equal to the other.

With respect to negation in linguistics, it is necessary to shed the illusion according to which we can find isolated negational units or elements in images such as "no" and "not," as can be found in the syntax of natural language. In order to understand the ways in which the visual mode can instantiate negation, all the while not having a stable grammar of disjoint signs in the manner of natural languages, it is necessary to conceive of a change in relevant discursive magnitude, and namely to shift the level of pertinence from the sign to that of the utterance.[55] In doing so, it becomes possible uncover the degrees of affirmation and negation at work in each enunciative configuration. It is also evident that the analysis should not be carried out at the level of figurative signs, that is, at the level of the objects which may be recognized within the image. Such an approach would involve an atomical perspective leading to absurd questions such as those mentioned by Groupe μ, for instance, "What is the negation of a tree?"[56] On the contrary, the issue of negation in the visual field should be addressed by means of an approach which is holistic and suprasegmental, or enunciative and plastic.

[54]See in this respect the notion of tensivity formulated by Zilberberg (2011, 2012).

[55]Concerning the various levels of pertinence in analysis, see Fontanille (2008).

[56]Groupe μ (1978).

2.6.1 Negation as a Conflict of Forces According to a Rhetorical Approach

It is postulated here that effects of meaning stabilized within an utterance preserve the traces of successive negations and affirmations produced throughout a narrative trajectory in which the negation of negation is not be considered as an affirmation, but rather as a process of bifurcation, hesitation, incertitude, incompleteness, regret, or of temporary resolution.

The image's capacity to negate something which it nevertheless represents may be approached by means of what semiotics calls the enunciative *thickness* of a discourse,[57] that is, the coexistence of diverging, even conflicting viewpoints, within a same planar utterance. Indeed, despite it representing objects, the image is by no means required to present them in a fully affirmative manner: It can modulate their degrees of presence to a point of virtualizing them, or even of negating them. The perspective of enunciation makes it possible to assert that the image "confesses" itself, so to speak. Indeed, since the works of Louis Marin (1993) on visual enunciation formulating the distinction between *transparency* and *opacity* in painting, that is, between representation and presentation of the representation, a process of duplication, or of multiplication, may be conceived to take place within the image. The image hence acquires the ability to declare itself as being true, erroneous, false, inaccurate, etc. More precisely, it may contrastively *assume* that which it affirms on the plane of *assertion*.

The most highly operational methods for studying the forms of negation in images have been proposed in the field of the rhetoric of images, as well as in the latest extensions of the theory of visual enunciation.[58] From a rhetorical point of view, the image has the capacity to modulate that which it represents, by means of the subtraction, diminution, diversion, division, addition, and multiplication of forces with respect to a given compositional expectation—as clearly demonstrated in Groupe μ's *Traité du signe visuel*[59] and in the works on iconicity by Jean-François Bordron.[60] In *Image et vérité. Essais sur les dimensions iconiques de la connaissance*, Bordron distinguishes between the intensive and extensive forces of negation. Building upon Kant (namely upon his essay *Attempt to Introduce the Concept of Negative Magnitudes into Philosophy*),[61] Bordron asserts that negative magnitudes for Kant are manifestly a subtraction which a force, and more generally, a magnitude, inflicts upon another one—similarly to how wind counters the course of a ship. Here, it is question of

[57]Bertrand (2003), Fontanille (2006).

[58]Concerning visual enunciation and its relations to rhetoric, see Dondero (2013).

[59]See in this respect Groupe μ (1992) and Klinkenberg (2016).

[60]Bordron (2011, 2013). For a confrontation between post-structuralist visual rhetoric and visual rhetoric from a cognitive and perceptual point of view, see Dondero (2010, 2011).

[61]See Kempf (1997).

intensive magnitudes, and the forces which are at play consist in rhetorical opera-
tions of subtraction or inhibition. In what concerns extensive forces, it is necessary
to be able to conceive of negative space: The negation of a portion of space consists
in the suspension of a sensible quality which is normally associated with a certain
presence in such space. In other words, negation can manifest through a rupture of
the dependency between portions of space and sensible qualities. Referring this time
to the Sartre of *Being and Nothingness*,[62] Bordron asserts:

> Sartre analyses the notion of distance. He sees in it an excellent example of negation within
> being. So, two points are separated by a certain length, the latter then being the negative
> element. Now, if we direct the intuition towards the length itself, then the negation manifests
> as the boundary, that is, as the points themselves. Negation remains, either as a separation,
> or as a boundary (which amounts to division and subtraction; the boundary restricts and
> therefore establishes a lacking). [...] Negation thus lies at the core of difference (the distance)
> and of identity (the two boundaries being constitutive of it). Negation would therefore be
> that which puts identity and difference into play. This example is characteristic of images
> and only involves extensive magnitudes since it is the same space which constitutes both a
> separation (distance) and a link (between boundaries). (Bordron 2016, p. 108, our translation)

Bordron's lesson is therefore even more radical than the one proposed here since
it posits negation as being at the core of any tracing, of any establishment of lines
and shapes onto a given surface. It is therefore irremediably linked to any act of
enunciation.

2.6.2 Negation from an Enunciative Perspective

From an enunciative perspective, the image can modulate that which is represented
through an act of non-assumption, that is, by a *distancing from* or by a *diver-
sion of* the meaning. The fact that certain objects are effectively represented in
the topology of the image does not automatically mean that their presence is fully
assumed by the enunciator or that they are fully revealed to the enunciatee. The
semiotic square designed by Fontanille (1989) which schematizes four modal rela-
tions between enunciator and enunciatee—exposure, inaccessibility, obstruction, and
accessibility—articulates this perspective in an exemplary manner (see Schema 1).

The enunciative approach, in order to achieve its full heuristic effectiveness, must
be associated with the concept of *modes of existence* as defined in semiotics,[63] and
which are of four orders: virtualization, actualization, realization, and potentializa-
tion. They enable us to identify the variegated degrees in which the presence of values
manifest in discourse, and hence to find, within visual configurations, dissymmetries
in enunciative assumption. Let's examine these four different modes of existence.

[62]Sartre (2010, p. 56, sq.).
[63]Fontanille and Zilberberg (1998).

In an image, it may indeed be possible to identify figures which are *realized*, these being fully recognizable and adequately located within a stable figurative environment where the space beyond the frame is not solicited. In this scenario, the image will be affirmative; it conceals nothing and the figures manifesting it function within a regime of exposure. A quite explicit example of full realization of presence and of total exposure of the image to its observer may be found in the family portrait by Paul Strand, *The Lusetti Family, Luzzara, Italy*.[64] In it, the forms are irenic, and no force deforms or puts the objects represented into competition with one another.

Other images refer to *virtualized* figures, that is, to figures which are absent, but of which the absence is made manifest: It is the affirmation of a negation—for example when there is an interruption in the stereotypical deployment of figurative syntax. The image by Denis Roche we described earlier, *28 mai 1980 (Rome, «Pierluigi»)* (Fig. 2.2), seems to constitute a good example of this kind of functioning: The gaze of the female figure directed towards the observer is virtualized to the benefit of displaying the creative act.

Actualized figures, for their part, are indeed present in the image at the surface level, but their degree of realization remains "pending" and/or they assume ambiguous or difficultly recognizable forms. This is often the case with blurring in photography, but also in painting, when the figures can be represented in their *occurring*, in their explosion/decomposition, or in their processes of appearance/disappearance, as may be seen in Francis Bacon's studies based on portraits of Pope Innocent X.[65]

Finally, certain images include *potentialized* figures, that is, figures waiting to be developed in other images or beyond the frame—the observer expects something further than what is offered by the image alone. An example taken from the repertoire of religious art, and more specifically from paintings of ecstatic visions, can be found in *The Ecstasy of St. Cecilia* by Raphael[66]: The observer cannot access the celestial vision within the image itself. What is represented in the cloud is but a glimpse of something of which the full view remains forever inaccessible.

2.6.3 *Susanna and the Elders* by Tintoretto: A Case of Negation in an Image

Let's return to the painting *Susanna and the Elders* by Tintoretto (Fig. 2.1), which seems to provide the best example of negation by enunciative means as well as by means of *metapictorial devices*, as indicated by art historian Victor Stoichita.[67]

[64]The J. Paul Getty Museum, Los Angeles, 1953, gelatin silver print, 11.7 × 15.1 cm.

[65]For instance, in Francis Bacon's *Study after Velázquez's Portrait of Pope Innocent X*, 1953, Des Moines Art Center, Iowa.

[66]Raphael, *The Ecstasy of St. Cecilia,* 1514–1515, National Art Gallery of Bologna.

[67]The book by Stoichita (2015) analyses metavisual devices such as windows, doors, curtains, mirrors, and geographical maps that may be seen in early modern paintings. Stoichita takes into

Susanna is portrayed nude: Her frontal nudity signals the offering of her body to the observer's gaze. Moreover, she is inscribed within a triangle constituted by means of perspective, functioning within the dynamics of a spatial cone inviting the observer to access and to explore. Such availability of Susanna's body and such a perspective offered to the spectator are nevertheless in contradiction with her being protected by the hedge from the indiscreet gazes surreptitiously surrounding her. Two elders are indeed located at the hedge's extremities: One is positioned in front of the woman, huddled against the hedge, while the other is standing towards the back. Both are concealed from her.

Negation presents itself here in the form of a modal opposition of the participative type,[68] that is, an opposition between two manners of gaining access to the view of the woman: On the one hand, an invitation to contemplate her while disregarding the obstacles (the woman is effectively represented in the foreground), and on the other hand, an invitation to spy through the obstacle formed by the hedge behind which the two other characters are hidden while they leer at her in their own manner. We are invited to enter and, while exploring the totality of the painting, we *gradually* realize there are hidden characters, camouflaged in the natural environment—only then do we understand that the access to the view is not direct, but hindered, obstructed.

This *mise en scène* of the forbidden gaze may be explained not only from an enunciative and modal perspective, but also from the perspective of the previously mentioned *metapictorial devices*. The hedge functions as a barrier to indiscreet gazes, yet the sides of the perspectival triangle, based on which the hedge is constructed, enable an infiltration of gazes from all sides, through lacerations in the boundary separating Susanna's sphere of intimacy, delimited by the projections of the mirror, by the hedge, and by the outside of this exclusive zone, dominated by interstices through which the indiscreet gazes of the elders penetrate. Of course, the hedge and, in a certain manner, the trees behind Susanna's back function as view-obstructing devices, that is, as partitions placed there to dissuade the delegate observer from looking. The hedge and the trees serve as partitions erected in the middle of the woods, which Susanna uses as an area protected against the gazes of others conjugating both her *ability to gaze upon herself* and her *desire to not be seen*—whereas for the elders, the hedge functions as an object enabling them to hide, endowing them with an *ability to gaze* and to achieve the *requirement to not be seen*. The modal duplicity of the hedge, in function of the positions of gazer and gazed upon, makes it an object

consideration the flatness of the surface (geographical maps) as well as the use of framing so as to construct various types of depths—for example, with the use of curtains which produce a form of restricted, exclusive visibility (revelation/concealment). Stoichita studies an example, *Las Meninas* by Velázquez, which presents all kinds of surfaces that are more or less opaque, transparent, reflective, and which thereby establish various types of relations with the enunciative deixis. All of these devices would have, according to Stoichita, the ability to found a reflection on pictorial language. In our view, they may be considered as enunciative devices which problematize the acts of production and of observation (act of focalization).

[68]Concerning participative categories according to Hjelmslev, see Paolucci (2010).

enabling both protection as well as the opposite, violation, due to its porosity. The hedge thus authorizes two trajectories of access which are opposite but nonetheless inclusive of one another.

In what concerns the metapictorial devices, the hedge functions as a metasemiotic device doubling the canvas of the painting. While the frame usually indicates what is to be seen by *focusing* the gaze and *inviting* to explore, here, it is the hedge which frames, while negating its very function of framing, because it is only by exceeding the frame formed by the hedge that we may access what is there to see. The hedge frames something while simultaneously inviting the observer to look away.

Like the hedge, the mirror also constructs modalities of enclosure and of opening, which are contradictory modalities of vision. The mirror's plane generates projections of light serving Susanna's act of introspection (she is actually curled over herself). While it provides Susanna with an intimate and exclusive space, the mirror opens towards that which is above and at a distance. It indeed frames, limits, and encloses, but its planar surface extends towards the infinity opened up by the garden rendered in perspective.[69] Susanna's body is located within the space concealed by the hedge, whereas her gaze, captured by the mirror, is trapped in a space which converges towards the garden and hence towards the infinity of the vanishing point. The mirror projects onto an open space all the while setting the boundaries of the space of intimacy it creates. In a manner that is just as contradictory, the hedge constitutes a device closing towards the ground and projecting shade, enabling Susanna to hide. But at the same time, the defensive membrane provided by the hedge is defective, because it is open at its extremities. The hedge and the mirror can thus be defined as points of suspension between configurations of opposite forces, between shadow and light, between closure and opening, or, in more specific terms, between non-closure and non-opening.

We see that negation is topologically exemplified by contradictions between forces which may conflict or balance each other. In order to grasp such instability, it is necessary to conceive of the painting's topology as being extensible and pulled between operations of expansion, stretching, and shrinking. This confirms our starting hypothesis that negation is not configured as a juxtaposition of places or objects which are mutually exclusive, but as a dual and reciprocal contradiction between perceptual and semantic fields installed by objects functioning as metapictorial devices. Such an analytical perspective regarding the tension between the enunciative forces at play in the image appears to surpass in terms of heuristics that of the visual rhetoric of Groupe μ (1992), which reveals substitutions as well as mixtures of objects depending on figurativity. The topological orientations we examine here are rather shaped by a dynamic of perceptual (and plastic) forces. Indeed, they manifest as *conflicts of forces* (projections, orientations, directions): In the case of *Susanna and the Elders*, the projection towards the area of non-intimacy and non-preservation of self is in conflict with the projection towards non-visibility and non-opening.

[69]On the mirror as locus of the narcissism of Susanna and of the enunciatee, see the sharp analysis by Fontanille (1989, *op. cit.*, pp. 98–104).

From the perspective of the modes of existence, one may conclude that, while we are first made to face the body of Susanna in its full *realization* given that it is nude and well visible, our gaze, *actualized* through the grasping of this frontal and illuminated nudity, undergoes a process of modal *virtualization* when we realize that the delegate observers instigate a crisis as regards the ability to gaze. As for the elders, they are present and *actualized* as onlookers but they do not fully *realize* their objective because they encounter a certain number of obstacles on their path: By means of perspective, we are placed in the position they would desire for themselves, that is, a frontal position by which we acquire the coveted status of invisibility.

In this manner of negation, the image, which is produced in order to be contemplated, denies its own vocation by showing something which should not be seen (which is forbidden or secret). *Susanna and the Elders* questions the status of the image and the focalization of our gaze within the frame by *multiplying the centers of attention,* inviting us to *hesitate* and, ultimately, to *look away.*

Susanna and the Elders is an image representing a secretive act of the gaze, that is, an act which conceals itself while exhibiting the manner in which it does so, in addition to exhibiting all the precautions which must be taken to first prohibit the gaze and then to transgress that very prohibition. Tintoretto's painting thus stages the *negation of the image's role and status*: that of being fully offered to the gaze.[70]

This painting effectively demonstrates that opposing forces do not coincide with the opposite poles of a category, nor with "filled" positions or areas: The conflicts between forces are accompanied, through semi-symbolic encoding, by contradictions in semantic trajectories which do not manifest as definite and complete. In tabular syntax, constituted by successions and interlockings of forces functioning as topological and semantic hesitations, as may be found in images, negation does not function as the reversal of binary polarities, and so, the tension never fully resolves.

References

Acquarelli, L. (ed.): Au prisme du figural. Le sens des images entre forme et force. Presses universitaires de Rennes, Rennes (2015)

Beyaert-Geslin, A.: Espace du tableau, temps de la peinture. Actes Sémiotiques Website. http://epu blications.unilim.fr/revues/as/2513. (2013). Accessed 25 May 2017

Beyaert-Geslin, A.: Devoir ne pas savoir faire. Actes Sémiotiques Website. http://epublications.uni lim.fr/revues/as/2477. (2012). Accessed 13 Feb 2016

Badir, S.: Note de synthèse sur l'aspectualité spatiale. Lexia. Rivista di semiotica **27–28**, 133–156 (2017)

Badir, S., Polis, S., Provenzano, F.: Benveniste serait-il aujourd'hui un linguiste de l'énonciation? Ars et Savoirs. http://aes.revues.org/492. (2012). Accessed 22 July 2018

Basso Fossali, P.: Protonarratività e lettura figurativa dell'enunciazione plastica. Versus **98–99**, 163–190 (2004)

[70]For reflections in art history regarding the ability of an image to define itself as concealed or as being not fully offered to the gaze of the observer, see Bredekamp (2017).

Basso Fossali, P.: Il trittico 1976 di Francis Bacon. Con Note sulla semiotica della pittura. ETS, Pise (2013)

Basso Fossali, P., Dondero, M.G.: Sémiotique de la photographie. Pulim, Limoges (2011)

Basso Fossali, P.: Histoire des formes entre diachronie et archéologie. Sémiotique et diachronie. Association Française de Sémiotique Website. http://afsemio.fr/wp-content/uploads/3.-Basso-Fossali-AFS-2013.pdf. (2014). Accessed 25 Feb 2019

Belting, H.: Das echte Bild. Bildfragen als Glaubensfragen. Beck, München (2005)

Benveniste, E.: Problèmes de linguistique générale 1. Gallimard, Paris (1966)

Benveniste, E.: Problèmes de linguistique générale 2. Gallimard, Paris (1974)

Benveniste, E.: The semiology of language. Semiotica **37**, 5–23 (1981)

Bertrand, D.: L'extraction du sens: instances énonciatives et figuration de l'indicible. Versants **44–45**, 317–329 (2003)

Beyaert-Geslin, A.: L'image préoccupée. Hermès-Lavoisier, Paris (2009)

Beyaert-Geslin, A., Dondero, M.G. (eds.): Arts et sciences: approches sémiotiques et philosophiques des images. Presses universitaires de Liège, Liège (2014)

Bordron, J.-F.: Rhétorique et économie des images. Protée **38**(1), 27–40 (2010)

Bordron, J.-F.: L'iconicité et ses images. Études sémiotiques. Presses Universitaires de France, Paris (2011)

Bordron, J.-F.: Image et vérité. Essais sur les dimensions iconiques de la connaissance. Presses universitaires de Liège, Liège (2013)

Bordron, J.-F.: L'énonciation en image: quelques points de repère. In: Colas-Blaise, M. Perrin, L., Tore, G.M. (eds.) L'énonciation aujourd'hui. Un concept clé des sciences du langage, pp. 227–239. Lambert-Lucas, Limoges (2016)

Beyaert-Geslin, A.: La couleur, la profondeur, les sensations. Quelques intérieurs de Matisse. In: Hénault, A., Beyaert-Geslin, A. (eds.) Ateliers de sémiotique visuelle, pp. 210–224. Presses universitaires de France, Paris (2004)

Beyaert-Geslin, A., Lloveria, V.: Une approche épisémiotique de la présence. Sur quelques portraits d'adolescents. VS Quaderni di studi semiotici **117**, 95–102 (2013)

Bredekamp, H.: Image Acts. A Systematic Approach to Visual Age. De Gruyter, Berlin-Boston (2017)

Colas-Blaise, M.: Comment penser la narrativité dans l'image fixe? La "composition cinétique" chez Paul Klee. Pratiques. http://journals.openedition.org/pratiques/6097. (2019). Accessed 16 Sept 2019

Colas-Blaise, M.: L'énonciation à la croisée des approches. Comment faire dialoguer la linguistique et la sémiotique? Signata Annals of Semiotics 1. https://journals.openedition.org/signata/283. (2010). Accessed 12 Mar 2016

de Certeau, M.: The Practice of Everyday Life. University of California Press, Berkeley (2011)

De Koninck, R.: Image du désir et désir de l'image. Ou comment l'image parvient-elle à se nier. Figura. http://oic.uqam.ca/fr/system/files/garde/1646/documents/cf191-12-dekoninck-image_du_desir.pdf (2008)

Deleuze, G.: Francis Bacon: The Logic of Sensation. Continuum, London (2003)

Desclés, J.-P.: Différentes négations: langues naturelles et logiques. Actes Sémiotiques Website. http://epublications.unilim.fr/revues/as/5112. (2014). Accessed 26 July 2017

Didi-Huberman, G., Mannoni, L.: Mouvements de l'air. Étienne-Jules Marey, photographe des fluides. Gallimard, Paris (2004)

Dondero, M.G.: L'iconographie des fluides entre science et art. In: Colas-Blaise, M., Beyaert-Geslin, A. (eds.) Le sens de la métamorphose, pp. 255–275. Pulim, Limoges (2009)

Dondero, M.G.: Énonciation visuelle et négation en image: des arts aux sciences. Actes Sémiotiques Website. http://epublications.unilim.fr/revues/as/2578. (2012a). Accessed 10 Feb 2018

Dondero, M.G.: Le spectacle dans l'image et la spectacularisation de l'image. Degrés **151–152**, 1–15, (2012b)

Dondero, M.G.: Le texte et ses pratiques d'instanciation. Actes Sémiotiques Website. http://epublications.unilim.fr/revues/as/3207. (2009b). Accessed 28 Aug 2017

Dondero, M.G.: Les aventures du corps et de l'identité dans la photographie de mode. Actes sémiotiques Website. http://epublications.unilim.fr/revues/as/4979. (2014a). Accessed 11 Mar 2017

Dondero, M.G.: Les forces de la négation dans l'image. In: Acquarelli, L. (ed.) Au prisme du figural. Le sens des images entre forme et force, pp. 105–124. Presses universitaires de Rennes, Rennes (2015a)

Dondero, M.G.: Rhétorique des pratiques. Semen. http://semen.revues.org/9380. (2011). Accessed 12 Mar 2016

Dondero, M.G.: Semiotyka wizualna między tekstualnością a praktyką. Wokół wypowiadania. In: Thiel-Jańczuk, K. (ed.) Taktyki wizualne. Michel de Certeau i obrazy, pp. 165–176. Jagiellonian University Press, Cracow (2015b)

Dondero, M.G.: Sémiotique de l'image scientifique. Signata Annals of Semiotics 1, 111–175 (2010)

Dondero, M.G.: Le spectacle dans l'image et la spectacularisation de l'image. Degrés 151–152, 1–15 (2012)

Dondero, M.G.: Rhétorique et énonciation visuelle. Visible 10, 9–31 (2013)

Dondero, M.G.: La totalité en sciences et en art. In: Beyaert-Geslin, A., Dondero, M.G. (eds.) Arts et sciences: approches sémiotiques et philosophiques des images, pp. 123–136. Presses universitaires de Liège, Liège (2014)

Dondero, M.G.: Photographier le travail, représenter le futur. Analyse sémiotique de l'iconographie du chantier des Halles à Paris. Communication & Langage 180, 79–94 (2014b)

Eco, U.: Theory of Semiotics. Indiana University Press, Bloomington (1976)

Eshraghi, I., et al.: Avoir 20 ans à Téhéran. Alternatives, Paris (1999)

Estay Stange, V.: Esthésie et négativité. Actes sémiotiques Website. http://epublications.unilim.fr/revues/as/5141. (2014). Accessed 28 July 2017

Floch, J.-M.: Petites mythologies de l'œil et de l'esprit. Pour une sémiotique plastique. Hadès-Benjamins, Paris-Amsterdam (1985)

Floch, J.-M.: Les formes de l'empreinte: Brandt, Cartier-Bresson, Doisneau, Stieglitz, Strandt. Fanlac, Périgueux (1986)

Floch, J.-M.: Visual Identities. Continuum, London (2005)

Fontanille, J.: Les espaces subjectifs. Introduction à la sémiotique de l'observateur. Hachette, Paris (1989)

Fontanille, J.: Le trope visuel entre présence et absence. Protée 24(1), 47–54 (1996)

Fontanille, J.: The Semiotics of Discourse. P. Lang, New-York (2006)

Fontanille, J.: Pratiques sémiotiques. Presses universitaires de France, Paris (2008)

Fontanille, J.: Sans titre… ou sans contenu. Nouveaux Actes Sémiotiques 33/34/35, 77–99 (1994)

Fontanille, J., Zilberberg, C.: Tension et signification. Mardaga, Liège (1998)

Fried, M.: Absorption and Theatricality. Painting and Beholder in the Age of Diderot. Chicago University Press, Chicago (1980)

Goodman, N.: Languages of Art. An Approach to a Theory of Symbols. Bobbs Merrill, London (1968)

Greimas, A.J., Courtés, J.: Semiotics and Language: An Analytical Dictionary (Advances in Semiotics). Indiana University Press, Bloomington (1982)

Greimas, A.J.: Figurative Semiotics and the Semiotics of the Plastic Arts. New Lit Hist, 20(3), 627–649 (1989)

Groupe μ.: Ironique et iconique. Poétique. Revue de théorie et d'analyse littéraires 36, 427–442 (1978)

Groupe μ.: L'effet de temporalité dans les images fixes. Texte 21–22, 41-69 (1998)

Groupe μ.: Traité du signe visuel. Pour une rhétorique de l'image. Seuil, Paris (1992)

Jollet, E.: La temporalité dans les arts visuels: l'exemple des Temps modernes. Revue de l'art 178, 49–64 (2012)

Kempf, R.: Kant. Essai pour introduire en philosophie le concept de grandeur négative. Vrin, Paris (1997)

Kerbrat-Orecchioni, C.: L'énonciation: de la subjectivité dans le langage. Armand Colin, Paris (1980)

Klinkenberg, J.-M., Polis, S.: On Scripturology. Signata Annals of Semiotics 9. (2018). https://journals.openedition.org/signata/1885. Accessed 15 Mar 2020

Klinkenberg, J.-M.: Un instrument au service de l'énonciation: l'index (Application au cas de la relation texte-image). In: Colas-Blaise, M., Perrin, L., Tore, G.M. (eds.) L'énonciation aujourd'hui. Un concept clé des sciences du langage, pp. 51–68. Lambert-Lucas, Limoges (2016)

Mengoni, A.: Anacronie. La temporalità plurale delle immagini. In: Mengoni, A. (ed.) Carte semiotiche **13**, 135–144 (2013)

Maingueneau, D.: Les phrases sans texte. Armand Colin, Paris (2012)

Maingueneau, D.: Discours et analyse du discours. Introduction. Armand Colin, Paris (2014)

Marin, L.: De la représentation. Seuil, Paris (1993)

Nixon, M., Aguado, A.S.: Feature Extraction & Image Processing for Computer Vision. Elsevier, London (2012)

Paolucci, C.: Strutturalismo e interpretazione. Bompiani, Milan (2010)

Paolucci, C.: Persona. Philosophie de la subjectivité et sémiotique de l'énonciation. Presses universitaires de Liège, Liège (2021)

Petitot, J.: Morphologie et esthétique. Maisonneuve et Larose, Paris (2004)

Rabatel, A.: Une Histoire du point de vue. Klincksieck/Centre d'Études linguistiques des Textes et des Discours, Paris (1997)

Sartre, J.-P.: Being and Nothingness: An Essay on Phenomenological Ontology. Routledge, London (2010)

Shairi, R., Fontanille, J.: Approche sémiotique du regard photographique: deux empreintes de l'Iran contemporain. University of Limoges Website. http://www.unilim.fr/pages_perso/jacques.fontanille/articles_pdf/visuel/semiotiqueregarddanslesphotosorientales.pdf. (2001). Accessed 10 Oct 2019

Silva, I.A.: Uma leitura de Vieja friendo huevos de Velásquez. In: De Oliveira, A.C. (ed.) Semiótica plástica, pp. 189–206. Hackerp, Sao Paulo (2004)

Stoichita, V.: Visionary Experience in the Golden Age of Spanish Art. Reaktion Books, London (1995)

Stoichita, V.: The Self-Aware Image: An Insight into Early Modern Metapainting. Harvey Miller, London (2015)

Thom, R.: Local et global dans l'œuvre d'art. Le Débat **2**(24), 73–89 (1983)

Thürlemann, F.: Fonctions cognitives d'une figure de perspective picturale: à propos du Christ en raccourci de Mantegna. Le Bulletin **15**, 37–47 (1980)

Thürlemann, F.: Paul Klee. Analyse sémiotique de trois peintures. L'Âge de l'homme, Lausanne (1982)

Vouilloux, B.: La narration figurée dans la Figuration narrative. Études de lettres 3–4. http://journals.openedition.org/edl/578. (2013). Accessed 20 July 2018

Zilberberg, C.: La structure tensive. Suivi de Note sur la structure des paradigmes et de Sur la dualité de la poétique. Presses Universitaires de Liège, Liège (2012)

Zilberberg, C.: Condition de la négation. Actes sémiotiques Website. http://epublications.unilim.fr/revues/as/2586. (2011). Accessed 29 July 2015

Chapter 3
To Present Presence: About the Contrasting Forces in Portraiture

3.1 Foreword

Portraiture has represented one of the most extensively studied genres in semiotics for exploring the transferability of the notion of enunciation from verbal language to visual language.[1] It notably served to test the relation of homology between, on the one hand, the opposition on the plane of expression between face view and side view and, on the other hand, the opposition between discursive and historical enunciation on the plane of content.[2]

This second part of the book proposes to address the portrait genre through the perspective of a dialogical relation between the gaze represented in the image and the gaze of the spectator, followed by an analysis of the manners in which this dialog gives way to more complex relations between the subject and the observer as we address the borderline case which is the soliloquy.

This being said, portraiture goes, however, beyond constituting a genre having proven adequate in illustrating the transferability of the notion of enunciation. In portraiture, one may observe the schematization of opposing or contrastive forces by virtue of which a background struggles against a figure in an attempt to outweigh it and gain preeminence in the image.

On this account, we will not address the portrait genre on the basis of its figurative level of organization, but rather based on the hypothesis of the existence of a plastic language. This would enable one to bring some nuance to the conception of portraits as simple renderings of independently existing models: Identity is rather constructed though the image, and this is done in an "autonomous" manner with respect to the

[1] Concerning the relation between the system of pronouns and the various types of gazes, see Beyaert-Geslin (2017) who complexified the distinction between frontal and side views by studying the case of portraits conjugated in the third person (corresponding to the indefinite pronoun "one," or the French "on"). See in particular the chapter entitled "Énonciation.".

[2] Concerning this opposition, also see the famous study by Schapiro (1973).

© Springer Nature Switzerland AG 2020

M. G. Dondero, *The Language of Images*, Lecture Notes in Morphogenesis,
https://doi.org/10.1007/978-3-030-52620-7_3

model which the image is indeed capable of deforming—suffices to think of the portraits produced by Francis Bacon and studied by Deleuze.[3]

In order to investigate the struggle of forces conflicting within the image, we could have chosen compositions that are highly complex in terms of the perspectives they put forth, but will prefer to address the genre which appears to present the simplest and most static schematization. In the portrait genre, the conflicting forces have very little latitude and this very fact should orient our investigative focus—in addition to its posing the greatest of challenges as far as the tensive approach to images is concerned. This means that we will deal more with the gradients of a subject's presence than with the subject's identity, while also paying heed to the distinction established by Roland Barthes between "resemblance" and "air": "Ultimately a photograph looks like anyone except the person it represents. For resemblance refers to the subject's identity, an absurd, purely legal, even penal affair; likeness gives out identity "as itself," whereas I want a subject—in Mallarmé's terms—"as into itself eternity transforms" (Barthes 1981, pp. 102–103).

Indeed, in *Camera Lucida*, Barthes likens the simple resemblance of a face to the extension of an identity, that is, to something which is quantitative, measurable, and of the order of extent—as one would say in tensive semiotics. Conversely to resemblance, the air of a face concerns the intensity of a presence, of the sensible qualities coming into being. In his words, "The air of a face is unanalyzable," (idem p. 107) because it is something which may not be quantified. An "air" is thereby defined as the "intractable supplement of identity" (idem p. 109). What Barthes suggested while distinguishing the concept of a face's "air," tensive semiotics could develop via the analysis of the forms constituting and bringing about the emergence (or disappearance) of the various configurations of presence.

In this second part, we will first attempt to identify the essential characteristics of portraiture, and more specifically the fundamental defining characteristics of artistic photography, which are in great part inherited from the painterly tradition. This will serve to examine what are the strategies employed in contemporary photographic portraiture in order to confirm, stabilize, or subvert these defining characteristics. We will explore the notion of presence in its rhetorical and tensive operations (withdrawal, fragmentation, augmentation), but also, perforce, in its temporal operations, because even an isolated image may signify a process via the multiplication of the temporal perspectives through which it is deployed. This will lead us to return to the question raised in the first part regarding the temporal disengagement of enunciation and regarding narrativization in the spatial arts. In particular, this section seeks to address the problematics pertaining to the temporality of portraits through a double question: Is presence always conjugated in the present tense? If so, is the portrait's present durative, or is it punctual?

Portraits appear at first glance as being highly *compact*, not very *articulated*, and excessively *immutable*, especially if compared with the other great genres of the painterly and photographic traditions. It seems that portraits only generate a

[3]For a presentation of the conceptual relations between Deleuze's energetic view of images and the tradition regarding figures and figurality (Lyotard, Marin, formalism, etc.), see Acquarelli (2015).

simple contrast, a binary figure-ground articulation which hinders the apprehension of any narrative deployment of the image. We will not, however, go so far as to assert that portraiture forms a *non-narrative* genre. To the contrary: Even in the case of single-scene still images which seem constituted solely by a figure-ground relation, photographic portraits will present a subject who is temporalized, or even aspectualized.

The aspectuality of which it is question here concerns a delegate observer's point of view upon the action represented in the image, a point of view which may be *inchoative, durative, terminative, iterative,* or *punctual.* Aspectuality, as a tool inherited from linguistics, enables us to pose the following three questions regarding images:

1. Does the image present its subject as stabilized in the present, as turned towards the past, or as projected towards the future?
2. When looking at a portrait, does the presence of the subject's face appear to be durative so as to endure and subsist, or does its presence seem punctual, as if it formed a singular and non-repeatable event? Is it rather a fugitive, evanescent presence, or to the contrary, is it in the course of emerging?
3. Is the face shown as *slowly* advancing towards the spectator, or does it rather seem to unexpectedly spring from the background in a *brisk tempo*, on the semiotic mode of an arisal (*survenir*)?[4]

The narrative functioning of the image therefore not only operates along the lines of its temporal configuration (present, past, or future tense), but also of its aspectual configuration. Is the act of gazing displayed by the portrait's subject in the process of stabilizing or of transforming? Is it nascent, or does it appear as if in a state of persistence or does it look like it's breaking off? What is the rhythm of the act of gazing favored by the portrait?

3.2 Portrait Structure

We may begin with a simple question: What is a portrait? What are the essential characteristics required for a portrait to be recognized as such, rather than as a landscape containing a human figure or as an event scene?

By taking account of the portrait's plane of expression, albeit general or ideal-typical, it becomes possible to list a first series of defining characteristics stemming from the tradition of research on the matter.

[4]According to Zilberberg's tensive semiotics, *tempo* concerns the opposition between fast and slow and thereby falls within the scope of "intensive" oppositions, whereas time concerns an opposition involving extensive and quantitative magnitudes (before vs. after). For a simplified presentation of this theory, see Zilberberg (2012).

The first concerns the *relation between figure and ground*. The background must present itself in the most neutral manner possible so that the figure may emerge and be met by the observer.

Whereas the first characteristic defining portraiture is the opposition between a neutral ground and an emerging figure, the tension between ground and figure causes their link to be irenic only in appearance; in each portrait, there is a tension towards the surface which makes the person represented emerge as an individuality from the magma which is the background. The tension between the figure and the ground on the plane of expression thus corresponds to a tension on the plane of content between the eroded identity (the background invades and devours the figure) and the identity cast forth (the background enables the figure to emerge). Each portrait is underlaid by a struggle of the figure to extract itself from the void, from chaos, from vagueness; if the background is sufficiently vague and the figure abundantly detailed, the identity portrayed manages to exhibit itself to the outside world as a deployed totality.

The second essential characteristic, ensuing from the first, is the fact that the figure must be positioned in the center, which ensures a certain *compactness* or density producing a "cohesive totality" against the void formed by the background. In the painterly tradition, the compactness of the figure is considered to be a necessary feature of all portraits, and this also reflects a literary topos regarding portraiture: Each portrait is meant to *condense* the life of the subject represented. Perfection in portraiture is achieved when the subject succeeds in *coalescing* his or her self (*rassemblement de soi*), past experience, and destiny in *the here and the now*, while ensuring the linkage of the moments of both the portrait's production and observation. On the plane of content, the density and compactness of the figure must be capable of signifying the sum of the represented subject's life experiences.

It is therefore unsurprising that the use of blurring has been excluded from portraits, as it would hinder the recognition and valuing of the subject, who by definition forms a well-determined and circumscribed totality. In portraiture, blurring would impede the subject's stabilization and would suspend any exchange with the observer; what would result from blurring would instead be a floating identity. Blurred portraits are indeed quite rare in the painterly tradition,[5] but may nevertheless be seen more often in contemporary photography. An example of the use of blurring in photographic portraiture may be found in the work of artist Laura Henno, who most often portrays girls whose youth suggests developing or hybrid identities typical of adolescence.[6]

The third characteristic of portraits concerns the absence of action, that is, the fact of *pose*. For the identity of the subject to become salient, his or her body must be immobile and not engaged in the performance of any action. The only relevant action would be gazing, the gaze being directed from the subject's inner space towards the environing world, and the objective being to put forth something intimate and

[5]Francis Bacon's production (see Deleuze 2003) forms one of the rare exceptions to this rule.
[6]Based on the interpretation provided by Beyaert-Geslin and Lloveria (2013).

exclusively unique, in an offering to the observer. Any action other than the subject's gazing would perturb this communication between subject and observer. As portrait theorist Jean-Marie Pontévia states, "in portraiture, the model is busy only with a single task: Looking like him or herself."[7]

The subject represented must therefore only display that part deemed to be the most "noble," the part closest to the eyes and to the head, because a view upon the body would already carry the value of a proto-action, or of a movement exceeding the simple act of gazing, thereby breaking away from the highest level of presence achievable.

To this third characteristic of portraits, we could associate the *frontality of the subject represented*. Frontality is deemed necessary because a portrait is first and foremost the *focalization of attention upon a subject*. It is for this reason that it is in portraiture, with its *centralized and compact frontality*, that presence is made present—that we have presence in the second degree: A portrait accentuates the face, that part of the body which is the most marked by past experiences and which condenses a life story to be displayed before a viewer.

While all of these characteristics hold for both painterly and photographic portraits, a fundamental difference distinguishing the two mediums must be kept in mind. Photography increases the level of intensity between the gazer and the gazed upon, and modifies the intensity of the interaction between model and artist. A gaze in photography differs from a gaze in painting. When we look at a painting, we know that the gaze has been painted *through successive views*, translated by the painter's hand and condensed into a single image. In many cases, the painter does not even use a true, individual model as such while painting. The gaze represented in a painting may therefore not be construed as being a gaze which authenticates the gaze of the painter. Furthermore, the painted gaze is constructed through gestures of the hand. *Hence, there is no symmetry between the painter's gaze and the observer's apprehension of the model* via *the trace left by the painter's hand.* Conversely, in photography, the photographer's act of shooting and the spectator's observation of the model through an act of reception give rise to a *symmetry between the gaze having produced the photograph and the gaze which observes*. This relation may be defined as *authenticating* because the substances upon which the productive gesture operates are the same substances involved during the act of reception: gazes and light.[8] This is of course not the case in painting, where subjects of portraits are not observed in the same manner as they were while they were being created.

[7] Our translation. See Pontévia (2000, p. 16).
[8] See Shaïri and Fontanille (2001, *op. cit.*).

3.3 The Forces of Absence Acting on the Forms of Presence

Portraiture may seem to be the most *affirmative* genre there is, inasmuch as it generally aims to exhibit to the observer a *totally revealed frontality*, one which is fully exposed, realized, and uncovered. Such *exposure* should nevertheless not be conceived of as a presence that is exclusively linked to proximity and to actuality: The portrait's field of action is rather modulated by various gradients of intensity of presence and absence.

The most relevant analytical category as regards portraits may therefore be said to be that of presence/absence. We may indeed consider any image to articulate various degrees of presence for the subjects it brings to attention. Contemporary productions, however, appear to disrupt this presence of presence, this plenitude characteristic of portraits. To see how they do so, let's first examine four emblematic cases.

It has been asserted above that a full and realized presence, which we identified with *exposure* as presented in Fontanille's schema (Schema 1), characterizes what is given without obstacle to the observer's view. Exposure characterizes, for example, the frontally displayed character in *Nicky*, a portrait by Rineke Dijkstra (Fig. 3.1).

The subject is offered to view, and the observer encounters no obstacle thwarting his or her desire to fully apprehend the model. This piece represents, in a certain

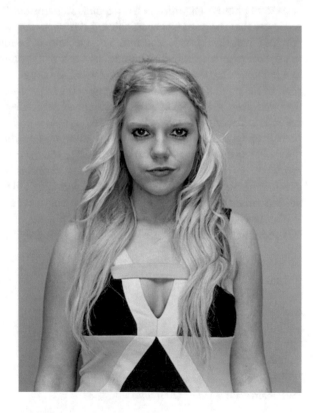

Fig. 3.1 Rineke Dijkstra. *Nicky, The Krazyhouse, Liverpool, England,* 2009

Fig. 3.2 Laura Henno, *A Tree of Night*, 2004

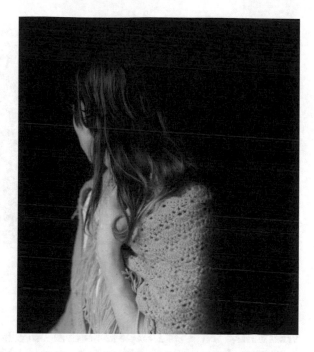

manner, a perfect portrait. But there are other cases where the observer cannot focus his or her attention on the subject because the latter is evasive, such as in the image by Denis Roche seen earlier (Fig. 2). We had described this image as an exemplary case of *obstruction* as per Fontanille's schema (1989), which is characterized by topological configurations displaying something incomplete, and presenting itself as a sort of negation of exposure.

Even more extreme cases may be found where the subject thoroughly refuses to be subjected to the observer's gaze, as in the following photograph by Laura Henno (Fig. 3.2).

In this third example, not only does the subject refuse and evade the shot (by turning away), but the observer is denied any power of vision: The background is completely dark and no longer functions as an enabler of the photographer's vision and as a ground from which the figure may emerge. To the contrary, the ambient darkness blinds the photographer, phagocytizes the figure, dissolves its contours, and destroys its compactness. This portrait displays the *inaccessibility* of the figure.

Finally, a fourth case may be considered, that of *accessibility*, which distinguishes itself from exposure in that we obtain a figure which emerges against a magmatic background—the figure succeeds in its struggle to emerge and to be recognized, albeit partially. As argued in the first part of this book, *accessibility* characterizes everything which allows itself to be glimpsed at through any breach that may extend the boundaries of the visual field (mirrors, reflections, open doors or shutters...). Accessibility distinguishes itself from exposure as the latter exhibits no sign of conflict or of overcoming an obstacle.

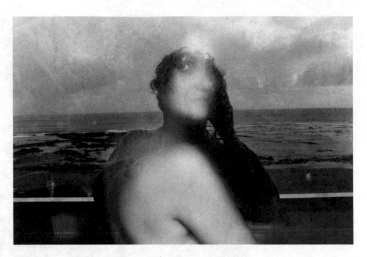

Fig. 3.3 ©Denis Roche, *24 décembre 1984. Les sables d'Olonne Atlantic Hôtel, chambre 301*

In this photograph by Denis Roche (Fig. 3.3), the appearance of both the model and the photographer is made possible thanks to the overcoming of an obstacle. What we have here is not a simple matter of exposure, but rather a most unexpected appearance. The photographer is outdoors, facing the big window of a hotel room. His gaze partly captures what lies beyond the glass, that is, his companion, and also partly captures what lies behind him, the sea, which is reflected in the glass.

This photograph transforms the face-to-face position of the model and photographer into a projection of both bodies onto a same surface of inscription: Although the window separates the bodies of the two protagonists, it simultaneously provides them with an interface, bringing them closer and superimposing their imprints. It functions as a surface which is both reflective (causing the photographer to appear) and transparent (allowing the woman inside the room to be seen). The functioning of the window is contingent upon the lighting and upon the point of view assumed. The photographer's body, placing itself between the direct light of the sun and the window so as to project its image partially as a reflection and partially as a shadow, ultimately imposes itself as the *condition of possibility for the appearance of the image of his companion located beyond the window's pane.* The obstacle represented by the distance inherent to the photographic medium which entails a separation between photographer and subject is, thanks to the transparent and reflective properties of the glass, made into a means of accessing the view *of both the photographer and his model,* that is, the surface of the glass collapses the distance separating the two bodies by enabling their simultaneous appearance through their projection onto one another.[9]

[9]For a deeper investigation of this image, see the analysis by Pierluigi Basso Fossali in Basso Fossali and Dondero (2011).

3.3.1 Operations of Withdrawal/Augmentation /Fragmentation/Proliferation of Presence

The degrees of presence exhibited by a portrait's subject may be studied while taking account of what we could call the *gradients of intensity* (qualitative, affective, and sensible) which depend upon chromaticity and upon the focalization type, and the *gradients of extent* (quantitative, measurable), which among other things concern the distance between the observer and the subject of the image, determined by the framing. The question may be raised as to what are the rhetorical strategies of withdrawal/augmentation/fragmentation/proliferation of a face's presence at work in a given portrait.

We propose to examine a few examples of withdrawal and augmentation taken from contemporary photography, before focusing our attention on the fragmentation of identity, as operated in the photographic series *Soliloquy* by British artist Sam Taylor-Johnson.

In the works by Dutch photographer Rineke Dijkstra, the portraits all seem at first glance to follow the same schema. However, a more acute gaze will reveal a great variance from one photograph to another in terms of the effects of the presence achieved by the subject.

Compared to the first portrait, *Nicky*, (Fig. 3.1), in *Abigail*, (Fig. 3.4), the subject's face does not appear to be emerging from the background: It is rather receding away from the observer's gaze. Indeed, the space between the photograph's upper edge and the subject's head is much greater than in the first portrait we looked at. In a way, it is as if the subject no longer succeeded in imposing herself over the background and began to retreat from the focal area of attention and to withdraw from the gaze of the observer; the contrast between the face's complexion and the background is indeed less sharp than in the first picture by Dijkstra which we examined.

Ultimately, *Abigail* portrays a withdrawal from presence. This is due to the framing strategies employed—the face is almost invaded by the background which gains ground within the frame, notably in the upper area—but also by a weakening of the chromatic contrast between the figure and the background.

There are also other strategies for withdrawing a face from presence, as shown in the following photograph by Egyptian artist Youssef Nabil (Fig. 3.5).

The distance between the frame and Charlotte Rampling's head is perfectly balanced so as to allow the figure to emerge from the background, and the chromatic difference between the subject and the background is indeed favorable to such emergence. By virtue of these topological and chromatic conditions, the image seems to follow the essential characteristics of portraiture's ideal type. The excessively homogeneous color of the skin surprises and, resembling the color of marble, removes any sense of vitality from the face's appearance. The skin is homogeneous in its texture to a point where it resembles the textural treatment of the background. The face seems to emerge from the background in its contours (extent), but to recede in its texture (intensity), because it approaches the background's level of neutrality.

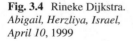

Fig. 3.4 Rineke Dijkstra.
*Abigail, Herzliya, Israel,
April 10*, 1999

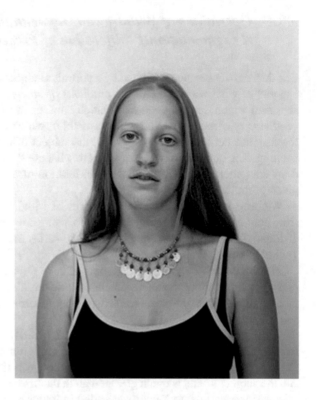

Another emblematic case of withdrawal from presence is represented in the work of a young photographer, Victor Guérin, who exhibited a series of photographs entitled *Revealing the Shadows. Portraits of the New Parisians* in 2014 at the Parisian residency for foreign artists and researchers called *Les Récollets*.

In this photographic series portraying fifty young persons, of twenty-one different nationalities, who had come to live in Paris, Victor Guérin tackles the issue of identity by addressing it conjointly with that of migration. The photographer endeavored to render the sense of being a stranger, without bearings, in a metropolis such as Paris. Indeed, these portraits by Guérin are very somber, as can be seen with *Ula-Change* (Fig. 3.6).

Guérin's silver halide black and white photographs, taken at night, are all signed with a word created in "light painting." The word is chosen and traced by the model by means of a torchlight, and the tracing is captured using long exposure. The word—in this case "change"—may be deciphered by using a system of mirrors (made available to the spectator during the exhibition of the works). The words which mark the photographs seek to assert that, however the subjects portrayed may be out of the shadows, the mere fact of being a stranger entails additional effort for them to emerge and be acknowledged: A trace must be made in order for one to succeed in inscribing oneself within visible space—in this case, it is the air which forms the surface of inscription. The tracing of a word identifying the person portrayed, expressing his or

Fig. 3.5 Youssef Nabil *Charlotte Rampling*—Paris 2011

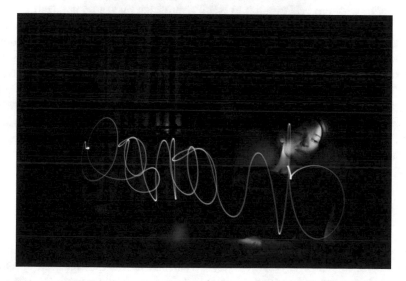

Fig. 3.6 Victor Guérin, *Ula-Change*, 2014

her desires and state of mind, constitutes a supplementary affirmation of his or her identity, in addition to the luminous body's assumption of a position amid the dark ether. This word traced using a torchlight provides the subjects of these portraits with their own individual bearings, while retro-illuminating them. It is a word that they inscribe from the position of their own point of view and which the spectator may only read using a mirror, that is, by adopting their position and therefore by sharing their point of view—a position which is oriented, in any case, towards otherness.

This series presents us with new enunciatory strategies and operations by which presence is achieved. It is always question of a figure which is focalized as being distant, almost absent, and which disappears due to the ambient darkness. From this darkness, something traces a path towards us, the observers. It is a corporeal trace which, on the one hand, is more anonymous than a face because it is more difficult to recognize, while, on the other hand, it is more personal than a face because it is traced by means of the person's sensorimotricity. In a certain way, the bodies and faces of the subjects represented are almost faded out of view, diluted into the obscurity in which the photographed rooms plunged. What saves them from the darkness, from unacknowledgement, from absence, and from anonymity, is the traced word which precedes them and which appears as an act of writing driven by their desire to emerge and to assert themselves. It is true that such trace is but a trace in the ether, which is a priori ephemeral, but the length of the pose and the patience with which it is held makes it possible to materialize it in photographic form.

Whereas in the portraits by Rineke Dijkstra and by Youssef Nabil, the presence was evanescent (in Dijkstra's portraits by the receding of the subject and by the confusion of the latter with the background; in Nabil's portraits, by a homogenization of the figure likening it to the background texture), in Guérin's portraits, we are confronted with a struggle for the emergence of a trace of presence. The written trace constitutes for the subject a proliferation of self, a mediation of self, a pre-face, an illuminated path towards the observer who may welcome and stabilize the figure. While the face may not yet be able to fully assert itself, the luminous trace is there to explore the darkness and to prepare an illuminated space to occupy. The trace of the word is a messenger announcing something to come, a sort of pre-presentation of the face: Here, it takes the form of what could be called a *request* for visibility on the part of the subject portrayed.

3.4 *Soliloquy* as a Negation of the Portrait

In order to pursue our exploration of the various strategies of subversion of the schema of portraits in contemporary photography, we will analyze a somewhat more eccentric case, that is, a series of images displaying identities of which the presence is dilated into two renderings. In this series, each photograph contains two images, disposed vertically; one being of a natural size, the other being much smaller. This rather emblematic case subverts the schema of portraiture outlined above. Nevertheless, and especially in the top images, we still have the representation of relatively centered

subjects removed from any sort of action. Yet, their identity is not "compact." To the contrary, the fact that the portrait in the top image is "continued" in another image in the bottom betrays the idea of a bounded identity, or at the very least questions the fact that identity may be visualized as a totality. We shall now explore this type of *sui generis* portrait.

3.4.1 *Introspection in Photography*

The photographic series *Soliloquy I–IX* (1998–2001) by British artist Sam Taylor-Johnson is made up of nine compositions and raises numerous questions concerning the visualization of soliloquy, of intertextuality, and of the sacred values of existence. While these two latter questions have already been addressed in a previous work (Dondero 2009a), we will now explore the first: the visual transposition of a concept which refers exclusively to verbal discourse.

Soliloquy is the intimate act of talking with oneself more or less aloud despite there being no other interlocutor present. Soliloquy is a solitary discourse, a situation which arises when the necessity to express one's own concerns faces the impossibility of communicating or of establishing a dialog. Soliloquy thus appears, from the standpoint of the one who accomplishes it, as a necessary measure for understanding oneself through self-narrativization.

To witness a soliloquy seems a rather paradoxical situation indeed. An image has for sole purpose to be looked at. When it presents itself with the appearance of a secret, this puts the spectator in a position which is uncomfortable, to say the least. If soliloquy is an intimate discourse, are we meant to gaze upon these soliloquies rendered in image form, or to the contrary, are we meant to look away? This question already arose with respect to Tintoretto's *Susanna and the Elders* (2.1.), specifically regarding the oscillation of the painting's subject, Susanna, between the act of concealing herself (or of surrounding herself with objects meant to safeguard her intimacy, such as the hedge) and of revealing herself, that is, of soliciting the observer's attention—Susanna is indeed displayed frontally, nude, and is fully illuminated. What may be said about the subjects represented in the *Soliloquy* series?

Generally speaking, these images display the relation between the enunciatee's act of spying and an oscillation between the acts of hiding and revealing oneself, as orchestrated by the enunciator. The whole series dramatizes the conflict between something intimate to be concealed and preserved and what is offered to view, such visibility making it, in a certain manner, open to violation.

Each *Soliloquy* has a double structure, comprising a large photograph each time representing a character alone in an introspective, pensive, and dreamy attitude, and a lower image, of far more limited size, representing various small-sized characters, an image characterized by a disjoint spatiality which differs completely from the first. In each composition, the subject featured in the upper image projects and disengages

him or herself through a self-narration manifested in the lower image and, by proliferating into several characters (the voices of others contained within the subject's own self), is able to confront his or her own otherness and complexity/multiplicity. The characters through which the main subject is projected embody narratives of self-visualization—images to which we have access despite them being images of the character's inner self.

The tension between the rhythms of condensation and dilation of identity characterizing the semantics of soliloquy is thematized by the various actors and actions displayed in the nine images of the series. Notwithstanding their diversity, these nine images all exhibit a same *structure of forces* dramatizing the hiatus between the cohesion and dispersion of identity.

Let's consider in greater detail the functioning of the operation of diffusion/dispersion of the subject into "plural" identities, using *Soliloquy I* (Fig. 3.7) as an example.

As is the case with each composition of the series, *Soliloquy I* associates two photographs of differing dimensions, disposed one above the other along a vertical axis. The top image, through the movement of the young man's arm towards the ground, may ultimately be read as an image founding the bottom image. The relation between the two images may be described as a relation of disengagement of the one

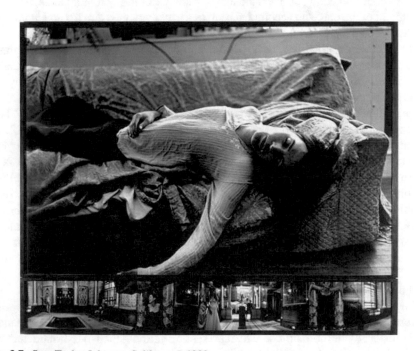

Fig. 3.7 Sam Taylor-Johnson, *Soliloquy I*, 1998

towards the other, that is, as a secondary or "internal" disengagement.[10] Although the spatiality of the lower image is totally incommensurable with that of the first, it should be understood as representing its enunciative development.

In the projective force of the young man's arm, there is a movement of distancing from the body, a same orientation as towards a differentiation and proliferation of the self. The arm, although it may function as a projective vector, carries a force of return: The hand closes upon itself as if to indicate a movement whereby the arm returns to the body.

The lower image, which presents a rather strange looking panoramic view of an interior setting, shows a proliferation of figures which, disunited and disharmonious, evade the organizing tendency of space. The effect of sphericity produced by the rotation of the camera lens over 360° contrasts with the geometrical decorations on the walls and with the mosaic composition of the floors which render the squares of the space in 360° as rounded shapes. The highest degree of spatial continuity, which "unwinds" the rectangular space by transforming it into a spherical view, would unify and transform any part of the photograph into a "center." However, owing to the centripetal tension of the spatial rendering, the figures mostly appear as being attracted towards opposite directions.

The lower image functions as a visualization of the intimate thinking of the subject in the top image. The multiple subjects represented in the lower section embody the "voices of others," which the soliloquizing subject in the top image projects through a narrative, but which nevertheless continue to form part of him, albeit through various degrees of appropriation (engagement). The engagement here unifies the figures who have been pluralized by the act of disengagement and makes it possible to identify the characters enunciated through the lower image as likely to belong to a single enunciator-character. This movement of return to the instance of enunciation presents itself as the enunciator's reappropriation of the subject's narrative self-projections.

From a technological standpoint, the images of the lower section result from a "continuous" shot through a lens that the artist makes to rotate for a full 360°, in an attempt to obtain a full and totalizing view of the subject's thinking. This spatiality serves to visualize the intimate discourse of the soliloquizing subject observing his multiple selves as if through a distorting mirror. These selves are presented to us through a panoramic view, but the effect obtained is not that of a holistic totality. To the contrary, the lower image results from the accumulation of multiple points of view which could difficultly be interpreted as stemming from a unifying point of view. Moreover, this *total* displaying of the scenes deployed over 360° contrasts

[10]"Internal disengagement" (or secondary disengagement) can be defined as an act of imitation of the act of disengagement installed within the utterance: "Taking into account the fact that the domain of the enunciation can be installed in the utterance *in the form of a simulacrum*[,] the space of here, taken separately, can be disengaged and inscribed in the discourse as *reported enunciative space*. It could then be articulated with respect to the chosen topological category, thus giving rise to a secondary referential system for the localization of narrative programs" (Greimas and Courtés 1982, "Disengagement" entry, pp. 90–91, emphasis added).

Table 3.1 Observation strategies. Fontanille (1999, p. 59)

	Strong intensity	Weak intensity
Strong extent	**Englobing strategy**	**Cumulative strategy**
	To consider, to contemplate To behold	*To prospect, to explore*
Weak extent	**Elective strategy**	**Particularizing strategy**
	To stare at, to examine	*To glimpse at, to scrutinize*

with the difficulties in apprehending them visually, this being due to their reduced dimensions.

In what concerns the framing, the two images constituting each *Soliloquy* may be described using the tools of tensive semiotics, which enable us to refine the analysis through an articulation of two dimensions—intensity and extent.

Intensity and extent each undergo variations along a continuous scale going from zero force to maximal force, which could translate into the following schema, modeled according to Fontanille (1999, p. 59) (Table 3.1).

The upper image is constructed on the basis of a "particularizing" strategy, presented as "somewhat myopic," because the enunciatee uses an isolated part of the object which is neither exemplary nor representative. The lower image would, on the other hand, be characterized by an oscillation between a uniting, "englobing" strategy which relies upon a principle of dominion over a totality and the "cumulative" strategy which, being unable to access all the aspects of the object at once, traverses them in a sweeping motion so as to exhaust all viewpoints (360°).

3.4.2 Denying the Gaze

Let's turn to the enunciative analysis of these photographs in order to examine what sort of gaze is established by the subjects of the top sections. In all upper sections of all of the images of the series, there is a tension between opposing forces, a tension between, on the one hand, the opening towards that which lies "beyond oneself," that is, towards otherness, and, on the other hand, the closure capable of maintaining identitary cohesiveness—what one may call one's own *sameness*.[11] In other words, these individuals give themselves to us all the while retreating.

[11] "Conversing alone," the subject casts him or herself into discourse, which entails differentiations in his or her self-belonging. It is for this reason that the category of condensation/dilation of identity is relevant in the analysis of this series. These poles also explain the tensive relation, within the subject, between *idem* and *ipse*, that is, between *sameness* (stability of character) and *ipseity* (maintenance of the self through self-narrativization). See in this regard Ricœur (1994).

Though the subjects in the top images may head towards us with their bodies, such physical impetus is not supported by the gaze, thereby preventing any dialog from taking place. All the characters are turned towards us, offering themselves to our view through their frontal corporeality, but none of them exchange glances with us.[12] In *Soliloquy I* (Fig. 3.7), the protential act is readable in each modulation of the posture of the sleeping man: in his arm coming towards us, in his frontally displayed face... His posture is agreeable, but nonetheless contrasts with the defensive closure of his eyelids. In *Soliloquy III*, the woman's gaze is offered to our view, but only indirectly. Her gaze is made visible by its projection onto a screen (a mirror, or what appears to be so at first glance), and this mediation makes it more distant from us.[13] In *Soliloquy IV*, the woman literally offering herself to our gaze in such a manner that we feel as if we could almost touch her also seems to pour herself over into the space of enunciation. But nevertheless, her face also is turned away. In *Soliloquy V* (Fig. 3.9), the direction of the young man's walking towards the space of enunciation contrasts with the downwards gaze directed towards the visualization of his own "self-narrative." In *Soliloquy VI*, the young girl sitting on the floor has her bust line turned towards our direction, whereas her body is curled over itself, suggesting she might tumble over into the lower section.

In *Soliloquy VII*, the feet of the character seem to exceed the frame's aesthetic boundary, but the gaze remains silent. In *Soliloquy VIII*, the character is once again "moving" towards us, but the handkerchief concealing his eyes prevents us from accessing his gaze. Finally, in *Soliloquy IX* (Fig. 3.10), the possibility of dialog is precluded by means of filtering. The substance filtering the gaze is at moments palpable and dense. Though it successfully hides the character's body, it nevertheless leaves his eyes visible. This operation of filtering functions as a polemical variant in the manner in which the body is exposed and the gaze is directed, as compared with what the previous items of the series established.

3.4.3 The 360° Space Strategy in Soliloquy

Let's now look at two of the compositions which appear to constitute major stages in the series' trajectory, *Soliloquy II* and *Soliloquy V*, notably because of their lower sections.

The top panel of *Soliloquy II* (Fig. 3.8) represents a man alone in a natural autumnal setting which is quite homogeneously illuminated.

The human figure presents itself perfectly along the central axis separating the rectangular image into two areas. Yet, both the inclination of the right shoulder

[12]In *Soliloquy II* also, the young man seems to address us through his gaze, but it is only an inchoate gaze. Indeed, its direction is not symmetrical to the axis of enunciation, but rather deviates towards the lower left.

[13]For a detailed analysis of *Soliloquy III* put into contrastive relation with the *Rokeby Venus* by Velázquez, see Dondero (2009a).

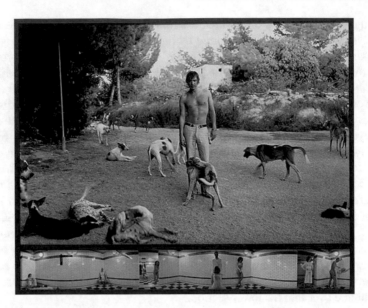

Fig. 3.8 Sam Taylor-Johnson, *Soliloquy II*, 1998

towards the ground and the pose of the hips construct diagonal trajectories breaking
the symmetry of the body with respect to the central axis of the frame. The alignment
of the body functions in the manner of a wave which breaks and twists the symmetry
of the standing posture. The dogs, encircling the man, also function as actors breaking
the geometry of the space.

Despite his frontal pose, the young man does not call out to us: The downwards
gaze he directs towards the left functions as a movement of departure from his frontal
position. Between his postural frontality and the diagonality of his gaze, the subject
appears to let his mind wander for a few moments of an unspecified duration. This
state "beyond time" and "beyond space" constitutes an interval which represents a
void in the narrative's progression, suspending the dialog between the subject and
the observer, and thereby transforming it into a soliloquy.

If we take the lower image into consideration, the only figure not taking part in
the activities shared by the other actors portrayed in the scene is a young man located
at the left extremity of the section. The fact that this young man is accompanied by
a dog lying by his side, in addition to his being bare-chested, reveals his identity.
It is hence through the projection of his homologue located in the top image that
he may be identified, whereas the dog provides an additional feature supporting his
identification. Beyond his being spatially isolated from the other characters in the
scene, he also appears dissociated from the sexual acts taking place before his eyes,
as if he were an outsider to the desiring and offering gazes cast by the other actors.

It may be asserted that the gaze of the top image's subject, cast diagonally from
a height towards the ground, assumes the form of a different type of gaze in the
lower space, one which is horizontal and sidelong. The figure which occupies a

central position in the top image occupies only a marginal and peripheral one in the bottom section. The dimensions of the figure also decrease while undergoing a change in their associated values: In the passage from the top image to the bottom one, there is a transition towards the subject's self-devaluation, towards his seeing himself as "small." The subject projected in the "second space" uses his sight to explore the space around him, but none of the figures he sees, who are all actants of reciprocity,[14] return his gaze. Just as the character in the top image does not reciprocate the observer's gaze, the character projected by means of internal disengagement is met with no gaze other than the spectator's, this gaze being one of low intensity, being lost among a multitude of focal points. The character's existential seclusion is complete.

As in other compositions from the *Soliloquy* series, in the bottom section, a 360° space substitutes itself to the *radial* perimeter of the top section's subject. The central character of the top image gives way to a diffraction of figures, the former's presentation contrasting with the spatial geometry found in the bottom section where there is no focal center, but rather a focal dispersion across the various positions occupied by the multiple characters represented. Moreover, whereas the top photograph imparts a sensation of openness and of serendipity, due to the dynamizing diagonal lines, the bottom image is traversed by no diagonal, and the whole section's composition plays along the horizontal and vertical axes. The horizontal figures situated at the two extremities of the bottom image express the space's closure upon itself. The 360° space is indeed a space which transforms its end into a beginning—and vice versa.

What further accentuates the opposition between the spatial organizations of the two images is the geometry of the tiling on the walls and of the checkered floor. In this place of pleasure, what predominates is a geometric structuring of infinitely reproducible spaces, suggested by the steady rhythm made of regular repetitions throughout the 360° space, but also and foremost by the nesting of rooms within other rooms, with openings in the walls which simulate passageways that are immediately closed off.

This space is constructed in a totally different manner than in the top image, the latter proposing a space that can be shared with the observer owing to its scale of 1:1. It is therefore possible for the observer to project his or her anthropomorphic coordinates into the enunciated space and to experience a perfect contiguity between the spaces of utterance and of enunciation. The open, natural, and chaotic space of the top image is welcoming, whereas the closed, geometrical, and reiterated space of the bottom one seems daunting and ill-suited to anthropomorphic apprehension.

As far as the chromatism and lighting are concerned, they confirm what was revealed by the spatial analysis: The illumination of the top image is diffuse, making

[14]Each couple engaging in sexual activities represents a dual actant, an actant of reciprocity. The couples multiply their displays of reciprocity and of copulation through the various articulations of their bodily postures. They thus appear to propose a catalog of relations pertaining to sexual communication, by illustrating tensive oscillations between opposite terms such as consent/refusal, active/passive, etc.

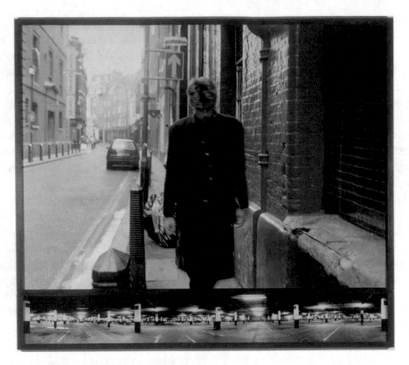

Fig. 3.9 Sam Taylor-Johnson, *Soliloquy V*, 1998

it a world that is uniformly perceptible through effects of *lighting*—its energy gradient conferring it global homogeneity in terms of luminosity. This configuration contrasts with the bottom image which is made perceptible through areas of high *brilliance*, that is, through luminous effects which localize concentrations of energy.[15] These areas dazzle and repel the observer, opposing a resistance to the gaze's penetration into the photograph.

The 360° space and the organization of the lighting function in the same manner in another piece, *Soliloquy V* (Fig. 3.9), which also operates a significant variation with respect to the other portraits of the series due its bottom section lacking a proliferation of figures.

Indeed, in the first four images of the *Soliloquy* series, the subjects, once projected through the bottom sections, would proliferate and differentiate themselves among a myriad of characters. Conversely, in *Soliloquy V*, the character is presented in the form of a lone figure. The young man walking along a public road transforms into a character imprisoned within a claustrophobic, almost indiscernible space. The seme of reclusion emanating from the spatial organization of the bottom image is confirmed by the specificity of the location represented: an impenetrable underground parking lot, marked by a full separation from the outside world.

[15]Regarding the parameterization of light in terms of luminosity, brilliance, chromaticity, and texture, see Fontanille (1995).

In the upper image, the presence of street posts and bollards orients the walker's trajectory. Conversely, in the image below, because of the spatial deformation, the logic underlying the spatial distribution of the objects proves difficult to reconstruct. Even the small number of cars in the top image seems to dwindle in the almost empty space below: It is as if the world lost its furnishing while the subject lost his ability to find his way through the meanders of his own self. The sparkling illumination of the rows of columns has a crushing and decentering effect, whereas the subject is displaced towards the periphery of the image. The subject does not manage to individuate himself, to recompose himself into a cohesive whole: He is represented in such small dimensions that he is automatically removed from any possible reciprocity with the gaze of the observer. With this removal, the relation instilled by an enunciative presence taking an *I-you* form is once again precluded.

Finally, *Soliloquy IX,* the last portrait of the series, presents itself as a story's end (Fig. 3.10).

Indeed, in all of the previously examined images of the series, when the corporeality of the character was displayed frontally, it was always the gaze which was denied to the observer, the corporeality of the subject functioning as the vector of exchange, contrasting with the act of averting the eyes. In *Soliloquy IX*, conversely, the gaze of the subject is actually conceded, but the thick and palpable vapor of the sauna forms an obstacle to the visual apprehension of his body. Once again, the orders of vision and of tactility are made to oppose: Whereas in the beginning of the *Soliloquy* series, it was the eyes which precluded any exchange with the observer,

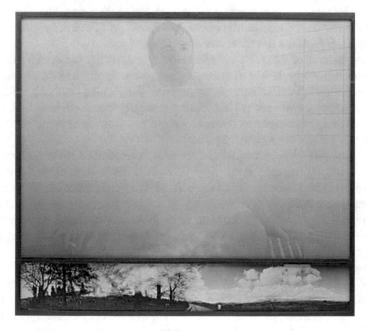

Fig. 3.10 Sam Taylor-Johnson, *Soliloquy IX,* 2001

now, a materialization of the air thickens so as to hide the subject's body, even substituting itself for it, since the subject's body appears to lose its physical consistency so as to assume the vaporousness of humid air. The vapor invades the observer: Could it be a punishment of sorts for having wanted to see too much?

If we look at the bottom image, we see a landscape with an isolated and deserted road emerging from its center, while its left is inhabited by a few dark figures concealed by the trees. In the previously examined works from the *Soliloquy* series, we observed a recurrence in the form of the relations between the top and bottom images: The subject projects him or herself from the upper section into the lower. Here, however, the subject of the upper image seems at first glance to be absent from the bottom image. But the lack of any recognizable human figure in the bottom image might not really signify his absence or a rupture with the enunciative isotopy of the other images of the series (the disengagement from the top towards the bottom). One cannot fail to notice that the vapor returns—its configuration changed—in the bottom image where it has been transformed into clouds.

The spectator's gaze follows, in the lower image, the luminous turns of the road leading towards the clouds, that is, towards a "greater horizon" figuratively rendered in the shredded materiality of the clouds. The "greater horizon" is featured in the photograph as the trajectory's terminal point, the place where the road disappears. Whereas in the upper image, the vapor imposed itself upon the observer as an invading tactile presence, it elicits in the lower image an effect of total distancing.

In this last portrait of the series, the character projects himself not as a body, but as water vapor, only to manifest himself in the lower image as an inconsistent contour. The character there is not in the cloud—he has become the cloud itself. Through his projection in the lower section, his contour multiplies, proliferates, and progressively distances itself from the deictic center of the body.

The evaporation of the man's body was already germinal in the figure of the sauna: The character made of flesh goes to the sauna to lose weight. The isotopic axis of the two images constituting *Soliloquy IX* is therefore the passage from corporeal matter to the loss of matter. We are not here facing a subject who is *present* in the world, but rather facing his resignation from the world and from life, whereby he simply "lets himself go" (he disappears into mist).

The cloud into which the subject transforms is the avatar of a process of rarefaction and of extensive diffusion: The contour of the cloud does not offer itself as a surface of inscription. The gaseous state is incapable of bearing the traces of the inscription of otherness. It is hence this inconsistency which guarantees eternal being, the state of no longer being traced/traceable by anything whatsoever, of no longer having any memory. The dispersion of matter in the ether functions as the argumentation of death operated by the image.

At the term of this analysis, we can make the hypothesis that Sam Taylor-Johnson's series of nine *Soliloquy* constitutes a very singular kind of portraiture, not one displaying a stable and compact subjective identity, but on the contrary, one presenting a divided subject who evolves over the course of the photographs, to the point of loss of self (*Soliloquy V*) and to the point of death (*Soliloquy IX*).

One could argue that the *Soliloquy* series *portrays the thinking* of the subjects represented rather than their identity, which would imply a huge challenge: representing the subject's inner space and his or her acts of introspection. The strategy employed to this end is self-proliferation, which indeed characterizes any act of introspection.

Soliloquy I-IX also succeeds in displaying the unfolding of such a thought process: We traverse several points of view by which the subject envisions him or herself. It is the lower images, difficult to apprehend due to their being five or six times smaller than the upper ones, which are meant to display the stages of the development of the subject's narrativization of self. This difficulty in terms of apprehension is highly significant, because the subjects look within themselves for enlightening representations while receiving their own images in return, these presenting the form of partial and unclear responses needing to be explored. Whereas in *Soliloquy I*, the subject looks lost in the midst of a group, the subject in *Soliloquy II* already appears to be totally excluded by the community surrounding him, as is also the case in *Soliloquy III. Soliloquy V* marks a turning point, because the subject finds himself all alone within a deserted space, but nevertheless faces similar difficulties in finding his bearings. *Soliloquy IX* presents itself as the end of a quest, whereby the subject evaporates into the ether, losing all consistency.

Adding more depth to portraits and making visible that which painting has always sought to represent—the subject's inner state—these photographs widen the view upon the subject by composing a double image showing the subject's thoughts at the very moment they are thought.

This series demonstrates the argumentative power held by images and also shows the strategies photography implements to problematize that which is not of the order of the immediately visible. These strategies implemented by photography confer it its metavisual power, which we will explore in the following part.

References

Acquarelli, L. (ed.): Au prisme du figural. Le sens des images entre forme et force. Presses universitaires de Rennes, Rennes (2015)

Barthes, R.: Camera Lucida: Reflections on Photography. Hill and Wang, New York (1981)

Basso Fossali, P., Dondero, M.G.: Sémiotique de la photographie. Pulim, Limoges (2011)

Beyaert-Geslin, A., Lloveria, V.: Une approche épisémiotique de la présence. Sur quelques portraits d'adolescents. VS Quaderni di studi semiotici **117**, 95–102 (2013)

Beyaert-Geslin, A.: Espace du tableau, temps de la peinture. Actes Sémiotiques Website. http://epu blications.unilim.fr/revues/as/2513 (2013). Accessed 25 May 2017

Deleuze, G.: Francis Bacon: The Logic of Sensation. Continuum, London (2003)

Dondero, M.G.: Le sacré dans l'image photographique. Études sémiotiques. Hermès Lavoisier, Paris (2009)

Fontanille, J.: Les espaces subjectifs. Introduction à la sémiotique de l'observateur. Hachette, Paris (1989)

Fontanille, J.: Sémiotique du visible. Des mondes de lumière. Presses universitaires de France, Paris (1995)

Fontanille, J.: Sémiotique et littérature: essais de méthode. Presses universitaires de France, Paris (1999)

Greimas, A.J., Courtés, J.: Semiotics and Language: An Analytical Dictionary (Advances in Semiotics). Indiana University Press, Bloomington (1982)

Pontévia, J.-M.: Tout peintre se peint soi-même «Ogni dipintore dipinge se» Écrits sur l'art et pensées détachées III. William Blake and Co, Bordeaux (2000)

Ricœur, P.: Oneself as Another. Chicago University Press, Chicago (1994)

Schapiro, M.: Words and Pictures: On the Literal and the Symbolic in the Illustration of Text. Mouton, The Hague-Paris (1973)

Shairi, R., Fontanille, J.: Approche sémiotique du regard photographique: deux empreintes de l'Iran contemporain. University of Limoges Website. http://www.unilim.fr/pages_perso/jacques.fontanille/articles_pdf/visuel/semiotiqueregarddanslesphotosorientales.pdf. (2001). Accessed 10 October 2019

Zilberberg, C.: La structure tensive. Suivi de Note sur la structure des paradigmes et de Sur la dualité de la poétique. Presses Universitaires de Liège, Liège (2012)

Chapter 4
The Metavisual

4.1 Foreword

To this point, we have examined issues surrounding the models of communication inscribed within images as well as the conflicts in terms of presence these images may exhibit. This third section, for its part, will seek to explore the question of the metavisual.

Firstly, we will discuss the hypothesis formulated in semiotics according to which verbal language is not the sole and universal translator of all semiotics (for example, of visual, musical, and audiovisual semiotics)—as opposed to what may be asserted by linguists and semiologists including Roland Barthes, for instance in *The Fashion System* (Barthes 1983) and in other of his texts about photography (Barthes 1977).

Secondly, we will revisit the notion of reflectivity in order to compare it with the notion of metalanguage. While the notion of reflectivity is quite widespread and uncontroversial in several disciplines pertaining to the study of images,[1] such is not the case for the notion of metalanguage. The main reason for this lies in the fact that the notion of metalanguage is built upon the hypothesis of a hierarchy between languages.[2]

Thirdly, we will delve into the work of V. Stoichita on meta-painting, and namely on what he calls "metapictorial devices," that is, the devices which use strategies of *mise-en-abyme* (of a "frame-within-a-frame"), such as paintings within paintings, but

[1] In art history, one may think for example of Louis Marin's (1993) opposition between transparency and opacity which concerns the distinction between *representation* and *presentation of the representation*, and which would pertain to a reflective functioning of the image. One could also think of the writings by Hubert Damisch (1972) on the work of art as a theoretical object.

[2] It is important to recall that philosopher Michel Serres already excluded any kind of hierarchy from the relation between one language and another and proposed the notion of generalized translation in his books *Hermès I. La communication* (1969), *Hermès II. L'interférence* (1972), and *Hermès III. La traduction* (1974). For a discussion regarding the paradigm of translation vis-à-vis metalanguage, see Bouquiaux, Dubuisson, Leclercq (2014).

© Springer Nature Switzerland AG 2020
M. G. Dondero, *The Language of Images*, Lecture Notes in Morphogenesis,
https://doi.org/10.1007/978-3-030-52620-7_4

also mirrors, niches, windows, geographical maps, doors, and curtains, and which entail a duplication of the processes of framing and of attention focalization. We will address the distinction between metatext, metalanguage, *métalangue*, and metastatus (or metadiscourse).

Then, we will explore a contemporary example of "images of images," that is, the visualizations of large collections of images carried out in the context of media visualization, as formulated by art historian and computer scientist Lev Manovich in collaboration with the Cultural Analytics Lab. After the analysis of images visualizations, we will focus on the predecessors to Manovich's work, the projects of Aby Warburg and Henri Focillon, which are to be understood as having inspired the analysis of sister-images through deep learning methods. Rediscovering the theories upon which these projects were grounded would be of great benefit as regards current practices of computer vision.

Finally, we will address the question of the metavisual from the standpoint of the techniques of image production, by defining the notions of substrate, application, and gestural act of inscription. These notions will prove capital for completing our investigation regarding the metavisual because they make it possible to shed some light on an area that has been insufficiently addressed by the semiological field: the matter and the gestures underlying image-making.

4.1.1 Between Semiology and Semiotics

Several disciplines devoted to images, namely the fields of art history and of visual studies, have addressed the question of meta-images in order to emphasize the reflectivity of images, that is, the capacity of images to describe themselves via their own compositional means.

In semiotics, the concept of visual metalanguage necessarily involves issues that were attended to in the first part of this book: the *sui generis* relation between *langue* and *parole*, and, more specifically, the absence of discontinuous signs in the visual field.

According to the assertions advanced by Benveniste, it would only be permissible to use the suffix *meta* in cases where the images are formed by a *system of disjoint markings* making them readable by virtue of combinatorial rules. If one were to accept Benveniste's assertions, an image displaying the act by which it was produced (the act of painting depicted in a painting, the showing of a shot being taken in a photograph, etc.) would not be considered to form a relevant instance of metavisual language because metalanguage would only concern signs which are *repeatable* from an image to another, based on a system of *invariants*. Could such lack of fixed-value units be ultimately attributed to the difference between the reflectivity of images (a vague concept accepted without difficulty in the sciences of images) and visual metalanguage (a more demanding concept at issue in the sciences of language)?

Indeed, several painters have attempted to establish a system of invariant features of visual language. Among such painters, we may think of Paul Klee, who was a theoretician of visual language through his writings and paintings, and who conceived of

Fig. 4.1 a, b, c

pictorial production as a performance, or as the execution of a system of fundamental formants. The case of Paul Klee is exemplary of research aiming to build a reservoir of forms on the model of the rules of music ordering each note, by conceiving of simple and complex tracings as forces orienting perceptual rhythms.

In the texts collected in the two volumes of the *Paul Klee Notebooks* (1961, 1973), the Swiss painter and theoretician identified and inventoried forms—and their deformations—within the plastic domain. For example, a line will be determined by segments (long or short), angles (acute or obtuse), radial lengths, focal distance, and will be governed by principles of *measurement* (Fig. 4.1a–c). Tones or chiaroscuro, for their part, concern issues of *weight*: White can have a more or less concentrated or diffuse energy; black can be more or less heavy. These degrees may be weighted amongst one another, regardless of the possibility for identifying intermediate levels of energy.

These traces and forms which can be inventoried may be conceived of as invariants functioning as disjoint and recombinable signs, similarly to notes in a classical musical score where each sign ensures a stability of values. These signs which can be inventoried are also destined to be deformed by the substance of painting (as are musical notes by the sounding matter)—leading back to the initial question concerning the relation between *langue* and *parole* and to the system of virtualities meant to be realized through utterances.

If one were to base oneself on the models provided by Paul Klee and by other theoreticians of images such as Miró who, in the course of their pictorial production, attempted to construct an alphabet functioning as a language, one would risk missing out on a wide range of artistic experiments which construct expressive "regularities" by various means and which do not depend upon fixed-value disjoint elements.

Furthermore, the hypothesis proposed by semiology also proves unviable in its attempts to identify the functioning of images on the basis of verbal language's atomical model, as the following lines will illustrate.

4.1.1.1 From Roland Barthes' Proposals to Plastic Semiotics

Opponents of the notion of visual metalanguage maintain that the visual domain cannot rely upon an alphabet of signs nor on stable combinatorial rules, the visual field being *devoid of morphological units and of syntactic rules.*

This same view has been advanced by Roland Barthes in his writings on photography, bringing us to the core of the distinction between semiology and semiotics.

The research conducted by Barthes (1977) on the relation between verbal and visual languages is based on the attempt to uncover a manner of decomposing photography into units. Such units, according to Barthes, would correspond to lexical segmentation, which entails that his semiology conceives of verbal language as the sole metalanguage capable of describing all other languages. Semiotics, for its part, aims to demonstrate that there are metalinguistic procedures in all non-verbal languages such the language of gestures, of images, of music, etc.[3]

As recalled by Paolo Fabbri in *La svolta semiotica* (1998), in Barthes' semiology (and also in Benveniste's semiology), the relation between languages is irreversible: According to Barthes, language can for instance describe photography, but photography could neither describe a discourse in natural language nor describe itself.

Semiology is therefore conceived by Barthes as a *translinguistics* by virtue of which verbality would lie at the core of any signification.[4] One may recall in this respect an excerpt from "The Photographic Message" in which, conversely to *Camera Lucida*, Barthes attempted to achieve an immanentist analysis of photography:

> From this point of view, the image—grasped immediately by an inner metalanguage, language itself—in actual fact has no denoted state, *is immersed for its very social existence in at least an initial layer of connotation, that of the categories of language.* We know that every language takes up a position with regard to things, that it connotes reality, if only in *dividing it up; the connotations of the photograph would thus coincide, grosso modo, with the overall connotative planes of language.* (Barthes 1977, pp. 28–29, emphasis added)

The difficulty, for Barthes, lies in dividing the *continuum* of the image: "[T]heir units are heterogeneous, [they] necessarily remain separate from one another; here (in

[3]See Caliandro (2008) and Dondero (2016a, 2017).

[4]On the matter of the exclusive use of speaking and verbal language in legal parlance, which, unfortunately, does not take other media such as photography into account, see Coccia (2015) who proposes to go beyond identifying the legal system with instruments belonging to the verbal medium: "To speak of specifically iconic normativity does not mean to understand and analyze the aesthetic dimension of the law, but to make of images the expression of a normativity *exclusively* expressible in a form which is by no means an aesthetic or visual translation of a law existing elsewhere" (p. 66, our translation).

the text) the substance of the message is made up of words; there (in the photograph) of lines, surfaces, shades" (idem, p. 16).

Greimas-inspired semiotics of photography and, more generally, of images, distanced itself from the attempt to separate denoted messages from connoted messages, as well as from postulating the dependency of images upon the divisions of verbal language.[5] This has been made possible by forgoing the quest for harmonization between the units of verbal and visual language thanks to a theorization of plastic semiotics[6] and of the uttered enunciation.

The problem of photography understood as a continuous message that is difficult to discretize, to divide, or to segment, has represented a challenge for the semiotics of the School of Greimas: The approach provided by plastic semiotics enabled to conceive of images as sets of relations of similarity and of difference, or of relations of contradiction, contrariety, similarity, opposition, expansion, and contraction which make sense within a frame. The image, thus conceived, will consist in a composition of forces in tension rather than in an addition of separate units.

The perspective of enunciation, which completes and complexifies the plastic analysis approach, enables us to analyze the image's signification while looking beyond the themes of the image, so as to analyze the global visual composition distributing the intersubjective positions (the simulacra of production and observation).

Furthermore, the plastic reading of the image was not conceived as a method exclusively devoted to the analysis of abstract images. It attaches itself to the topological, eidetic, and chromatic features of any image; it allows one to study the identifiable oppositions on the plane of expression which are to be put into relation with oppositions on the plane of content—what we call the "semi-symbolic relation." It is a solution capable of going beyond the search for units of signification which would correspond more or less to the objects of the world and to the lexicon. In this respect, a study by Odile Le Guern (2013) addresses the issue of semi-symbolism in relation to visual metalanguage, which may be conceived of independently, provided a departure is made from the figurative standpoint of Barthes (i.e. from the search for visual units lexicalizing objects of the world) so as to embrace the englobing point of view of plastic semiotics. The figurative standpoint adopted by Barthes is indeed based on a paradigmatic and local perspective whereas the plastic reading concerns forms and forces, that is, it involves a global and suprasegmental view of images, one which also drives the theory of enunciation. Le Guern asserts that as long as we consider the image, as does Barthes, to be a collection of figurative signs, that is, to be a collection of visual signs which are dependent upon lexicalization, and which constitute units referring to something recognizable in the natural world, we would be unable to understand the language of images or its reflective level.

[5]Concerning the differences between the semiology of Barthes and the semiotics of Greimas on the matter of images, see Dondero (2017b). On the evolution of the notions of *studium* and *punctum* between Barthes' *Camera Lucida* and Claude Zilberberg's tensive semiotics, see Colas-Blaise and Dondero (2017).

[6]Classical references: Greimas (1989), Floch (1985).

4.1.1.2 From Semi-symbolism to Image Diagrams

Semi-symbolism is one of the approaches enabling us to conceive of a system which underlies the image and which depends upon the identification not of units, but rather of oppositions—oppositions which have always been deemed to operate within images, but which can also be extended to intertextual relations between images.[7] While semi-symbolism was indeed formulated to analyze images taken in isolation, which by themselves will produce and exemplify a code, considering the relation between two or more images causes new questions to emerge, such as those outlined in the introduction of this book:

1. Can we speak of a metalanguage in the case of a single image which would integrate its own language and metalanguage?
2. Does an image need another image (within a series, a sequence of citations, etc.) for its signifying structures to become apparent? In such case, each image would be conceivable, especially in the field of art, as the *translation* of another image; in short, any image forming part of an intertext would be understandable as a site for readdressing and clarifying other images.[8]

Concerning the second matter, Le Guern (2013) studied two 1914 paintings by Matisse entitled *Notre-Dame* and *View of Notre-Dame*,[9] these serving as the starting point for a reflection on the distinction between a discourse on *code* or on *langue*, which she calls metalanguage, and a discourse on *parole* or on the *iconic utterance*, which she calls metadiscourse. The two paintings in question have been publicly displayed together during the *Matisse—Pairs and Sets* exhibit held at the Centre Pompidou in Paris in 2012. This event sought to highlight the presence of pentimento, of reformulation, and of self-quotation in the work accomplished by the French painter.

The two paintings distinguish themselves from one another inasmuch as the second one appears to constitute a reflection on the first, in particular with respect to the structure, which was "hidden" in the figuratively dense first painting. The second painting traces the lines enabling us to understand the manner in which Matisse conceived of the plastic and geometrical structure of space and how he conceived of the first painting's topology. Le Guern asserts that it is the emphasis on systemic oppositions, achieved by confronting the two works with one another, which reveals

[7] See in this respect our proposition in Dondero (2009a).

[8] A third question would complete the second: Can metalinguistic discourse production specifically pertaining to images be accomplished by means of another language, for instance an audiovisual, gestural, musical, or verbal language? If such were the case, it would no longer be a matter of translating between two visual utterances belonging to a same medium but rather of an intermediatic reflection in which two technical and/or technological specificities would be made to mutually translate one another, putting the specificities of each language into comparison, without any hierarchy being relevant. See in this respect the distinction formulated by Klinkenberg (2000) between homosemiotic metasemiotics and heterosemiotic metasemiotics.

[9] *Notre-Dame*, 1914, oil on canvas, 147 × 98 cm, Kunstmuseum Solothurn, Solothurn (Switzerland), *View of Notre-Dame*, 1914, oil on canvas, 147.3 × 94.3 cm, The Museum of Modern Art, New York.

the existence of a code based on the association of the planes of content and of expression: "The confrontation between the two paintings actualizes the revelation of the existence of the plane of expression and of the systemic opposition which *constitute the painter's palette of paradigmatic choices* necessary to the representation" (Le Guern 2014: 333, our translation and emphasis). Allowing the spectator to compare two realizations of a same motif, the Cathedral of Notre-Dame, is to make him or her aware of a structure underlying the composition which reveals, beneath the figurative representation, the constitutive elements of a plastic *language* ("the palette of paradigmatic choices") specific to the artist. According to this approach, an image would need another image commenting it in order to become heuristically visible.

The first question, on the other hand, would delve even deeper in what concerns the issue of metalanguage: Can an image, alone, succeed in exemplifying its metalanguage? Can the image represent something and, at the same time, exhibit the reflection on the manner by which it represents that "something" itself?

It was previously mentioned that the works by Marin (2006, 1993), who is one of the art historians who is the closest to the theory of enunciation, approached this question and that Marin's notion of *opacity* already answers it in great part.

It is, however, possible to go further and to pave the way for a more detailed and dynamic conception of the notion of *meta-* by asserting that visual language produces *folds* within itself, showing images to be constituted by schemas which appear to shed away "like a fine layer" from everything that is represented in the image, to report the words of film theoretician Metz (2016, p. 10). According to this hypothesis, images would comprise *at least two strata*: On the one hand, unique and singular components which do not repeat, which are not organized into relations and, on the other hand, schemas and structuring forms. These structuring forms may be conceived of as relations of relations, as diagrams which emerge and detach from the objects represented in the image. These schemes do not however transcend the materiality of the image; they are immanent to it because they are produced by mereological relations present in the form of differences, contrasts, or symmetries.

We may conclude that if the hermeneutics of images depend neither upon verbal interpretation nor upon a universal visual metalanguage, it is because the image itself generates an *explicative language* made of schemas emerging from the processing of its materiality, where *fine layers are shed* from what is represented. At this stage, one must ask whether such self-description is guaranteed by something which may be conceived on the model of a *formal device* of enunciation which would repeat from one image to another (in the manner of pronouns in verbal language). Is it then simply question of an *organizing level* emerging from the perception of the plane of expression which differs in each image? The question of the relation between a general formal device and the specificity of the structuration of each image may be posed, and this once again raises the fundamental issue addressed earlier: that of the relation between *langue* and *parole* in visual language. But the progress made here enables us to better identify intermediate levels between the general and particular levels and to ask more precise questions: May a truly spatial level of organization be transposed in order to analyze an image other than the one in which it was identified

in the first instance? May this level of organization be conceived of as giving way to a diagrammatical functioning, which would constitute both a particular and general apparatus (*dispositif*),[10] and which would allow the transposition of schemas from one image to another, all the while respecting the material qualities of each image? This "diagrammatical" hypothesis will be tested in the chapter concerning the "frame-within-a-frame" device in art and its transposition to the study of scientific images (3.3).

4.1.2 The Uttered Enunciation and the Metavisual

The issue of metalanguage already forms part of the theory of the uttered enunciation and can be addressed in the context of images in at least two manners:

1. The first involves intersubjectivity and the system of shifters, that is, the manner in which each image orients the eventual gaze of the observer through a kind of visual pronominality which will be configured along its actorial, spatial, and temporal dimensions (see the first part of this book). From the actorial stand-point, visual language, like verbal, musical, and gestural languages, articulates relations between enunciators and enunciatees, that is, between *simulacra of subjective and intersubjective relations*. These simulacra function as mediators between flesh and blood spectators and the configuration of images—embodying *possible* intersubjective relations. In light of this, the following question may be raised: Would any shifter be automatically conceivable as a *meta-* device in what concerns the acts of production and of observation?
2. The second involves the acts of *splitting (duplication)* and of *proliferation* entailed by devices which frame and focalize attention within the image (a painting within a painting, a gaze directed towards the eyes of the spectator, etc.). Conversely to the shifter approach, this option rather stems from *impersonal* enunciation as theorized by Metz (2016), who conceives of enunciation as the traces of the acts of production and observation represented (figuratively) or signified (by plastic means) within the utterance.[11]

Another question then arises: Does the duplication of an image through another image within it (via framing devices such as mirrors, frames, doors, etc.), as described by Stoichita (1993)[12] and Metz (2016), correspond to the conducting of an operation

[10]For a deeper examination of the notion of diagram as a device which is both particular and general, see Chauviré (2008), Stjernfelt (2007), and Dondero (2014d). For a discussion on diagram and enunciation theory in linguistics, see La Mantia (2020).

[11]For a deeper examination of the distinction between enunciation as a shifter and the notion, inspired by Metz, of impersonal enunciation, see Paolucci (2010, 2017, 2020).

[12]All of these devices would, according to Stoichita, have the capacity to found a reflection on pictorial language. In our view, they also function as enunciative devices which govern the pronominal relations with the observer. For instance, mirrors, if shown facing the observer as occurs in *Las Meninas* by Velázquez, will interrogate the observer regarding his or her role as producer of the

of self-analysis by the image? In other words, when there is a duplication, or a *mise-en-abyme*, is there automatically a process of analysis?

Furthermore, are the acts of framing, of multiplying the scenes by means of reflective surfaces, and of stratifying surfaces by problematizing their relations linked, as are shifters, to intersubjective relations, or are these two autonomous movements? Is it useful to continue distinguishing them? Or is any image, in showing the perspective through which it must be looked at and by necessarily embodying a point of view accessible to the observer, already meta- in the second sense, that is, by mimetism of the acts by which it is produced and observed?

We will list four types of uttered enunciations in painting and in photography where it is difficult to distinguish between what rightfully belongs to the system of shifters and what pertains to the reflection proposed by images conceived to duplicate their own acts of enunciation.

– *Representing enunciation in the utterance*

Throughout the history of painting and of photography, there is a continual occurrence of paintings which exhibit the painterly act in the course of realization and of photographs which display photographers focusing their lenses on models. In the case of Vermeer's famous piece *The Art of Painting*,[13] the *act* of painting is directly represented, so as to present the observer with a pictorial disengagement (*débrayage*) towards the act represented within the painting as well as with the result of said disengagement—the painting is being painted within the painting. The painting is visible and so is the model since the painter faces away from the observer, assuming, as an actor of the utterance, a third-person position. In other cases, such as in *Las Meninas* by Velázquez[14], it is the painter whose gaze addresses the observer from a first-person perspective, which means that we cannot have access to the painting being painted. Moreover, Velázquez's painter looks at us as if he were painting the spectators, who, incidentally, assume a second-person position (singular or plural) within the dialog established by the "I" position assumed by the figure of the painter. In Velázquez's painting, the models, conversely to Vermeer's, are not "represented directly": They are solely made of the pictorial matter emerging from the canvas, which is only visible to the painter. These models may be seen reflected in the mirror at the back of the workshop, positioned so as to face the painting's viewers.[15] While this painting hides the canvas from the viewer, it nevertheless exhibits something more than does

image. Thus, the enunciative and metalinguistic instances converge, because these metalinguistic devices question the acts of viewing and of producing the image, these being the two fundamental enunciative operations. One could nevertheless continue to distinguish the uttered enunciation from metalanguage, since it concerns the simulacrum of the communication situation in the image and the role played in it by each actant, whereas the meta- level concerns the reflectivity of painting upon itself as a medium.

[13]This painting was created circa 1666 (between 1665 and 1670) and is exhibited at the Kunsthistorisches Museum in Vienna (oil on canvas, 120 × 100 cm).

[14]This painting was created in 1656 and is exhibited in the Prado Museum in Madrid.

[15]Concerning the various interpretations of *Las Meninas* and of the characters represented in the mirror in the back, see Nova (1997).

Vermeer's: a view upon the corporeal movement of the painter who, as an actant of the pictorial making, becomes an actant of the gaze, of observation.

Velázquez's painting represents a veritable theoretical proposition on the process of framing and on framing devices which include doors, windows, mirrors, canvases, curtains, and, of course, paintings. All of these devices may serve the illusion of depth or its negation and may be identified for instance as shifters, as is the case of mirrors, or as devices for duplicating the pictorial act itself. Moreover, *Las Meninas* also constitutes a representation of what it is to be both the spectator and the model of a creative act.

It appears that these two paintings, which both represent the pictorial act, engage each of the two functionings of enunciation described earlier: The presence of paintings and of any kind of framing device exemplifies a reflection on the acts specific to image-making; at the same time, the more or less dialogical gazes of the painters and models seem to effectively illustrate the presence of personal shifters (front view, side view, three quarter view, face view mediated by a mirror, etc.) as being necessarily linked to the devices for framing and duplicating the acts of production and of reception.

– *Engagement and drawing in the observer's gaze*

While the first case addressed concerned a duplication of the pictorial act articulated into various actantial positions (to observe, to paint, to capture one's model, etc.) via its explicit representation, the second type of uttered enunciation, typical of portraits, is that of the engaged gaze. We have already encountered it in *Las Meninas* by Velázquez, but it must be distinguished from the representing of the act of image-making. Indeed, in Velázquez's *Las Meninas*, the subject looks towards the spectators as a *painter in the act of painting*, whereas in a portrait, the subject represented looks at the spectators in the manner of a *subject displaying his or her identity*; a subject whose sole activity consists in self-gazing, being gazed at, and gazing at the eventual spectator. In both cases, it is a matter of engagement: In the first case, the gaze serves as a reflection on painting, and more specifically on the corporeal positions of the image's producers, models, and spectators; in the second case, the engaged gaze is at the service of personal enunciation and of the inquiry upon identity. It is not here a matter of showcasing the productive practice of an object or of a social role[16] via a gaze, but indeed of putting an individual face-to-face with another individual.

Moving towards the domain of photographic production, it may be noted that all photographic portraits put the viewer into direct relation with the gaze of the character, now looking towards the viewer, and who had been captured by the gaze of the photographer. As already outlined above, there is, in photographic portraiture, a surplus of authentication in comparison to painterly portraiture, and this, solely owing to the specificity of the photographic process which makes it possible to look at something that was set by the image-maker's gaze. In other words, the action

[16]For an intriguing analysis of portraits of actors, see Lenain (2015).

which is represented (looking and focusing attention) is the same as the action which enabled to capture it (looking and focusing attention).

It would, however, be reductive to conceive of engagement as being exclusively exemplified by characters presented in face view, since objects may also be presented in such manner. Still life painting constitutes an exemplary genre centered upon the frontal display of objects. A still life painting will represent no character nor any action as such, nor will it involve any figuration of the system of gazes; what allows in its case to speak of enunciation and of dialog is the fact that the object represented (glass, knife, plate, flower, etc.) always seems to be falling, from the table/niche/shelf on which it is inevitably placed, towards the space of enunciation, that is, towards the image's space of production and of observation.

In the case of still life paintings, the intersubjective relation is impersonal as it exceeds the system of the direct representation and display of human gazes: The enunciative relation also extends to the positioning of the objects with respect to what lies beyond their frame and to the position of the observer. The observer is indeed targeted by the objects represented which appear to fall towards the frame's outer space, that is, towards the boundary which lies between the representation and the space of the enunciative act. One could assert that these images are conjugated in the future tense, because they illustrate the fully spatial trajectory extending from the *here* of an object falling towards an *elsewhere*, that is, towards an abyss which, from a temporal standpoint, will only lead to the transformation of perishable objects into dust.

We, as observers, thus represent the future of the still life because we are positioned in this abyss beyond the frame, representing a humanity also destined to be transformed into dust. In this sense, the still life addresses viewers in a manner which is impersonal (as humanity) rather than personal (as individuals), to the contrary of what takes place in portraiture. Indeed, the dialog in the still life does not take the form of an *I-you* relation (first and second persons of the singular) but of a *we-you* relation (first and second persons of the plural). It is an impersonal dialog because the still life does not address a specific individual, but the generality which is any mortal or vulnerable human, and it does so in addressing a warning, the *memento mori*. The unstable balance of the multiple objects indeed prompts reflections on the instability of positions, on the fragility of all things, as well as on the deceitfulness of all appearances—the still life also reproduces reflective surfaces which construct mirages, thereby proving itself to be the "deceitful" genre par excellence.

We could finally assert that the still life is a hybrid genre, because it does establish a dialog, albeit an indirect one, between objects which construct architectures while being in precarious equilibrium and destined to fall—*common interchangeable objects*—and a *non-singular human figure*, one devoid of a specific identity.

Relations of disengagement and of engagement are of course also conceivable in the context of abstract art, as soundly demonstrated in the analysis by Fontanille (1994) of a painting created by Rothko in 1951, *Untitled*.

– *Perspective*

The third type of uttered enunciation concerns the manner of constructing space while selecting a place for the spectators using various types of perspective and planar arrangements throughout the depth of the image. We have seen with Tintoretto's *Susanna and the Elders* that the strategies of uttered enunciation involving perspective are neither localizable nor identifiable as visual units: It is the geometric construction of the englobing space which determines the relations between the gazes and the spatial placement of the objects. Conversely to what occurs in *Las Meninas* by Velázquez, the enunciative act represented in Tintoretto's piece is not the act of painting, but instead, it problematizes the act of the free circulation of the gaze, such act being *disseminated* throughout the entire construction of the painting's space, through the multiplication and triangular arrangement of devices authorizing and/or forbidding the gaze. This would therefore be a case of impersonal uttered enunciation founded upon the architecture of space; yet, this architecture is strongly based on the circulation of the gazes, on their directions, their crossings, their avoidances, etc. The act of observation is supported by gazes organizing its structure and functioning as axes of reference for the spatial circulation of the focal points of attention.

– *Texture and "sensorimotor" techniques*

Whereas the first type of uttered enunciation represents the act of production inasmuch as it makes the act of enunciation into the explicit subject of the visual utterance, this fourth scenario concerns paintings displaying the technique, namely the sensorimotor movements, by which the utterance itself was produced.

The enunciative approach by shifters (pronominality) directly meets here that of displaying the technique employed and the very act of production/observation (impersonal enunciation). In painting, texture implies a relation between the treatment of the inscription-receiving surface (the substrate) and the rhythm of the movement of the paintbrush (the application).

It goes without saying that shifters in painting do not replicate the shifters of verbal discourse, but generate other ones, such as rhythms of texture, which stem directly from the producer's sensorimotricity. Sensorimotricity may be conceived of as to involve a kind of pronominal structure that does not concern shifters as do views in painting (face/side), but rather the traces of the painter's sensorimotor movements.[17]

We may thus answer the question formulated in 1991 by Christian Metz in *Énonciation impersonnelle ou le site du film* (*Impersonal Enunciation, or the Place of Film*) which established a distinction between uttered enunciations focused on shifters and those focused on the manners in which texts undergo a process of splitting in two, that is

> of enfolding themselves, of appearing here or there as if in relief, and of shedding a fine layer of themselves on which the trace of *another nature* (or another level) is engraved; a trace that is concerned with the act of production and not the product. (Metz 2016, p. 10)

[17] On the relations between objects and body markings, see Fontanille (2004) and Fontanille (2011).

The uttered enunciation in the visual domain should be understood as both a means by which intersubjective communication is inscribed within the image (through shifters) or as a means by which the utterance problematizes, in a more or less explicit manner, its productive act (through impersonal enunciation).

It therefore appears, in the end, that texture in painting holds together the personal shifters and the impersonal enunciation described by Metz: The texture assumes the function of shifter and at the same time manifests in an exemplary manner the relation between substrate and application. It is clear that painting and photography constitute their respective formal apparatuses of enunciation through different relations between the substrate and what is applied to it. In the case of photography, the application of the image to the substrate is achieved through the intensity of light selected during the act of framing (and then during the act of shooting), while the function of substrate itself is enabled by the paper's grain and degree of absorption.

We will return at the end of the book (Subsection 3.6) to the complex relation between substrate and application, in view of clarifying it by linking it to the notion of the substance's plane of expression. For the moment, let's return to the metapictorial devices theorized by Stoichita in the context of early modern painting in order to see if the operations these devices enable in painting may also be useful for analyzing other types of images, such as those having a scientific status, via the transposition of schemas.

4.1.3 Metavisual Devices by Victor Stoichita[18]

The works of art historian Victor Stoichita have greatly advanced the semiotic reflection on what are called "metavisual" or "metasemiotic" devices. In this chapter, we will first return to each of them before exploring the possibility, for the analysis of scientific images, of using these devices which Stoichita described while analyzing the paintings of the early modern period. An attempt will be made to answer the following questions: Is such a transposition legitimate? Furthermore, may these devices be useful for understanding the rhetoric of visualization in contemporary science? If so, what kind of adjustments would be required?

Among the numerous works by Stoichita, *The Self-Aware Image: An Insight Into Early Modern Metapainting*[19] (2015) and *Visionary Experience in the Golden Age of Spanish Art* (1995)[20] address the matter of the composition/decomposition of paintings (relations between *ergon* and *parergon*) and, more specifically, the relations which each image as an *articulated totality* maintains with its parts as well as the relations each part establishes with other parts within the whole. This question is at the basis of Stoichita's book *The Self-Aware Image*, devoted to the relations between

[18]In this chapter, we return to many of the reflections formulated in an article published in *Nouvelle Revue d'Esthétique* (Dondero 2016a)

[19]Stoichita (2015).

[20]Stoichita (1995).

the topology of religious painting and the modern period genres deriving from it (portraiture, still life, landscape, etc.). More specifically, the book shows the manner in which, during the modern period, these genres gained autonomy with respect to religious paintings, an autonomization resulting from operations of border-shifting and from framing strategies which transformed the *margins* of religious paintings into the *centers* of genre images. The various metapictorial devices (windows, niches, paintings, mirrors, doors, curtains, geographical maps, panels), according to Stoichita, brought about new genres at the dawn of the fifteenth century (landscape, still life, portrait, domestic scenes, etc.). Each of these metapictorial devices entails *operations* which orient the focalization of attention, add points of view, withdraw from view, these being processes which we will examine in detail.

The pivotal device explored by Stoichita, the *frame*, performs operations enabling us to focus our attention on the image's center and periphery, to distinguish englobing and englobed forces, as well as to distribute the elements upon which the structure of the image and our perceptive trajectory will be founded.

Let's begin with the most classical device, the *painting within a painting*. It involves operations of montage, that is, rhetorical operations of bringing into proximity, of distancing, of including, and of putting into brackets, which may be seen for example in the painting cabinets studied by Stoichita.[21]

In the case of religious painting, and notably in the paintings of visions investigated by Stoichita in *Visionary Experience*, other functions of the frame-within-a-frame may be identified: namely the *duplication* and *hierarchization* of levels of reality such as the terrestrial and celestial levels.[22]

This first device studied by Stoichita involves the *crossing of perspectives, the nesting of points of view into one another*, and, in some cases, namely in the religious painting of visions, their *hierarchization*.

The second device he examines is the window, which allows the illustration of actions operated within the image such as "overcoming," "going beyond," "projecting towards a distance," "conquering distance," and "taming the distant," which developed within the landscape genre. The operations to be retained as being specific to the frames constituted by windows are those of *projection, exploration, surpassing*, and *anticipation*.

A third metavisual device may be identified as the *niche*. It values operations characterized by opposing forces such as/blocking the view towards the horizon/and/invading the spectator's space/, to an extent where the latter's attention will be redirected towards him or herself, as occurs with a mirror. The niche is also a device used in still life paintings which, all the while appearing to delve beyond the banality of everyday objects, calls upon the consciousness of the spectator in two manners: First, the obscurity of the depths and of the wall facing the spectator engulf any potential opening towards the horizon and towards what lies beyond, and second,

[21] One of the examples given by Stoichita is the painting by David Teniers the Younger, *The Archduke Leopold Wilhelm in his Painting Gallery in Brussels*, Vienna, circa 1650.

[22] One of the examples given by Stoichita is the painting by Alonso Cano, *The Vision of St Bernard*, Madrid, 1650.

the falling of objects towards the threshold separating the image from the space of observation[23] engage the spectator in this process of falling. Therefore, operations characterizing the functioning of niches which should be retained are the *obstruction of the horizon from the observer's view* and the counterbalancing *invasion of the observer's space*.

The fourth device is the *mirror*. As is the case with all reflective surfaces present in the image (armor, glasses, bottles, silver and gold cutlery, etc.), the mirror makes it possible to redirect the gaze towards the production of the painting and constitutes a form of reflection upon the activities of producing and of looking.[24] Conversely to niches, mirrors do not block the view towards the horizon: To the contrary, they allow a reversal of the depth of the horizon towards the foreground of the image and may serve to include the figure of the painter within the painting. Mirrors make it possible for the producer (and/or observer) to be reflected within the picture—this is what explains their use for displaying the process of generation as may be seen in the portrait genre and namely in self-portraits. Mirrors may thus be conceived of as framing devices enabling one to *reverse a view* as well as to *add points of view* within the image by englobing the scenes which would a priori be external to it, such as scenes showing the production of the painting itself.

The last devices we will examine, *doors* and *curtains*, for their part, favor sideways observation, that is, a gaze which bypasses obstacles and which infiltrates—a *gazing through*.[25] Doors and curtains may be used to reveal or to hide, but especially to glimpse discretely: They form a *breach* in the circumscription of the field of vision.

Conversely to the openings provided by windows, which are always openings towards otherness and towards the distant, half-open doors and curtains are openings onto proximity and onto the interior; it is for this reason that these devices are associated with the interior scene genre, which notably became highly developed in the seventeenth century Netherlands. Each image comprising doors or curtains exhibits different manners of opening or of closing the field of vision created by the painting's framing. The rhetorical operations ensured by these devices consist in *the withdrawal from view or the parcellation of the view,* on the one hand, and *the insertion of a view bypassing obstacles*, on the other.

4.1.3.1 Transposing Operations from the Arts to the Sciences

Is it relevant to put these mereological operations to the test of a corpus of contemporary scientific images? The approach distinguishing between fundamental visual

[23] One of the examples given by Stoichita is the painting by Juan Sánchez Cotán, *Quince, Cabbage, Melon and Cucumber*, San Diego, 1602.

[24] One of the examples given by Stoichita is the painting by Simon Luttichuys, *Vanitas still life with skull, books, prints and paintings by Rembrandt and Jan Lievens, with a reflection of the painter at work*, 1635–1640.

[25] One of the examples given by Stoichita is the painting by Nicolaes Maes, *Eavesdropper with a Scolding Woman*, London, 1655.

schematizations appears justified as it is founded upon the attribution of an atemporality of sorts to the perceptive operations, similarly to the way the categories of "classical" and "baroque" function in the view of Heinrich Wölfflin (1917), these categories being indeed transhistorical and governing visual compositions of all times and of all statuses. It is certainly useful to detach them from their relation with artistic specificity and to find a sufficiently abstract level of comparison so that the transposition from the arts to the sciences may achieve relevance and heuristicity.

However, a first general distinction should be made before undertaking our exploration regarding scientific images from the fields of molecular biology, astrophysics, and archeology. While each painting examined by Stoichita constitutes an autographic totality[26] which is unique and original—its status as an art work makes immutable and sacralizes each of its lines, rendering it *non-modifiable*—the visualization of a scientific object is, on the other hand, always produced through various chains of images which are mutually specified and determined and, most importantly, which are continuously put into question, manipulated, and potentially *falsified*.

We could start with the hypothesis that no scientific image corresponds to a *single* scientific object in its totality, but that several images may, together, construct an *approximation*[27] so as to account for a functioning which we could call an "objectal totality"—which, in the experimental sciences, is always temporary. It is in fact only in works and articles of vulgarization that the presentation of *an* image will have the pretense of displaying *a* scientific object, such as a nebula in astrophysics, for instance. This would, however, be a matter of images obscuring the fact that they are composed of thousands of previous visualizations obtained through several wavelengths over several years of data collection—visualizations which are then filtered, recomposed, compressed, etc.

Consider the following image of a galaxy cluster displaying the fact that it is composed of several data obtained at various wavelengths (Fig. 4.2). It results from a process of compositing, associating, superimposing, and translating multiple images (right), culminating in the illusion that this cluster of gases constitutes a totalizing and compact object (left).

While we have previously described artistic images as autographic (unique, original, immutable because sanctifying a non-repeatable act of production), we could assert that the general functioning of scientific images rather likens them to symbolic systems which are deemed to be allographic. In these types of systems, as is the case in music, a work as a totality will be constituted of multiple executions.[28] This totality is, however, only transcendent, never materialized into a unitary object. In the case of

[26]Concerning autographic and allographic symbolic systems, see Goodman (1968).

[27]For a more profound reflection on this matter in relation to Bruno Latour's theory regarding scientific reference as exposed in several of his books, among which Latour (2001), please refer to Dondero (2010b). These works address the *constraints* (of a mathematical or technological nature) which link each image (or more specifically, each step of what we call the "chain of mediators") to the images preceding and following it, while constituting, at the end of the trajectory, a relation totalizing the object of scientific research—thereby making it intelligible.

[28]The allography characterizing notational semiotic systems such as music derives from the existence of a score using a distinct class of fixed-value signs and by the multiple (more or less accurate)

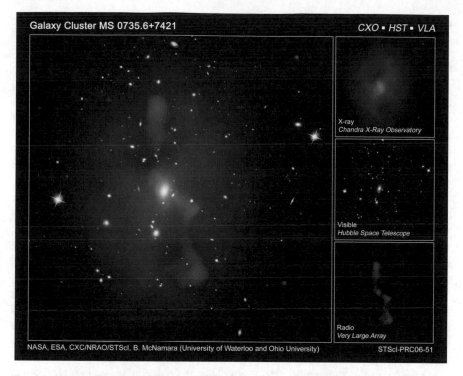

Fig. 4.2 Galaxy Cluster MS 0735.6 + 7421. NASA, ESA, CXC/NRAO/STScI, B. McNamara (University of Waterloo and Ohio University)

scientific images, as well as in music, there is never a coincidence between the object (visual or acoustic) and the transcendent theoretical object constituting its identity (the "nebula" object, for example, or the "symphony" object). A transcendent theoretical object is constituted of a multiplicity of executions. Scientific images, for their part, are the products of manipulation and of experimentation, ready to be repeated, verified by other researchers, and eventually invalidated. The images of scientific research discourse offer "partial answers" which are characterized as successive approximations and trials of which the commensurability must be tested[29] (with one another and with the instruments having produced them, as well as with the laws of mathematics); it is for this reason that images which test the object of research in order to stabilize it into a known object are understood as strictly controlled fields of experimentation.

executions of such score. It distinguishes itself from the autography of systems which value the unicity of the image's substrate and its syntactic and semantic density.

[29]Latour (1999) in this respect talks about the "chains of reference" which, in order to be considered robust, must be reversible, that is, "The succession of stages must be traceable, allowing for travel in both directions" (p. 69).

4.1.3.2 Totality and Parts in Scientific Images: The Case of Molecular Biology

Let's consider a first example of images by focusing on the mereology of research objects. As asserted above, the rhetorical and mereological operations in the visual domain are founded upon framing and its alteration. The cases we now examine come from an article in the field of molecular biology, published in 2006 in one of the most prestigious immunology journals, *Immunity*. The article in question, entitled "Dynamics of Thymus-Colonizing Cells during Human Development,"[30] presents a great variety of images devoted to the various populations of immune cells meant to colonize the thymus of the fetus before and after birth.[31]

It is clear that none of the images presented in the article correspond to a singular object, to a specific entity, be it of a cell, a protein, the thymic organ, or anything whatsoever. The object of investigation indeed corresponds to a series of experiments, which are often too lengthy to be fully reported in publications. The hypothesis made here is that in view of limiting the sequence to what is relevant for study, a form of totality of the scientific object is guaranteed by the set of images which constitute the article. We thus consider the article to present the englobing whole *and not* the full range of experiments on the phenomenon in their entirety. The images selected for publication are therefore already the result of a frame-within-a-frame, or rather of the *arresting upon images* within the dynamics of a flux or of a very lengthy experimental process.

At the beginning of the article in *Immunology*, the object of research is still virtual and finds itself to be discursively constituted as the experimental and scientific manipulations progress. The object of inquiry is submitted to segmentations and manipulations over the course of the article.[32] The visualizations show the transformations undergone by the process itself, or, more precisely, the manner in which it is segmented spatially and temporally, as well as the manner in which it is analyzed. As suggested above, the first characteristic of the image is that it frames, selects, segments, isolates parts, and focalizes the observer's attention. This functioning is

[30]Haddad et al., *Immunity* 24, pp. 217–230, February 2006.

[31]The point of the research can be summarized very succinctly: All of the cells in the immune system develop in the bone marrow except for the T lymphocytes, which develop in the thymus. The thymus is colonized by cells produced in the bone marrow transported through the blood: It is a matter of understanding which are the cells that will enter the thymus. Are they undifferentiated stem cells which reach the thymus by means of a random trajectory, or are the cells colonizing the thymus predetermined to do so? We know that cellular differentiation already begins at the bone marrow stage, but how to identify cells which may be preprogrammed, that is, which are selectively dedicated to the colonization of the thymic organ?

A research stay was carried out on this topic at the University Institute of Hematology (IUH), Paris 7, in 2014 under the supervision of Bruno Canque. I would like to thank Bruno Canque and Kutaiba Alhaj Hussen for their generous explanations and exchanges.

[32]For a semiotic theory of the manipulation of scientific objects, see the works of biologist and semiotician Françoise Bastide, and namely the collection of her articles translated into Italian (Bastide 2001).

in harmony with one of the most fundamental operations in biology which consists in isolating problems via models, that is, identifying borders within a perpetually transforming flux of life.

Whereas the full set made up of all of the images published in the article already constitutes a "frame-within-a-frame" with respect to the experiential flow of the phenomenon the article sets out to study, the subset of images to be found on page 226 (see Fig. 4.3) exhibits a first type of *frame-within-a-frame* which is internal to the superordinate (general) frame. We thus have various types of frames all geared towards the search for the cell meant to colonize the thymus.

The first two images displayed in the upper section (group A) comprise four small rectangles located around the edges of the green shape; they serve to specify the zones which will then need to be *detailed* and *upon which attention must be focalized* so as to pursue the exploration—so as to further it.

The four images in the lower section which form group B (C1, C2, C3, and C4) indeed proceed, or are disengaged, from the two images of group A by means of focusing and zooming in. Not only do the four resulting visualizations provide a sharper focus in terms of image definition (microscopic vision being more detailed), but they also perform a true *opening onto a new scene*, upon a process within the process.

This functioning could be likened to that of the window device—fittingly, these types of frames-within-a-frame are called "windows'" by biologists. Although in artistic images, and namely in landscapes, the representation of a window entails an opening towards otherness, that is, an opening from the inside towards the outside, in biological images, the window functions as an opening towards the inside of the object. On a more general level, it functions as the indicator of a *forward projection of the research*, of an act of anticipation: other images will follow. This process enabled by the device of the window in the landscape genre involves a passage from the known (the inner space from which the gaze originates) towards the unknown (the outer space opened to the gaze by means of the device). In the above example taken from biology, the generation of the images forming group B extracted from group A coincides with the passage from the global level to the local level and with the passage from a more superficial level to a deeper one.

These focalizations also function as devices entailing the multiplication of new scenes which may, in turn, themselves provide access to further scenes, through the opening of new windows. These images deepen the view into the object to be analyzed while opening towards new terrains, new visions.

In parallel, the operation of focalizing upon a segment taken from a flow of experiments entails the *determination of a salient area over a ground*, the ground being the area of the image where no transformation occurs. On the one hand, with C1, C2, C3, and C4 (group B), there is a gain in the intensity of the view in comparison to the images of group A, but on the other hand, there is also a loss in its extent in comparison to what was provided by the first two images forming group A. The new images have provisionally lost the background which was constituted, in the upper images, by the green colored tissue. C1, C2, C3, and C4, for their part, present another type of framing, one which functions in a different manner than do devices

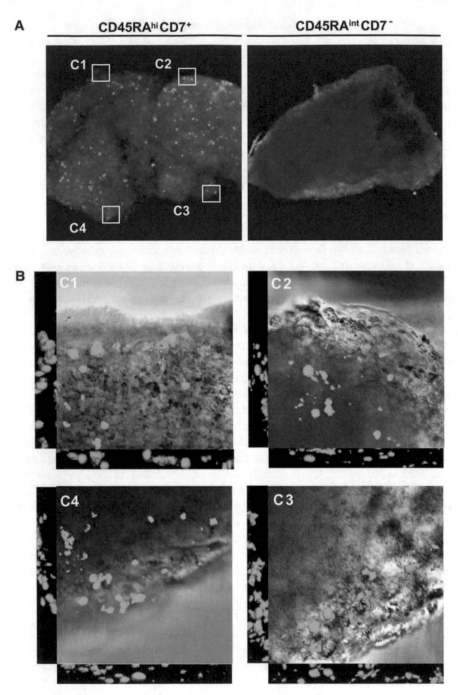

Fig. 4.3 "Ex Vivo Thymus Colonization Assay." (Haddad et al. 2006, p. 226)

of the "window" type: framing by *superimposition*. C1, C2, C3, and C4 are shown *superimposed over a new background* (itself made of green specks over a black background) which is in part hidden but which, at the same time, emerges. C1, C2, C3, and C4 highlight (by means of the green specks over the grey background) a population of cells selected in a way so that some proteins will be fixed upon the thymic organ.

But how to explain the functioning of the black backgrounds from which the light grey backgrounds emerge and from which the green concretions obtained by fluorescence emerge in turn? It is the partially inaccessible black background that enables the grey background to emerge before the observer, this grey background appearing, due to its saliency, as something endowed with a more marked degree of iconic stabilization than the black background. It must also be noted that each group of images (A and B) comprise a double frame: The first two images (group A) present the viewer with a totality (the green tissue) which is geared towards the further focalization upon the four parts selected by the frames—thereby leading to an operation of subtraction. Images C1, C2, C3, and C4 are indeed the products of the extraction from the provisional totality represented by group A. They also require a frame which functions, on the one hand, as the memory of the totality from which they were extracted and, on the other, as a means to display what may be explored thanks to the new views obtained by means of focalization.

One could thus assert that the images in the upper section (group A) comprise frames which could be called *protentional*, that is, *frames which reach towards the future of the experiment* (group B), whereas the images in the lower section (group B) rather seek grounding upon group A: They are superimposed over backgrounds which *serve as their memories,* the latter constituting types of frames which could be called *retentional*.

It is thus that we define the images of group A as *pending* images, because they prefigure other potential images, images to come (disengagement). Conversely, the images from group B constitute a sort of deployment/deepening of the images from group A, of which they carefully maintain the traces (engagement). C1, C2, C3, and C4 *preserve the memory of the trace* of a sort of micro-totality which produced them. What is significant here is that the acts of framing may entail several types of operations, these being more or less protentional or retentional.

We see here that the manipulations of framing operated upon the images may be understood, following Jean-François Bordron (2010), as a *gesture* constituting morphologies produced on the basis of an experiential flux: This *gesture*—which is indeed an act of manipulation—operates upon totalities and parts, that is, upon a hierarchy of combinations and selections of framings which constitute the scientific experiments. It may therefore be asserted that the research object is endowed with a *dynamic* prone to the production of multiple *compositions*.

The function of opening accomplished by means of windows may be seen in this other sequence of images (Fig. 4.4) which, conversely to the previous one, does not open new scenes, but rather performs selections and sortings.

Indeed, in sequence A, the very first image to the left, which forms part of a series of three images, shows a population of selected cells (those susceptible of colonizing

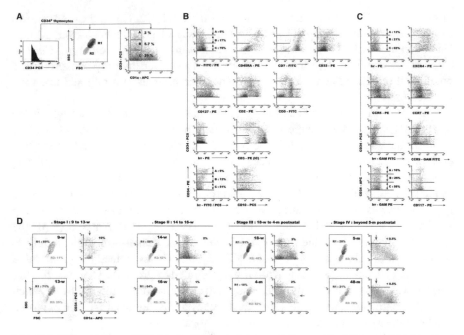

Fig. 4.4 "Phenotypic and Molecular Characterization of Immature CD34 + CD1a2/+ Fetal Thymocytes" (detail, Haddad et al. 2006, p. 223)

the thymus), whereas the second image shows the various sizes of the cells forming this population. The third image also performs a sorting, because it accounts for the temporalized development of cells only of a specific size, represented in red. This method of sequencing images does not involve operations of focalization or superimposition, but rather of division and sorting.

This sorting method only partially resembles the functioning of the metavisual devices of doors and curtains; it is not a matter here of subtracting from a visual field, but indeed of sorting and dividing—operations performed more rarely in the context of artistic images. Exceptions may be found in paintings which take the form of experiments on the breaking down of light, as is the case for instance in paintings by Sonia and Robert Delaunay, or in studies on the dissolution of bodily movements such as those produced by Duchamp as well as by Boccioni and the Italian futurists. In Duchamp's *Nude Descending a Staircase*, for example, the sorting operation applies to the decomposition of the movement of a human subject into its components. The components of the human body fail to correspond to the components of its movement. What this work displays is precisely the imperfection in terms of correspondence: The composition of the parts constituting a body are in the process of bursting, and at the same time, the form of the movement is not yet emancipated from the totalizing form of the body, which can still be identified nevertheless.

In the case of scientific images, the act of sorting is clearer and more distinct because the matter which is operated upon has undergone prior segmentations and

discretizations; the sequence of images may be said to be a *continuum* of discontinuities. It is also artistic images which will exhibit imperfections or uncertainties that are not required to be resolved. The pictorial matter which undergoes segmentation in artistic images is dense, being syntactically and semantically saturated by gestures as is any autographic work. It is also no coincidence if, in several disciplines and notably in astrophysics, all images which cannot be refuted receive the designation "artist's impression," despite being produced by scientists. Science has recourse to the label "artistic" when the visualization is neither based on mathematical foundations nor on verifiable data; in a certain manner, such reference to art functions as a promise of future scientific development.[33]

4.1.3.3 Totality and Parts in Scientific Images: The Cases of Astrophysics and Geophysics

Let's now take a look at other images, namely images from the field of astrophysics. Images produced for astrophysics rather function by the *addition* of points of view, obtained by recording multiple wavelengths of light, as seen previously (Fig. 4.2) and as also seen in the following image representing 10,000 galaxies (Fig. 4.5), produced by combining thousands of photographs. This image was published under the "Sciences" column of *Le Monde* in March 2014; it reveals an additional point of view comparatively to what was recorded in 2009 (Fig. 4.6). The 2014 photograph "adds" the ultraviolet view to the data recorded in the 2009 photograph.

Each wavelength view may be deemed *a type of framing*, a different manner of focalizing and testing the power of visualization provided by the various technologies involved in the exploration of the stars.

We had characterized the operations specific to the framing device which is the mirror as being *additive* in what concerns the points of view offered by the image; the mirror indeed makes it possible to incorporate, through its act of framing, objects and areas of the phenomenological space otherwise excluded from the field of vision. The mirror integrates multiple points of view, namely *complementary* ones. The histories of painting and of photography present many notable examples of such inclusion of heterogeneous points of view nested within a frontal perspective. In addition to the studies by Stoichita on paintings such as *Las Meninas* by Velázquez or *The Arnolfini Portrait* by van Eyck, we may recall the aforementioned photograph by Denis Roche, *28 mai 1980 (Rome, «Pierluigi»)* (Fig. 4.2), which portrays a "battle of devices" and which superimposes the point of view of the photographed subject over the photographer's point of view by means of a mirror.

However, conversely to artistic painting and photography, the insertion in an astrophysics image of an additional point of view or visual stratum does not result in a heterogeneous multiplicity, but rather in a *total homogenization* of the multiple luminous traces. This homogenization is due to the fact that the electromagnetic spectrum supports the commensurability between the various kinds of luminous

[33]See in this respect Dondero (2016b).

Fig. 4.5 The new eXtreme Deep Field, 2014. © NASA; ESA; G. Illingworth, D. Magee, and P. Oesch, University of California, Santa Cruz; R. Bouwens, Leiden University; and the HUDF09 Team

exploration. This is typical of astrophysics and contrasts for example with the strategies of image-making used in archeology, notably those used to produce images by means of geophysical methods of electromagnetic projection, which are completely different.

Archeological images too are constructed through the superimposition of perspectives and of exploration methods, and namely through the compounding of images obtained by means of various methods of prospection (magnetic, electromagnetic, radar, etc.)—which are all non-invasive methods of investigation. In the image below (Fig. 4.7), it is a matter of compounding data obtained from both electromagnetic prospecting and aerial prospecting. The heterogeneity of the methods of detection, contrarily to what was shown in the example from astrophysics, is preserved and even valued; it does not achieve an integration of the traces within a homogeneous visual syntax, but rather their differentiation, or what we may call a diagrammatic intravision.

In this composition, we are dealing with two juxtaposed figurative syntaxes, producing a "diagrammatic intravision," understood as an interstice between two regimes of visual exploration. Diagrammatic intravision is a form of visibility entailed by the reciprocal transposition of two regimes of vision (and of measurement) between which commensurability is sought. It is an interstitial view which

Fig. 4.6 Hubble Ultra Deep Field, 2009. NASA; ESA; G. Illingworth, UCO/Lick Observatory and the University of California, Santa Cruz; R. Bouwens, UCO/Lick Observatory and Leiden University; and the HUDF09 Team

enables us to perceive the potential transposability of the relations from one system of representation to another.

Such commensurability is supported by networks of relations on the plane of expression which are characterized in a contrastive manner and which may serve to construct differential values on the plane of content. But it is not a matter of a simple isomorphism between the planes of expression of each system of representation. Diagrammatic intravision must be understood as a dynamic making it possible to reconstruct evolving patterns, to grasp syntaxes, on both the plane of the utterance (processes related to the events and to the objects observed) and on the plane of the enunciation (process of investigation).[34]

We have seen that images in astrophysics seek to add, to superimpose, to integrate, to almost phagocytize the luminous traces, or to collapse the heterogeneity of the captures into a single image, as seen for example with the images of galaxies (Fig. 4.2). The visualizations composing the resulting image possess, one might say, a "transparent" consistency as compared with other visualizations, the final objective being a superimposed image homogenizing the traces of the various data captures. The image obtained is therefore an image of the transparency, that is, an image constructed upon the composition of various perspectives and areas of relevance (a functioning resembling that of Stoichita's mirror—all differences being kept in

[34]For a comparison between diagrammatical functioning in the artistic field and in mathematics, see Dondero (2012c).

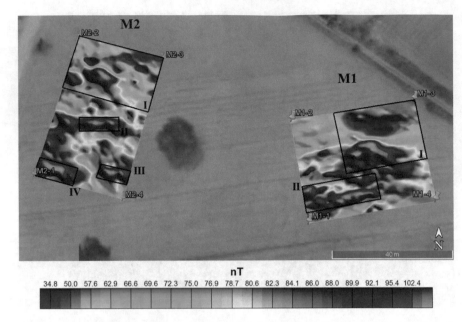

Fig. 4.7 Magnetic prospections in the archeological site of Xalasco, in the North-East of Tlaxcala, Mexico (This image was taken from the article by Juárez, K. R., López-García, P. A., Argote-Espino, D. L., Tejero-Andrade, A., Chávez, R. E., & García-Serrano, A., "Magnetic and Electrical Prospections in the Archaeological Site of Xalasco, Northeast of Tlaxcala, Mexico", *Glob J Arch & Anthropol*, 2017; 2(2): 555581. DOI:10.19,080/GJAA.2017.02.555581. Thanks to Denisse L. Argote-Espino for having granted reproduction rights for this image)

mind). It indeed seems that the final image is bound to compactify the partial visualizations, to gather that which is dispersed in the universe; it thereby aims to construct simulacra of cohesion for what in reality is diffused over time and space.

Now, this is far from holding for geophysically-based archeological images, in which the various measurements and detection methods mobilized are never perspectively integrated with one another. Indeed, images produced in this discipline do not seek to integrate the diversity of traces: To the contrary, they exhibit the heterogeneity of the research methods and the impossibility of recomposing these traces into a unit (a functioning reminiscent of Stoichita's doors and curtains). Such valuing of the heterogeneity of multiple visual syntaxes makes it not only possible to achieve double or multiple views over the same event, but also to investigate on the basis of the dissimilation of traces. Each image in archeology must show the diversity of the methods for connecting the surfaces with the subsoil or the various parts of the subsoil, and each method of investigation involves a process of exfoliating something compact. The image aims to signify the research methods themselves and namely the fact that each system for capturing and for representing the data is based on a "successive sampling" of the stratified layers which make up the subsoil: The image-capturing strategies as well as the representation strategies aim to dissimilate the stratifications.

Astrophysics and archaeology thus exhibit, in what concerns the object of perception, two different types of virtuality: The object of astronomy is inaccessible to our senses, hidden because it is too diffuse and too far away, too distal, whereas the object of archaeology is hidden because its stratification is too compact. It follows that in astrophysics, the images actualize the object via assimilations with compact evanescent phenomena and which precisely aim to represent certain phenomena by transforming them into an "objectal totality," whereas in archaeology, the images work by dissimilating stratified and compact matter.

Astrophysics operates by superimposing and integrating modules of light; archeology, on the other hand, operates by differentiating between strata. While the aim of astrophysics is to visualize phenomena by representing them as unitary objects, archeology, basing itself on the methods of geophysics, aims to represent the tension of forces capable of revealing the reciprocal relations between temporal strata corresponding to the various strata of the soil (diagrammatic intravision).

The functions of images in archeology are therefore completely different to those they assume in astrophysics: Starting with a compact object, an exfoliation of the subsoil is required in order to show all the diversity which constitutes it. Each stratum must reveal another, or several others: It is dissimilation that makes it possible to see and to operate. This is the very process which the image is meant to highlight.

To conclude this comparison and this section devoted to scientific images, we may thus liken the functioning of images in archeology to the operations enabled by doors and curtains as were described by Stoichita when addressing Dutch Golden Age paintings of domestic scenes. The works of painters such as Vermeer or Maes, which show intimate acts such as writing or reading love letters, present the conflict between the prospect of focalizing upon these acts and the obstacles which must be overcome in order for such focalization to succeed. Doors and curtains, constituting devices through which the gaze may traverse, are examples for composing points of view enabling a double view, that is, the view which is acquired after having overcome an obstacle. Earlier in this book, the strategies of vision provided by doors and curtains had been characterized as means leading to a certain type of accessibility: What meets the gaze of the observer is not the inability to see (inaccessibility), nor is it exposure, but rather an intravision requiring to be exploited (see Table 1). This is indeed what happens in archeological images generated by means of procedures stemming from geophysics: to overcome the obstacle formed by the compaction of the soil and of the subsoil, which cannot be uncompacted, but from which the heterogeneity and stratification of traces must be made to emerge.

In what concerns images in biology, we have, on the other hand, observed a certain variety in the framing devices employed: While the most frequent operations are openings by means of windows, we can also identify functionings that use niches, that is, the construction of equilibria between forces closing off the horizon and forces causing forms to emerge before the observer (retention and protention).

In conclusion of this comparison between the metavisual in arts and in science, it may be said that the transposition of metasemiotic devices via framing operations has enabled to highlight both the various strategies for composing the totalized scientific object as well as the rhetorical operations by which it is manipulated. Indeed, the

artistic and scientific images examined exhibit many differences, especially when comparing them on a strictly figurative basis. The differences are also significant if we consider these images from the point of view of their social status, that is, on the basis of the economy of values making them interpretable. Art concerns the contemplation of objects which are unique and "protected," whereas science involves acts of object manipulation and of verification. Nevertheless, a striking correspondence has been observed between the operations of composition/decomposition of visible matter in art and in the scientific examples selected, and this enabled to identify shared diagrams within the processes of argumentation and of reflection upon itself which the visual conducts.

4.1.4 Visualizations of Image Collections: The Case of "Media Visualization" by Lev Manovich

Before addressing Lev Manovich's computational analyses of images, which presented a renewed approach for understanding the metavisual, consider the following typology proposed here to distinguish between four acceptations the suffix *meta-* is believed to assume in semiotics depending on the discursive levels involved:

1. *Metatext* (or *meta-utterance*): Concerns a text's reflection upon itself—an example would be the *mise-en-abyme* of a photograph within a photograph, for instance;
2. *Metalanguage*: Concerns an image's reflection upon the specificity of its own medium in what concerns the relation between its substrate and that which is applied to it—an example may be found in the textures of Van Gogh's paintings which make the techniques employed visible;
3. *Metastatus/Metadiscourse*: Concerns an image's reflection upon its own status, or upon the enunciative praxis of the various social domains which govern it. Metastatutory reflection problematizes the fact that any reflection performed by means of the image will be contingent upon what we have called images statuses (artistic, scientific, religious, advertising, ethico-political, etc.), these being definable as *symbolic systems making intelligible that which is realized within them.*[35]

It is worthwhile examining the notion of metastatus which concerns visual language and its breaking down into statuses, these having been discussed in the first part of this book. Indeed, the matter of the existence of visual language and the relation between *langue* and *parole* may be addressed via the notion of status. As previously stated, there is no universal visual language; each image produces

[35] As stated by Bordron (2016), there is an economy behind each semiotic expression; in other words, the form of any expression is only intelligible against the background of an economy. In his view, "economy" firstly designates the ordering which founds the possibilities as regards the images' values and their eventual circulation.

a kind of local grammaticalization contingent upon the enunciative praxis specific to the social domain within which the image is interpreted. Nevertheless, there is often a discrepancy between the status within which the image was produced and the status serving to found its intelligibility. For example, images produced within domains such as religion, current affairs, or advertising, may be later interpreted in the manner of artistic objects. The status pertaining to the image's production does not necessarily correspond to the status pertaining to its interpretation, but the traces of the passage from one status to another are of course recorded in the object's biography and in the stratification of its meaning.

While semiotics, in conceiving of the field of art as the exemplary domain, has often projected the theory of artistic images onto a general theory regarding the reflectivity of images, it is also necessary to conceive of the existence of other types of reflective processes. This would require differentiating the notion of enunciation as applicable to various social fields, but also breaking down the notion of metavisuality according to them.

Consider the case of the fashion advertising photograph. Rather than displaying the ways in which it exhibits itself as a photograph (photographic reflection upon photography—a metalinguistic function), one of its major objectives is to show the manner in which it theorizes the *more general functioning of the world of fashion* (reflection of photography upon the field of fashion advertising—a metastatutory function). The latter of course comprises a reflection on the body and on the temporality of the cycles of fashion itself (renewal, the return to tradition, the aura of old days, the construction of the classical…). Photography is also well positioned to account for a reflection on time, given that since its inception, it has problematized the matter of synchronization, that is, the more or less great harmonization between the temporality of the object (or of the event) and the temporality of the shooting. Its mediatic specificity, which is characterized by instantaneity and imprinting, makes it apt for reflection on the matter of fleeting temporality.[36]

4. *Métalangue:* Concerns an image's reflection upon the forces and forms which govern the visual domain as per the functioning of our perception—an example may be found with the previously mentioned case of Paul Klee, who aimed with his theory and painterly practice to constitute a visual *langue* from which the various *paroles*/products would proceed. *Métalangue* also characterizes media visualization which we will explore from the perspective of the frame-within-a-frame, albeit in an entirely different context from what we have seen so far.

The computational visualizations of images we will now examine are images of images. The purpose of calling them "visualizations" is to thoroughly distinguish them from the images which are at their source—and which constitute their objects of study. Indeed, the objects of these visualizations are large corpora of archived images (Big Visual Data) and they pursue a fundamental objective: Analyzing the images by situating them in a measurable and numerically-controlled space. The

[36]These questions have undergone further exploration in Dondero (2014a) and in Basso Fossali & Dondero (2013).

images constituting visualized corpora may comprise paintings, as well as artistic photographs or photographs belonging to other statuses.

Media visualization, as practiced by art historian and computer science specialist Lev Manovich and by the Cultural Analytics Lab,[37] will provide a starting point for studying the particular case that visualization for purposes of image analysis constitutes with respect to contemporary metavisual practice.

It should be noted from the start that the visualizations examined here coincide with a very specific form of scientific analysis, that is, *analysis carried out by means of visual language* as well as by means of mereological strategies of composition/decomposition—this being also the case for the "frames-within a-frame" studied by Stoichita.

As concerns the distinction between metatext, metalanguage, *métalangue*, and metastatutory reflection, the images of images used in media visualization would pertain to what we have called "*métalangue*." All such visualizations encompass several images, which sets them apart from the reflective regime of metatexts. It is also not a matter of metalanguage, given that the analyses by Manovich do not take account of the mediatic specificity of the images. What distinguishes these analytical visualizations is the spatial arrangement of the measurable formal characteristics of the images, these being obtained through an automated analysis which does not account for the substrates of the images or for the applications by which they are established. Consequently, these experiments may be situated as pertaining to the reflective regime of *métalangue*, because the algorithms used by Manovich and the Cultural Analytics Lab seek to organize the corpora by virtue of general criteria of visual perception (and not of medium specificity).

Media visualization as an example of distant reading—or, in other words, of automated and statistical analysis—to be distinguished from close reading (qualitative analysis, conducted "manually"), finds its roots in the works of Moretti (2005, 2013). The latter test the method of distant reading with regards to the development and structure of the system of literary production (worldwide and over the long term). Manovich revisits Moretti's theory and analysis methods in order to transpose them onto image and film corpora, hence the name "media visualization." But it would be a mistake to describe this method of analysis as a simple quantitative method; to the contrary, it aims to recombine the microview afforded by qualitative analysis with the telescopic view afforded by quantitative analysis, in the sense that it is capable of combining the presentation of single images (or of audiovisual documents) in addition to the general view over patterns which may emerge from large sets of images. Conversely to traditional methods for visualizing data, these visualizations have the particularity of presenting and ordering the corpus of images *as it is*—that is, without reducing it to symbols. In other words, the difference with traditional data visualization resides in the fact that in media visualization, collections of images undergo no processes of reduction and abstraction into geometrical figures such as dots, squares, or triangles. As noted by Manovich (2015, 2017), within the

[37]"Cultural analytics" is a methodology for the exploration and analysis of large corpora of images and of various media inspired by visual analytics and by visual data analysis.

digital humanities, images and all sorts of collections and archives of images and audiovisual documents generally undergo a process of abstraction and symbolization in order to be analyzed. This operation of abstraction makes it impossible, for the visualization's observer, to access the original corpus at its basis—thereby also making it impossible to ascertain the visualization's relevance and scientificity. For its part, media visualization does not require sacrificing the corpus for the sake of visualization. The corpus *remains accessible throughout its analysis.* Manovich does not renounce asserting the *corporeality* of each image *as an artifact* all the while shedding light on the corpus' *structure*, that is, upon the *relations* woven between the images constituting a given collection. In short, the objective is to represent the *structure* by showing *all* the elements which constitute it. When, conversely, traditional visualization transforms a corpus into data (numbers, symbols, geometrical figures), it becomes difficult for an observer to *evaluate the relevance and the validity* of the analyses performed and of the structure of the set of data highlighted by the aggregate visualization, because the corpus has been transformed, translated, transposed, and its phenomenology has been reduced. One might even advance the hypothesis according to which media visualization visualizes all visual utterances forming part of a corpus as *artifacts*, and not as *data*, which would lead to speak not of "Big Data," but of "Big Collections of Cultural Objects."

These visual analyzes of image archives add a new perspective to what we have until now called "metavisual" due to their involvement in computational analysis. The metavisual field would, in this case, concern at least two levels:

1. The parameters which serve to organize these image visualizations are indeed visual descriptors (chromatic saturation, luminosity, contour topology, dimensions, etc.); *the organization of the visualization is therefore accomplished by taking account of the visual qualities of the images analyzed;*
2. The automated distribution of the images—and hence their analysis—is directly visualizable by means of a topology governed by abscissa and ordinates. It is a *topological schematization* functioning as a matrix organizing the images of the collection. This topological schematization is a *matrix which organizes the visual characteristics of the images.* In short, metalanguage would not only coincide with the parameters involved in producing the images, but with the very design of the matrix along abscissa and ordinates, that is, it would coincide with the organization which maps the relations between the images.

In the next pages, we will address the visual analyses of Manovich and of the Cultural Analytics Lab according to two perspectives, that is, from a meta-enunciative perspective and from a "mereological" perspective, in order to answer the two following questions: What are the reflection strategies at work in analytical visualizations stemming from media visualization regarding the collections of images they take for object? What is the mereological relation between the final visualization and the multitude of images it contains, filters, and manipulates? How is visualization constructed as a *totality*, as a *global form*, from a collection of millions of images?

Before addressing image visualizations and describing the enunciative and mereological relations between source images and visualizations, it is necessary to briefly consider the issue of the digital materiality of the images forming part of the digital archive.

4.1.4.1 Morphological Dynamics in Digital Images

During their digitization, the painterly or photographic source images, which are at the center of our investigation, undergo a first type of "remediation": They are transformed in their materiality and transposed onto new substrates, these being digital mediums.[38] For Manovich (2001, 2013), digital archives of cultural objects such as images and films are viewed as *sets of virtualities.* These sets of virtualities are identifiable in the databases which, according to Manovich, contain "all expressive possibilities, compositions, emotional states and dynamics, representational and communication techniques, and 'content' actualized in all the works created with a particular combination of certain materials and tools" (2013, p. 226).

In sum, the archive comprises all the items which are the cultural objects having been archived in addition to all the combinations already produced with these objects.[39] Other combinations always remain possible, as demonstrated by several theoreticians among whom Bachimont (2010), who maintains that the only manner to bring life to an archive and to ensure its legacy is to *manipulate* the characteristics of the objects forming it, that is, to recreate works from other works, based on the issues relevant to the present. Stockinger (2015) also stresses the importance

[38]Several researchers have addressed the matter of digital representation as the locus of commensurability between various cultural objects. See for example the article by Lassègue (2013) in which he asserts that: "Digitization consists, as its name indicates, in encoding into digital form [...]. With respect to the physical flow of phenomena, it is a matter of conducting a sampling of measurements which "break down" the object according to a pre-established fixed scale of measurement: For example, an image will be sampled according to a specified length while a sound will be sampled according to a given frequency. In both cases, the digital encoding obtained will have the particularity of *making completely homogeneous the phenomena* which, through perception or interpretation, manifest themselves as being highly different: Nothing distinguishes a series of numbers encoding a length from another sequence of numbers encoding the manner in which to disambiguate two linguistic categories. But from this homogeneity, it follows that any phenomenal order seems a priori able to receive a digital encoding and, from this, discrete representation. [...] [A]ny phenomenon, be it natural or linguistically instituted, may be transposed onto the one-dimensional plane of digital coding which is the writing of numbers. Arithmetic is therefore at the core of digitization" (p. 85–86, our translation and emphasis).

[39]Manovich conceives of databases as the *symbolic form of contemporary culture*, similarly to the role played by perspective in the modern age since the Renaissance (Panofsky). Databases, in his view, would distinguish themselves from the symbolic form of narration which characterized modernity (of the 19th and twentieth centuries). Manovich asserts that databases and narrativity do not have the same status in digital culture: "In new media, the database supports a range of cultural forms which range from direct translation (i.e., a database stays a database) to a form whose logic is the opposite of the logic of the material form itself—a narrative. More precisely, a database can support narrative, but there is nothing in the logic of the medium itself which would foster its generation" (Manovich 2001, p. 201).

of indexing and re-editorializing the texts of the past in view of current research. These two practices lie at the core of our culture's endurance, transmission, and development in any manner.

This type of combination/recombination of old objects so as to make new ones is enabled by the specific characteristics of the archived data and notably by the constitution of their plane of expression. In *The Language of New Media* (2001), Manovich described four characteristics of these objects—*numerical representation*, *modularity*, *automation*, and *variability*—a description which is summarily reproduced and presented here.

1. *Numerical representation*: concerns the fact that each object, for instance an image, is constituted of digital code, meaning that "it can be described formally (mathematically)" (Manovich 2001, p. 49). This implies that these objects are "subject to algorithmic *manipulation*" (ibid.), thanks to the *discretization* of their constitutive elements. For instance, each image may "be described using a mathematical function" (ibid.). Discretization involves two processes: first, *sampling* the image's grid at regular intervals which determine its resolution, the density of its details, and its fitness for manipulation; then, *quantification*, by which an image may be assigned a numerical value "drawn from a defined range (such as 0–255 in the case of an 8-bit greyscale image)" (idem, p. 50). Sampling and quantification prepare these objects for manipulation. It is indeed such availability to manipulation exhibited by the components of each object that is capital in the visualizations by Manovich which we will examine.
2. *Modularity:* concerns "the 'fractal structure of new media'. Just as a fractal has the same structure on different scales, a new media object has the same modular structure throughout" (idem, p. 51). Images may be "represented as collections of discrete samples. These elements arc assembled into larger-scale objects but they continue to maintain their separate identity" (ibid.). This is why it is possible to make new films out of other films and new images from those which are available, as well as from their parts stored independently in digital archives: "In short, a new media object consists from independent parts which, in their turn, consist from smaller independent parts, and so on, up to the level of smallest 'atoms' such as pixels, 3D points or characters" (idem, p. 52). It is the structure of programming languages which allows this fractal organization of data in digital archives.
3. Automation: The numerical coding and the modularity of the objects forming the archive "allow to automate many operations involved in media creation, manipulation, and access. Thus human intentionally can be removed from the creative process, at least in part" (idem, p. 53). It is also possible, thanks to automation, to manipulate image archives so as to obtain images of images.
4. Variability: also stems from the numerical coding and modularity of the objects and more specifically concerns the fact that each object or image "can exist in [*multiple*], potentially infinite, versions" (idem, p. 56). These versions often simply result from the assembling of independently stored elements, obtained by means of algorithmic operations.

One of the consequences of variability is that it is possible to dissociate the data *from the interfaces through which they are accessed*; in other words, to display the database each time using different interfaces. It must also be noted that the principle of variability rests upon the principle of *scalability*, that is, upon the ability of an object to be modified in its order of magnitude. The modules which compose images are indeed flexible and extensible. Each version of the same image may therefore be generated at various sizes or levels of detail.

What does this availability of visual elements to manipulation entail? One could assert that in computation era we are facing a passage from images as *stabilized products* (paintings as the inscription of colors and of lines upon a substrate having recorded a painter's sensorimotricity, for example) to images as *storage areas* enabling the *manipulation* of their constitutive *variables*. Source images such as paintings and photographs undergo a remediation which "decomposes" them into *environments of virtualities*. Within these environments, images may be reactualized and "recomposed," hence analyzed.

The characteristics mentioned by Manovich can help understand the nature of databases, in which each object is apt to undergo computational implementation and hence be subject to a great number of visualizations thanks to the controlled modification of visualization parameters and to the choice of relevant variables. This aptitude favors exploration and experimentation upon collections of images. Manovich explains the notion of image we have chosen to call "environment of virtualities":

> a digital image consists of a number of separate layers, each layer containing particular visual elements [...]. Throughout the production process, artists and designers *manipulate each layer separately*; they also delete layers and add new ones. Keeping each element as a separate layer allows the content and the composition of an image to be changed at any point: deleting a background, substituting one person for another, moving two people closer together, blurring an object, and so on. (2001, p. 202, emphasis added)

This manipulability of layers taken separately can be exploited not only by artists and producers, but also by analysts. The images are decomposed in the sense that they are translated into a set of values and properties which may be visualized separately.[40] What makes this most useful is the fact that the analysis of each image's specific plastic properties is achieved while integrating it within a large corpus. The type of visualization chosen by Manovich makes it possible to organize large corpora of images by means of parameters grouping images according to their properties— among which plastic characteristics such as chromatism, compositional topology, and shapes—and then by organizing them spatially along axes (abscissa and ordinate).

Such positioning reflects the role of an image within its collection. In this type of remediation, each image depends on the collection (or corpus) within which it is involved, because the collection assumes a status of system, of environment—not one which is virtual, but one which is actualized—within which the image finds its place, its new configuration, as a unique image within a collection. Each image's system of reference is therefore not an abstract system, because such system is not based

[40]Concerning this characteristic of separation between layers in the context of image classification by means of tags, see the invaluable article by Boullier and Crépel (2013).

on a perceptually-dependent general grammar such as that formulated by Groupe μ in *Traité du signe visuel*.[41] Here, the grammar is determined by the values of the digitized collection as a whole; it is a system made of *co-texts*, of attested images, in which *commensurability* is guaranteed by the images' numerical values. It is this commensurability which constitutes the system and which makes it possible to conduct analyses using operations such as grouping, distribution, superimposition, etc.

4.1.4.2 *Time* Magazine Covers (2009): Between Forms and Patterns

We shall now look at examples of visualizations considered here to represent acts of disengagement constituting *performances upon archives*, that is, appropriations of the virtualities contained within databases.

The visualizations of images produced by Lev Manovich have a scientific objective and, more specifically, they aim to achieve a diachronic analysis of the corpora, of the archived collections. This may include, for example, analyzing the evolution undergone by a specific pictorial style, the levels of grey exhibited by a collection of mangas taken over several years, the trends in terms of luminous intensity exhibited by an artistic movement, etc.

Let's look at a very significant example of this type of automated analysis, that is, the montage of images depicting 4535 covers of *Time* magazine spanning from 1923 to 2009 and ordered by publication date, enabling us to see changes in design and in style over the course of those seven decades (Fig. 4.8).

These types of visualizations which enable a *distant reading* of the production of an artist, of a designer, or of several designers succeeding one another in time offer a significantly different perspective as compared to the perspectives available to the artist or to the audience at the time of each image's production, in addition to being significantly different from the perspective available to analysts manually conducting a close reading. Admittedly, close reading is incapable of grasping a whole corpus in its entirety or of grasping transformations in their *graduality*. The types of mappings provided by distant reading enable for their part to grasp in a single view the entirety of an artist's production or the entirety of the production by an institution such as *Time* magazine. Such visualizations would reveal a working program which may have been *unconscious* from the part of the designers and which may have gone unnoticed by the successive audiences. Such visualizations highlight the trends which may have not been intentional or premeditated by the designer, and which, for the analyst, are visible only by means of a global and distant view exceeding any local view that may have been afforded to *either* producers *or* audiences. As stated by Pierluigi Basso Fossali (2019), the attention of the artist/designer is always directed towards linguistic and stylistic strategies, whereas what is provided by means of visualizations of large corpora is *an overview of the material substance* of the work—revealing a program or a progression that the artists/designers may have followed unconsciously. In a

[41]Groupe μ (1992).

Fig. 4.8 Manovich and Cultural Analytics Lab. Image montage. *4535 Time Magazine Covers* (1923–2009); Manovich and Douglass (2009)

way, choices made by the producers may reveal themselves only after the fact, when production over a long period is organized over a *same* planar surface. Whereas the view of the producer is always local and devoted to specific enunciative choices, the view over the full range of production taken over an extensive period of time may still appear as somewhat shapeless, requiring that significant patterns be identified.

It is also possible to zoom in and obtain a detailed or microview over a short period, which remains linked to patterns emerging over the long term.

By zooming in, separations may for example be seen between one editorial strategy of *Time* magazine and another, notably relating to the presence or absence on the covers of white borders around the heading. It becomes easy to see that when the white borders disappear from the magazine's layout, the white color temporarily persists in the cover's background, before disappearing for a very long period while giving way to the dominance of the color red. Many other observations of this type are possible from a quick glance upon the area of visualization.

It must also be noted that these visualizations never form immutably stabilized entities, given that the observer may intervene upon them, for example by returning to the source documents of the visualization. The images forming a corpus may vary in their modes of existence over the course of the visualization (be more or less actualized, realized, potentialized, virtualized). Indeed, as already mentioned, the source images forming part of a collection may be viewed in detail. In such case, the montage undergoes a kind of *potentialization*. However, once the collection is viewed as a global montage, thereby *actualizing* the whole, then *patterns* take shape within this whole and a shift occurs in the interactions between the modes of existence: The *shapes* of the patterns *overshadow* the images of the corpus. The pattern shapes are transversal with respect to the source images; they emerge and become *realized*, while the source images are *virtualized*.

By according themselves to the dynamics of the modes of existence, the observation strategies also undergo a process of diversification. In the case of montages, a "cumulative" observation strategy will be favored.[42] The cumulative strategy includes the possibility to peruse the different aspects of the image collection bit by bit, as it develops from left to right before our eyes, so as to arrive at an exhaustive knowledge of the corpus. On the other hand, zooming in entails an observation strategy which may be defined as *particularizing*. The latter can be described as a focalization upon one part of the collection which, by necessity, is neither exemplary nor representative of the whole.

In this kind of visualization, all that matters is the emergence of *patterns*, and such emergence is possible when using unfixed observation settings, shifting between a *cumulative strategy* (a global point of view) and a *particularizing strategy* (a local point of view).

One may thus visualize, on the one hand, the entity formed by the corpus as a whole, via montage, which is given by the collection's chronology, and on the other hand, the parts (the source images) which compose the montage. What spans

[42]This employs the typology of enunciative focalization proposed by Fontanille in several of his works, including Fontanille (1998 and 1999).

Fig. 4.9 Manovich and Cultural Analytics Lab. Slice Visualization. Manipulation of the corpus from Fig. 4.13. Manovich and Douglass (2009)

the whole corpus and its parts are the patterns which themselves construct a new entity, namely, a new shape which, according to Manovich, allows the discovery of something new compared to the understanding that can be gained from each part of the collection taken separately or from small corpora isolated from the continuum of temporal transformations.[43]

The same images forming the collection may also be visualized in a different manner, in order to pursue different objectives, which do not involve diachronic analysis, but other types of analysis, for example in order to detect regularities, returns to previous trends, isolated cases, etc. One of these types of analysis is made possible by means of "slice visualization." In the example below, each cover of *Time* magazine is visualized through a vertical line passing through its center and standing for the average of its chromatic characteristics (Fig. 4.9).

In other visualizations in which the image corpora are classified and grouped according to parameters of brightness and saturation, we can readily see that *the visualization coincides with the analysis*, namely, with the operations of *division*, *classification*, and *clustering* performed upon the corpus. These visualizations no longer function as montages, but indeed as "diagrams of images" (Fig. 4.10).

While the montages sequence the images by standard metadata (by date), the diagrams of images use plastic parameters to perform classification and clustering over the corpus, this constituting in itself a process of analysis (division). Also, it may be hypothesized that these cluster visualizations are metavisual in the sense that the image corpus is arranged over a tabular surface itself organized along abscissa

[43]Concerning the emergence of forms as serving to extend mathematical and artistic knowledge, see Chauviré (2008).

Fig. 4.10 Manovich & Cultural Analytics Lab. 4535 *Time* magazine covers (1923–2009) orga-
nized by *X* axis (date of publication) and Y axis (a combination of brightness and color saturation
measurements of the cover images). Manovich and Douglass (2009)

and ordinate axes according to visual classification parameters (first level of metavi-
sual reflection), and more specifically according to plastic parameters which are not
dependent on standard metadata (second level of metavisual reflection).[44]

The idea that visualization may be used for purposes of image analysis is certainly
not new; Aby Warburg[45] and others had already visualized groups of images over
a same surface in order to gain a better understanding of their mutual relations,
their kinship, and their genealogy. While the idea is not new, what is nevertheless
innovative in Manovich's work is that *the visualization of images coincides with
a quantitative analysis* achieved by statistical and computational means over *large*
corpora which are difficult to study "manually."

Such analysis is to be understood as the result of mereological operations of
division, grouping, superimposition, etc. Organized into a diagram, the images that
share the same features will be located in the same areas of the diagram; the ones that
do not will be placed in opposite areas. The position of each image within a group of
images offers a precise characterization of its plastic properties and puts them into
relation with the qualities of other groups of images, the spatial representation of the
measurements of the intensity of each classification parameter being governed by
abscissa and ordinate axes.

This type of analysis makes it possible to study images *through* their plastic char-
acteristics, namely, their chromatic, eidetic, and topological categories. During the
analysis, the image is in a way *broken down into its qualities*, which are all *made
independent* from one another in the digital environment. As stated earlier, there
is a passage from the image as a *stabilized product* to the image as an environ-
ment in which to manipulate its constitutive *variables*. And these variables have
an autonomous existence, since parameters such as saturation or brightness may be
assessed independently from one another for each image; this stems from producing
visualizations by means of an automated decomposition of source images into their
plastic characteristics.

[44]For a comparison between metavisual theory in semiotics and the use of metavisual devices in
Manovich's research, see Dondero (2019).

[45]Concerning the relations between the works of Warburg and those of Manovich, see Hristova
(2016). For a computational analysis reviewing Warburg's panels and, more specifically, the gestures
characterizing the pathos formula, see Impett and Moretti (2017). Thanks to Virginia Kuhn for
bringing this work to my attention.

During its process of decomposition, the image loses its formal compactness and becomes *calculable matter*, thereby enabling its analysis. In the resulting visualization, the image acquires another "form"—one which puts it into structural relation with the corpus of which it forms part.

As previously indicated, the visualization which we call "montage" uses only standard metadata to organize the images (publication date, etc.). In archival practices, and, more specifically, in practices of table indexing, one may use the date of production, the city, the name of the author, and other metadata which are entirely contextual, that is, which are exclusively "external" to the image's own characteristics. In the visualizations we have called "diagrams of images," in contrast, the image collection is not exclusively organized on the basis of image metadata, but also through the *extraction of the plastic characteristics of the images* ("feature extraction processes").[46] As Manovich explains in several of his studies, traditional indexation strategies using metadata presents the inconvenient of *adding* features external to the images, whereas *extracting* plastic features from the images is a process that remains true to the composition of the images themselves, without resorting to lexicalizations of the image's features.[47] It is also for this reason that we have deemed this strategy to be "metavisual."

4.1.4.3 Visualizing van Gogh's Paintings

In other diagrams of images, for instance in those which Manovich calls the "style space" of a painter, the relation between whole and parts differs, as do the strategies of observation involved. In the two visualizations which compare Van Gogh's Arlesian production with his Parisian production (Figs. 4.11a, b), two plastic variables, luminosity and saturation, are mapped over the global space formed by the *virtual* pictorial activity.

These two visualizations represent Van Gogh's production during his Parisian period and during his Arlesian period, respectively.

After being measured, the images' features were used to position the images so as to map their mutual relations in terms of the selected parameters: As with all diagrams in media visualization, the images which exhibit the highest level of resemblance to one another are clustered within a same area, away from the images which do not resemble them.

[46]On this matter, see Nixon and Aguado (2012).

[47]Indexing images solely by means of lexicalizations and standard metadata is inadequate for the study of images in their own language, which is constituted of plastic contrasts (chromatism, topology, formal composition) and of mereological relations of composition. Such opposition between standard metadata and visual descriptors, transposed to the history of semiology and semiotics, would be equivalent to the opposition between the 1960 s' Barthesian approach to the image (based on lexicalization) and the 1980 s' approach of Greimas and Floch (based on differential and semi-symbolic relations). In this respect, see Colas-Blaise and Dondero (2017) and Dondero (2017b).

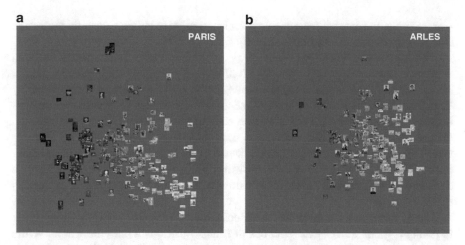

Fig. 4.11 a, b Manovich and Cultural Analytics Lab. Comparison of the paintings produced by Van Gogh in Paris (left) and Arles (right) with respect to brightness and to saturation. *X*-axis: brightness average; *Y*-axis: saturation average. Manovich (2011)

Whereas the *Time* magazine montage examined earlier shows a *bounded* and *exhaustive set*, the two visualizations of Van Gogh's production form a set having for field of relevance the painterly production of the time (system of virtualities/*langue*), among which Van Gogh's production occupies a limited extent (productions/*paroles*). Although this visualization indeed depicts a totality (all paintings produced by Van Gogh in Paris and in Arles), it also comprises an area exceeding the case under study (the outer space of *possible* painterly production). These visualizations do not display a set "in isolation" as would a montage, but rather show its elements (the paintings forming the set) and their aggregations against an *empty* space (the grey background).

This empty space is also relevant for analysis because it is populated with virtual paintings; it is a space *which could have been occupied*. The background space therefore constitutes a virtualized presence. For example, if we look towards the lower right area of the second visualization (Arlesian period), we see an empty space which could have been occupied by more luminous paintings, paintings which Van Gogh indeed never produced.

With respect to the schematization proposed by Fontanille in *Sémiotique et littérature* (1999) regarding the various strategies of observation, these visualizations are governed by observation patterns which differ from those seen with the montages which we examined earlier. It is not a matter of traversing the object bit by bit in order to achieve exhaustivity, but rather of positioning the works in a manner which is *visually motivated and justified* within the visualization. What is at work here is an *englobing* strategy aiming to construct *coherent sets* within the corpus by operations of clustering and classification. It is the distribution of the images according to exclusively visual descriptors (in this case, brightness and saturation) which allows us to speak of a *visually motivated disposition:* Had the descriptors been standard

(for example, the date), it would have been impossible to obtain a visually motivated disposition of the parts within the totality.

This englobing visualization strategy organizes the corpus into a diagram exhibiting the relations between the paintings that were actually produced and the virtual ones. When zooming in, this strategy gives way to another one which may be called *elective*—in contrast to the *particularizing* strategy seen with montages— because it is possible to focus attention on images or parts *selected* beforehand, guided by the *position* they occupy as determined by the operations of distribution. Thanks to the englobing strategy, the observer may approach each image with *advance* information regarding it, because the distribution operations give each image a place within a network that explicitly directs the focus of the observer during his or her exploration.

The *selective* approach targets a specific image or zone. The precision of the targeting is guaranteed by the network of image positions within the whole. While montages are characterized by a particularizing perspective, albeit one which is somewhat "myopic," the selective approach is already directed towards a specific objective thanks to the visually motivated global configuration of the whole of the corpus.

The four strategies of observation identified while studying diagrams and montages of images (cumulative and encompassing when assuming a global perspective, particularizing and elective when assuming a local perspective by zooming in) show two fundamental trends in our relationship to images. *Control and monitoring approaches* predominate in the two cumulative and encompassing strategies used to grasp the whole, whereas *penetrative* approaches prevail in particularizing and elective strategies.

These two types of approaches were also revealed by Basso Fossali (2019) to be operational within screen culture. In his view, the screen fulfills two antagonistic "dreams": The dream of penetrating the image, of merging with it, and of incorporating it, and the dream of scrutinizing the world from a detached, omniscient perspective, using an autonomous interface affording total control and entailing a duplication of the world. In other words, a fusional desire which conceives of the image as a prosthesis, as opposed to a desire to monitor and to control, using a visualization that functions as an anonymizing interface:

> The screen provides the mechanism that can articulate/incorporate these two traditional dreams, although the viewing syntax supported by it is even broader and *more complete*. Indeed, in screen culture there is a push to surpass these two mythical imaginary projections in order to explore viewing systems that can alternate or blend completely opposed viewing conditions: a *contemplation* constrained to at most a frame or a detail, versus *unfixed observation* in which the sole advantage is the ability to amass insights. (p. 9–10, emphasis added)

4.1.4.4 Indexation of Instagram Photos in "144 H in Kiev"

Finally, we will examine a third and last case which shows the relation between visualization and image indexation using tags, that is, a corpus comprised of photographs shared over Instagram during the Maidan Revolution, in Kiev, in February 2014.

In their article "The Exceptional and the Everyday: 144 h in Kiev," Manovich and his art history and computer science colleagues (Manovich et al. 2014) noted two fundamental characteristics of historical journalism: (1) the events are presented from a distant view; and (2) such view of the events is usually assembled and interpreted by a single scholar. In contrast, Manovich and his colleagues proposed to distance themselves from this approach and instead use social media sites such as Instagram in order to present and compare several thousands of individual experiences of a same event. In a way, what they offer is a *distant view of individual views*, that is, a distant view upon what was unique to each personal experience, which is also a way of combining distant/quantitative viewing with close/qualitative viewing. There is a second advantage to their approach: It became possible to show the contrast between representations of exceptional events and representations of daily life, as well as between events which took place in the central parts of the city and in its periphery—something not assured through coverage by a single journalist or researcher.

In order to collect all the photographs shared on Instagram during the Maidan Revolution, Manovich and his colleagues used the Instagram API, a set of software libraries, as data access tools. They collected 13,208 geo-coded images shared by 6165 Instagram users in the central part of Kiev between February 17 and February 22, 2014. They used their own custom software tools to analyze the images along with upload dates and times, geolocations, and tags, in order to produce visualizations by means of various techniques. The images had been tagged using 5845 unique tags. In order to reveal the unique character of these days of the revolution, the researchers also downloaded images from periods characterized by a return to normal, from February 24 to mid-May 2014.

In their article, they explain that the information on Kiev's Maidan Revolution was reported by the international media in a manner that was rather conventional and predictable, showing only what was happening in Independence Square. In contrast, the authors determined the whole downtown area to constitute the relevant locus for their investigation, which of course includes Independence Square, but without excluding other nearby streets and squares. The photographs of the events pertaining to the revolution itself (burning cars and buildings, protest demonstrations) are accompanied by photos of normal events and places from daily life (selfies and parties, in particular), which explains the project's title, *The Exceptional and the Everyday*. The presence of photographs unrelated to the events of the revolution enabled to chronicle how the everyday and the exceptional can coexist within the photographs and experience of thousands of Instagram users.

At first glance, the full montage reveals six "waves," following the alternation between photographs taken at night and those taken during the day (Fig. 4.12). The images are organized by the date and time at which they were shared (from top to

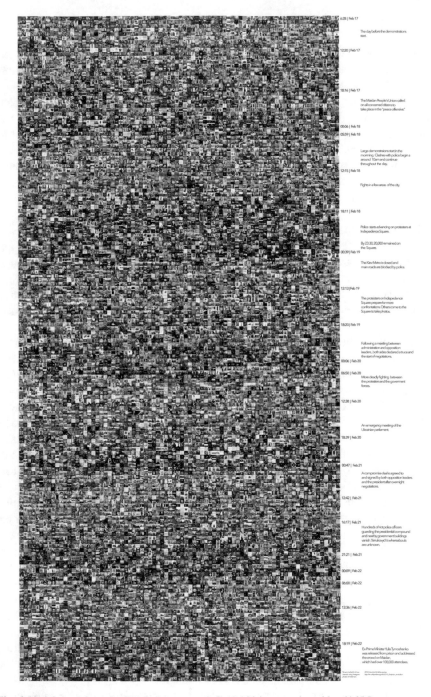

Fig. 4.12 Manovich et al. (2014). Montage of all 13,208 images shared by 6165 Instagram users in the central part of Kyiv during February 17–22, 2014

bottom and from left to right). A brief summary of the events of the 2014 Ukrainian Revolution was added in the right part of the figure.

Manovich presents other visualizations of the photographs organized into montages not by date of sharing, but by hashtags such as: #маˇйдан, #maidan, #euromaidan, #євромаˇйдан (in Ukrainian) or #евромаˇйдан (in Russian), #euromaydan, #Euromaidan. Euromaidan is the name of the revolutionary movement.

The montage arranged by hashtags reveals that many images using the hashtags linked to the revolutionary movement do not show revolutionary events. According to Manovich, this should not be considered to be insignificant as far as understanding the revolution is concerned. These montages also reveal the reverse trend, namely, that many images not using tags connected to the revolution do show the events which took place at Independence Square.

Furthermore, many photos are referenced with multiple tags, which amplifies their significance, because they may be serially visualized. If an image has two tags, for instance "euromaiden" in both English and Ukrainian, it will be visualized twice; its significance will hence be greater than an image tagged exclusively with "euromaiden" in Ukrainian, which will be present in the montage as a single image. This observation raises a question: Why are some images addressed to multiple linguistic communities while others are addressed to only one? This is where a qualitative semiotic analysis may contribute, notably in order to answer a more specific question: Are there some images which are more straightforward than others, images that can be more readily understood by the international community? How may a figurative and plastic analysis be used to account for this difference between images destined to have a local impact (in the Ukraine) and images destined to have a global impact (addressed to the international English-speaking community)?

Manovich and his colleagues did not limit themselves to image visualizations using standard metadata and hashtags, however. They also produced visualizations based solely on plastic parameters, which led them to a complete rearrangement of the image archive. To this end, they had recourse to computational analyses geared towards the identification of "clusters" enabling them to identify groups of photographs having the characteristic of including both a light area and a darker one.

Figure 4.13 shows that some landscape photographs have been altered using Instagram filters so as to make their colors resemble those of the Ukrainian flag; although one may have deemed them at first glance to be unrelated to the events, their inclusion within the cluster helps reveal their links to the revolution.

Compared to the image montages examined so far, the above one displays a hybrid strategy: It is indeed an image montage, but one which was obtained via cluster analysis, that is, via an analysis conducted not only by means of an exclusive use of standard metadata, but also by the extraction of the images' plastic features, the latter usually being characteristic of diagrams of images rather than of montages.

Montages reveal patterns, whereas diagrams of images may serve to show image groupings. These two analytical strategies, the montage and the diagram, make it possible to discover new combinations, differences, and new relations between images belonging to a same set.

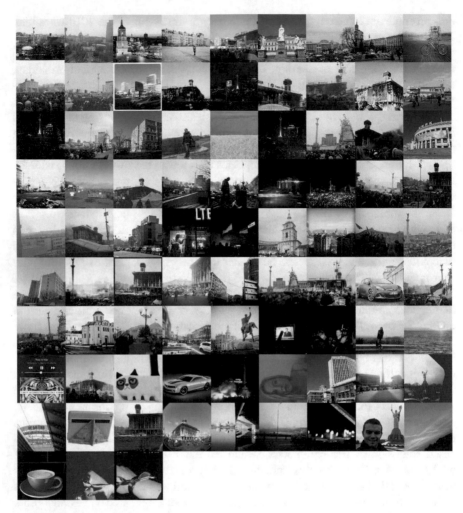

Fig. 4.13 Image montage. One among the 60 clusters identified by application of cluster analysis to the image set. Manovich et al. (2014)

The overview of these montages is capable of revealing other forms than those constituted by the images belonging to the collection. These other forms are constituted of patterns, and they provide a *view through and across* the montage and its constituent parts; in short, these are forms which traverse the whole and the parts. In the example here, the analysis is conducted via an operation of division followed by a process of recomposition that gradually filters in among the parts of the collection. These transversal forms are the result of an oscillation between the general overview and particular, local views and, more specifically, between one mode of existence

and another for both the collection as a set and for the images taken individually.[48] This back-and-forth between generalization and particularization is what makes the transversal view provided by the patterns possible.

The diagram of images, rather than giving rise to transversal forms, produces clusters within which the images may be positioned with great distance to one another (due to their highly different styles or plastic qualities) or be partly superimposed (being comparable in terms of plastic composition).

Generally speaking, Manovich and his colleagues employ "cross-parameterization," understood here as the cross-mapping of several analyses obtained through various manners of parameterizing the collection. While cross-parameterization is able to successfully characterize the signature of a unique image thanks to measurements in terms of intensity and extent as regards each plastic category involved, it cannot be expected to reveal an image's signification, as would the semi-symbolic analyses produced in semiotics over the course of the last few decades. While semi-symbolism can still play some part in quantitative approaches to analyzing large corpora, the connection between expression and content cannot be reduced to a relation occurring in one single image or among a small group of images. In this context, semi-symbolism would rather take the form of considering a group of images that share, on the plane of expression, for instance a same level of brightness and of chromatic saturation, in contrast to another group that has the opposite features. As regards the plane of content, it would be a matter of examining oppositions based not on general categories (such as life/death or nature/culture), but on categories specific to the world of images (genre, style, type of perspective and of enunciative strategy, etc.).

In short, diagrams provide a mapping of the field of images selected as object of analysis. Such mapping should be viewed as an extension through which it becomes possible to identify contrasting areas or superimpositions on the plane of expression. Tests should then be run to see whether these oppositions reflect any thematic or generic constants on the plane of content, which would enable us to see and understand if images sharing the same characteristics on the plane of expression are more or less homogenous on the plane of content.

In this sense, the type of meaning which can be uncovered involves a reflection solely pertaining to the world of images, or to metavisual signification,[49] and not to the universal or mythical significations[50] to which classical semi-symbolism has habituated us. This signification is namely accessible thanks to the design of the visualizations, which enables global as well as local views upon the collections: The perception of transversal forms (patterns) in the case of montages, and the perception of *relations of relations* in the case of diagrams of images.[51]

[48] See Dondero (2017a).

[49] It must be kept in mind that, in the diagram of images, the classification parameters pertain to the plastic dimension, and the results of these classifications are visualizations.

[50] See in this respect the critique by Basso Fossali (2018–2019).

[51] On the work by Manovich and the notion of diagram, see Dondero (2017c).

Against the potential criticism of Manovich's lack of content analysis, i.e. that he confines his work to exploring the quantifiable, superficial qualities of the images' planes of expression, it appears that he supplies a structuralist defense. Even when it is a matter for Manovich of obtaining an image's signature by cross-parameterization, his objective is not to impose a semantic reading of the image—whose signification is in any case bound to be abstract if the image is isolated from its collection. Instead, he seeks to show the place occupied by the image with respect to a context formed by a time period, a study, a corporate ad campaign, or a testimonial, for example. With Manovich's approach, we are invited to explore vast collections of images where a multitude of parameters intersect so as to allow the singularity of an image to emerge from a corpus, rather than to achieve its semantic stabilization.

4.1.5 Media Visualization in Light of the Heritage of Focillon and Warburg's Work Seen Through the Lens of Digital Art History

Foreword

The media visualization project is capable of analyzing large collections of images through visualizations revealing the evolution of a painter's production over time and of comparing the trajectories of several painters from a diachronic point of view.[52]

In these automatic visualizations, one may easily recognize the heritage of the panels of images by Aby Warburg, published in the *Atlas Mnemosyne* in 1924–1929 (2012),[53] these being the first attempts to visualize images on the basis of the similarities between their forms and of their inherent dynamics. These panels represented a first attempt to understand the influence of images on images, even unconscious influences, through a visual medium, the panel providing a surface helping to understand the graduated relation between visually close and distant images.

The following section will examine the research project regarding the genealogy of forms as it was conceived of in the work of Aby Warburg, in particular in the *Atlas Mnemosyne*, as well as in the book *The Life of Forms in Art* by Henri Focillon, published in French in 1934 (1992). These projects were left unfinished due to the difficulty in detecting patterns throughout very large corpora obtained from museums and collections which were both dispersed and disparate (in terms of covered periods and media). The digitization of works of art, the availability of online databases, and the computer processing of large corpora of images now make such projects technically feasible, notably thanks to convolutional neural networks (CNNs) (Le Cun et al. 2015).

[52] See for instance the visualizations of the works by Rothko and by Mondrian here: http://lab.sof twarestudies.com/2011/06/mondrian-vs-rothko-footprints-and.html.

[53] See Hristova (2016) regarding the possibility of testing by computational means the choice of similarities operated by Warburg in his panels.

4.1.5.1 Focillon and Warburg's Intellectual Projects Concerning the Genealogy of Forms

There is much benefit to returning to fundamental knowledge developed in art history, particularly in works on the genealogy of forms, in order to try to develop the automatic analysis of large image collections. Returning to the work of Warburg and Focillon on forms imposes itself for at least two reasons:

1. First, to respond to the largely justified criticisms voiced by several researchers in media studies (for instance Hall (2013)) and in art history (for instance Bishop (2018)) regarding the current state of research in digital art history and in the digital humanities. These criticisms concern the precedence of *methodology over theory*, as well as the precedence of *mechanical positivism over critical thinking*.[54]
2. Second, a return to the fundamental texts by Focillon and Warburg should be made because they may be useful in problematizing the work devoted to visual similarities in the field of machine learning and in complexifying it.

Both Focillon's and Warburg's work put forth a *biological conception of forms*, in addition to sharing a vision of the succession of forms over time. The first important notion that Focillon and Warburg have examined is the *interval* between the manifestation of one form and the manifestation of another which takes that form and transforms it.[55] Concerning the interval, Focillon states that:

> It is not sufficient to know simply that events follow one upon the other; what is important is that they follow *at stated intervals*. And these intervals themselves authorize not only the classification of events, but even (with, of course, certain restrictions) the interpretation of them. The relationship between two facts in time differs according to the distance that separates them; it is somewhat analogous to the relationship of objects in space and in light, to their relative sizes and to the projection of their shadows (Focillon 1992, p. 138).

What Focillon in *The Life of Forms in Art* generically calls "metamorphosis," Warburg more technically calls a process of "depolarization" and "repolarization."[56] For Warburg, who aims to construct an "iconology of the interval," the interval is charged with energy ready to be released and repolarized.

Another similarity between Warburg's and Focillon's thinking includes the conception of *conflict* and the notion of the *stratification of forms* from different times within the same period of history. Aby Warburg identifies active conflicts within the Renaissance style, marked by the coexistence of both mathematical and Dionysian thinking (consider the widespread figure of the nymph, for example). Focillon is very close to this idea, particularly when he states that history is to be understood as an "overlapping of widely extended presents" (p. 84). This means that for Focillon,

[54]For a more complex and balanced overview on digital tools and art history, see Drucker (2013).

[55]Regarding Warburg and the notion of interval, see Agamben (1999).

[56]Comparatively to Focillon, Warburg has a more marked interest for the semantic transformation of recurring ancient forms. On the depolarization and repolarization of dynamograms, see Hagelstein (2009).

too, *heterogeneous formal and semantic characteristics* can coexist within the same style at the same point in history. This also means that both Focillon and Warburg consider that it is possible for the parts of an image *to not be synchronous.*

Furthermore, both researchers had worked on the *latent effects of forms.* On this matter, one of the most suggestive sentences of *The Life of Forms in Art* describes the emergence of one form from another, and it does so while having recourse to the notion of "*aura*":

> For form is surrounded by a certain *aura*: although it is our most strict definition of space, it also suggests to us the existence of other forms. It prolongs and diffuses itself throughout our dreams and fancies: we regard it as it were, a *kind of fissure* through which *crowds of images aspiring to birth* may be introduced into some indefinite realm—a realm which is neither that of physical extent nor that of pure thought. (p. 34, emphasis added)

The tension between the evidence, the uniqueness, and the realization of a totality embodied by a work of art and its purpose to generate other images via the aura it creates all around it raises the question of the sketch which preceded it, a question appearing to have been somewhat neglected by current digital art history. The sketch draws attention to the fact that each work of art must be studied through the *formal movements that prepared it. This is why an image's final version constitutes only one of the possible perspectives for investigation.* It would be necessary to take into account the oscillations that occurred in the sketches having prepared it.

Contrary to digital art history, contemporary modeling in technical art history led by Marco Cardinali is committed to the study of gradual changes between one sketch and another by reconstructing hesitations, pentimento stratigraphy, and the progressive realization of uncertain forms.

A recent paper by Cardinali (2019) shows, thanks to X-ray images, a series of pentimento in Caravaggio's *Calling of Saint Matthew* (1559–1660). The purpose of modeling these types of trajectories of forms is to present the *forms* to computer vision and to pattern recognition as a *variable tension between contrasting/opposing forms*—and not as something stable and steady.

In relation to opposing and contrasting forms inside a single painting, an illuminating example may be found in the paintings by Bacon, as Deleuze stated in his seminal book *Francis Bacon: The Logic of Sensation.* Bacon's paintings are constructed on the basis of forces of restriction and diffusion, on figures that extend beyond their frame and which, through acrobatics of sorts, are absorbed by devices such as sinks, toilets, or umbrellas. Some other paintings stage forces allowing the body to explode, and the figures are always caught in a conflict between restraining forces signified by geometric figures and explosive and dissipative forces.[57]

Whereas Deleuze (2003) is devoted to studying forces inside one painting or inside a triptych among Bacon's works, Focillon's and Warburg's idea about the tensions of forms also concerns the relations of forces *between* paintings. In a paper

[57]The conception of form in Deleuze (2003) is very close to the fundamental idea of the tensive model by Zilberberg in French semiotics: The oppositions are always gradual, and in order to measure and study the entire *spectrum* of a category, we need two concepts: intensity (qualitative characteristics of discourse) and extension (quantitative characteristics of discourse).

entitled "Aby Warburg and the Nameless Science" (1999), Giorgio Agamben examines Warburg's conception of the transmission and survival of forms. Agamben in fact describes memory as the ability *to react to an event over a variable period of time* (the aforementioned *interval*). The trace left by the event constitutes a potential energy which is stored and which may be reactivated and discharged. In images too, this energy is preserved, and may then be selected according to the wishes of the various succeeding periods: This may for instance result in the revival of a motif, for example a motif from Renaissance paganism. In other words, images are considered to be *dynamograms*, which are forms having *recorded* a dynamic force. The aesthetics of dynamograms which Warburg aims to establish can be described through three phases of a process explaining the survival of the patterns: polarization, depolarization (or disconnection), and repolarization. It is the contact with the new era that allows polarization, which can change or even totally reverse the original meaning of the symbol.

While digital art history looks for similarities and repetitions of motifs in collections of images, what Warburg was looking for was the survival of *forces, not motifs,* namely types of *energies condensed in images of the past that would otherwise have been polarized in more recent images.* The following assertion by Georges Didi-Huberman says a lot about the question of motifs:

> Iconography can be organized into motifs, even types—but the Pathos Formula (*Pathosformeln*), on the other hand, define a field that Warburg thought was strictly *trans-iconographic.* (Didi-Huberman 2001, p. 145, emphasis added)

4.1.5.2 Focillon and the Notion of Technique

Matter imposes its own form upon form

(Focillon 1992, p. 96).

As regards the transformation of forms, consideration must be given to Focillon's idea of form because it allows one to focus on fundamental characteristics of the image that are not sufficiently or even at all taken into account by computational analysis, especially in what concerns the technique applied during the production process.

One of the weaknesses detectable in the practices of current automatic image analysis is precisely the *lack of attention to the resonance of forms with the medium that supports them.* At present, analyses of the visual similarities of images obtained by computational instruments are carried out mainly in two ways:

1. By using only feature extraction: The main shortcoming of feature extraction used alone is that the similarities between the shapes that are identified by the algorithms are neither historically nor technically relevant;
2. Through the combination of a first classification by means of standard metadata (production date, author, genre) and a later classification based on feature extraction and grouping images according to their plastic characteristics (color, light intensity, shape of the contour, etc.).

As already stated, the main flaw of classification by standard metadata is that images are classified according to information *added* to the image, via lexicalizations which do not correspond to the characteristics that identify each image as unique. Nor do the lexicalizations used in the classification of images reflect the characteristics of visual language, namely the forms of organization peculiar to it.[58] Furthermore, the procedure that applies a first filter and operates a first classification via standard metadata may prefigure certain results or may overly restrict the corpus which will be later analyzed by means of feature extraction. The risk is that metadata classification is already influenced too much by stabilized knowledge in art history. This prevents new discoveries and, consequently, a renewal of the categories used in art history or a critical look at them.

In both cases, attention to the characteristics of the image's medium, or even to its technique, is very low in image processing, yet the technique is what matters most in an image, because the form is formed in the material, in the matter.[59] In this respect, Focillon considers technique to result from the dynamics established between the type of tool, the movement of the hand, and the characteristics of the medium. Indeed, each material will have a certain purpose, even a "certain formal vocation,"[60] just as the form will have a "certain material vocation." Such dual vocation is integrated through the gestures of production.

It is necessary to conceive of the shapes represented in an image as the result of forces involved in each of the components mentioned by Focillon. The material substrate, for example, is necessarily characterized by autonomous forces that identify its specificity, such as the physical qualities of wood, plastic, etc. All materials have various characteristics of strength, elasticity, hardness, resistance, etc. that may be considered as forces that will confront other forces, in a more or less conflictual or concordant manner, for example the forces characterizing the gestural rhythm during the act of inscription of lines upon the substrate (see Sect. 3.6).

Does such attention to technique represent a utopia as regards computational analysis due to the difficulty in calculating these contrasting forces? According to Francesca Rose's interview with Johanna Drucker, Anne Helmreich, and Matthew Lincoln, published in French in the *Perspective* journal, the answer is yes:

[58] All things considered, this procedure has the same shortcoming as Roland Barthes' semiology which used the segmentations provided by verbal language to read images—and which has been usefully criticized by Greimasian semiotics. Regarding the critical view upon the categories of art history, see Drucker et al. (2015).

[59] It must also be said, as noted in Benoit Seguin's thesis (2018), that clustering and searching through reproductions of artworks independently of their medium effectively solves a difficult problem of cross-domain image searches. The best solution would be to be able to perform a search in two different ways: the one including the relevance of the medium, the other supporting a cross-domain query.

[60] Regarding the interferences between the various arts which result in crossings and transfers of techniques and materials (consider the relations between oil painting and watercolor in the English school, or the relation between etching and painting in the work of Rembrandt), see Focillon (1992, p. 108). These crossings result in the novel application of certain techniques to materials to which they were not usually applied, for example with etching by painters, water painting, pictorial elements in architecture, etc.

The precision required for certain types of description—for example, the way in which the artist manipulated a particular pigment in a particular part of a painting, and the relationship between this technique and the visual effect produced—brings to mind the spectrum of Jorge Luis Borges' scale 1 map, which is impossible to achieve. (Drucker et al. 2015, p. 32, our translation)

The authors continue:

How to acknowledge or integrate the materiality inherent to an object? It is also a matter of scale, inasmuch as our interaction with the digital substitutes takes place through our screens, search engines, etc. This alters the original visual relation between the object and the person manipulating it. (Drucker et al. 2015, p. 33, our translation)

In what concerns the technical studies of art, the answer to this question will be different. In the words of Cardinali (2019):

This specific connection of [Focillon's] formalism to the emerging field of technical studies has not yet been deeply examined. But Focillon was well aware of the relationship of formalism with technical studies, since he viewed technique as having two meanings: "The word 'technique' has two meanings, which complement and overlap each other: *technique of execution, or technology*, properly speaking, and technique of style, or *morphology*. (Cardinali 2019, p. 63, emphasis added)

Cardinali and his colleagues at the Biblioteca Hertziana in Rome want digital art history to be closer to technical art history. They call for the complexity of each form to be taken into account as if it were always a stratigraphy of forms.

Moreover, by quoting Focillon (1932), Cardinali asserts the following:

The distinct moments in time in the creative process are *inscribed under the surface of a painting*; it is no coincidence that art historian Henri Focillon (1881–1943) assumed this very same point of view: "In a painting, above and beyond what one could call the optic layer, there is a whole infinitesimal depth *not accessible to sight where various artifices are worked out*, whose results are immediately perceived by our eyes without our knowing their hidden sources ... [technique] works in the depths but it works on the surface, because the work of art is at once a trade secret and something evident which is deliberately calculated [...] and complete criticism [...] has to be at the same time, in the real sense of the words, penetrating and superficial". (Cardinali 2019, pp. 62–63, emphasis added)

4.1.5.3 The Contrast Between Art History and Technique-Dependent Analysis

The problem today, in the light of computer science breakthroughs, can be described as follows: While Focillon and Warburg aim to study metamorphosing forms, computational logic works by digitizing or decomposing the whole into measurable or even minimal characteristics.

This is how the procedure is described even in the context of deep learning. As stated by one of the greatest theorists of convolutional neural networks (CNN), Yann Le Cun:

First, in array data such as images, local groups of values are often highly correlated, forming distinctive local motifs that are easily detected. Second, the local statistics of images and other signals are *invariant to location.* In other words, if a motif can appear in one part of the image, it could appear anywhere, hence the idea of units at different locations sharing the same weights and detecting the same pattern in different parts of the array. (Le Cun et al. 2015, p. 439, emphasis added)

The fact that, according to Le Cun et al. (2015), the motifs are considered to be indifferent to their location within a given whole implies that the complexity of the art form is not fully taken into account. What we really need is to describe an entire artwork, which cannot be reduced exclusively to a structure made of separated parts but which, on the contrary, can be characterized precisely as a *composition*—which is a *whole traversed by tensions between forces.*

Admittedly, Le Cun and his colleagues in the aforecited article aim at something other than artwork analysis, which is to name objects in the context of disordered compositions and to automatically produce captions from complex images. One must bear in mind that the identification of objects in an image does not form the objective of the analysis of artistic images,[61] especially as regards the project of the genealogy of forms. The analysis of artistic images cannot be achieved by following the segmentations of the lexicon of natural language or of the figurative object because, as already stated when quoting Warburg, *the meaning of forms is trans-iconographic.*[62]

We have seen that the logic of segmentation and the indifference to the location of a motif contradicts the conception of the image as constituted by contrasting forms. In this sense, the work of philosopher René Thom is very useful because he considers the image to be not a set of isolatable parts but *a composition which emerges from the tension between conflicting centrifugal and centripetal forces.*[63]

In his articles on art and aesthetics, *Local et global dans l'œuvre d'art* (1983), René Thom states that aesthetics deals with the relationship between local and global. The composition of a totality depends on the relationships between the perceptual fragments of a painting and its contours. Thom speaks of radiation, of proliferation, and even of tensions between forces. These contrasting forces make the painting into a *compact* unit.

One of the characteristics of beauty in painting identified by Thom is the *contour effect*. Beauty can be brought to light by the effect of the contour and of the frame, which enables one to identify the *centers of attention that organize perception*—the

[61] Masson and Olesen (2021): "In the SEMIA project, for instance, we not only made prior determinations as to which sensory aspects of the images to focus on; we also had to decide between different approaches to feature extraction. As previously mentioned, the use of a neural net was one of them—but as it turned out, this method was primarily successful in making matches in terms of shape. For such image characteristics as colour, texture and movement, we had to use task-specific algorithms, which turned out to perform better in those cases".

[62] The way of representing the differentiation and succession between images that resemble one another proposed by Kuhn et al. (2012) in their work on video corpora served as inspiration here.

[63] On the relationship between Thom's work and diagrammatical forces in Deleuze's *Francis Bacon: The Logic of Sensation*, see Aa.Vv. (2013).

frame of a painting makes it possible to identify centers within it which are endowed with a certain prominence:

> While looking at a painting (or more generally a plastic work), the mind starts by *grasping its contours*; then, in an effort at analysis, there will be an endeavor to discern, within the centers of the work, subjects carrying a certain *prégnance*.[64] The total space of the work thus finds itself to be separated into partial domains, which are the zones of radiation from a center (or more generally of a local configuration of details taken individually). One could think that this division comes from a kind of proliferation of the contour towards the inside, a proliferation which intensifies when no particular detail captures one's attention... It is essentially the *conflict* of these *prégnances* (...) which will ensure the *unity* of the work of art. (1983, p. 5, our translation)

It is very important to emphasize that the unity of the work of art is ensured by the conflict between contrary forces. It is effectively the contrary forces which entail the compactness of a painting; where there is no conflict, there is no cohesion.

Thom, like Warburg, is also not solely interested in the forces internal to the image, that is, in the forces which develop between the contour and the centers of attention within a two-dimensional surface, but also in the matter of the propagation of the force of the image towards the exterior, towards the corporeality of the observer, for example.

Indeed, according to Thom, beauty is always localized, and it is the contour, or the frame, which enables beauty to emerge. But beauty, which, in order to exist, must be framed, is not necessarily synonymous with boundedness and enclosure—to the contrary because "an art object is the source of an aura of beauty filling its entire surroundings (according to highly subtle laws because the propagation is far from being isotropic)" (p. 5, our translation). He then continues:

> A form, in itself, always entails a mechanical interpretation, a "force field." This force field may be subjective in origin (according to the theory of Harry Blum, form recognition is but the choice of an optimal motor strategy for manually grasping this form); it may be objective, describing the forces which the object may emit or endure. (p. 7, our translation).

What is made relevant here is the relation between the forces within an image and both the motor strategies for apprehending these forces (which Thom calls subjective), as well as what he deems to be objective in origin, that is, the fact that the painterly object receives forces emanating from physical matter, such as light, which it fixes and stabilizes upon a material substrate, and which it then redirects outwards, including towards other images.

In the following section, we will examine the manner in which the question of the establishment of works of art—which may explain the production of forces— was addressed via the instruments of tensive post-Greimasian semiotics, notably by developing upon the Hjelmslevian relation between purport, substance, and form.

[64]TN: As noted by Wolfgang Wildgen, "The term in French 'prégnance' (or even less evident in English'pregnancy') should be understood as a lean-translation with the lexical content of German 'Prägnanz'" (Wildgen 2010, p. 82).

4.1.6 The Techniques of the Substrate

While analyzing the visualizations produced by the Cultural Analytics Lab, we left aside a decisive phenomenon—that of a change in substrate for works produced by the eye and by the hand. These assume in media visualization a status of source images and receive numerical values, which are measurable and quantifiable. The shift from a painterly or silver halide substrate towards a digital medium involves that the image may be manipulated using algorithms which proceed from the discretization of the elements composing it, with each element being capable of being manipulated independently. As stated earlier, such discretization allows for the commensurability of the image with any other image having been previously transposed into digital code. The change in *substrate* therefore entails a change in the image's *constitution* in the sense where the digital encoding causes the image to be *decomposed* into its characteristics, these being selectable in the visualizations serving to analyze it.

These precisions point towards the delicate issue of image substrates, which was only recently addressed in visual semiotics. This issue has also been approached in other fields such as art history as well as visual studies, namely via the distinction between image and picture. According to Mitchell, the former would refer to a composition made of abstract relations, whereas the latter would rather concern a socially relevant technical materiality.[65] From a semiotic point of view, what is usually understood by *image* in the context of visual studies would fall under the domain of the form of expression, whereas the concept of *picture* would be covered by the notion of substance of expression, which had always been overlooked in semiotics. It proves necessary to return to the foundations of visual semiotics in order to understand the origins of these disciplinary choices before proposing remedies to this reduction which we could call "allographic."[66]

4.1.6.1 Form and Substance in Light of the Techniques of Establishment

If we look at the classical schema of Hjelmslev's semiotics (Table 4.1), we see that purport achieves signification *through two distinct forms*, corresponding to the two planes of language constitutive of the semiotic function: the plane of expression and the plane of content.

[65] See in this respect Mitchell (1994, 2005, 2014). The difference between "image" and "picture" lies in the fact that a picture is an image that has been stabilized onto a mediatic substrate. For Mitchell, the medium is conceived of as the set of material practices which associate an image with an object to make it into a picture.

[66] We return here to a concept of Nelson Goodman extensively addressed in other works (Basso Fossali and Dondero 2011; Dondero and Fontanille 2014) and which refers to the allography of notational semiotic systems such as music—which possesses a score and a class of distinct, fixed-value signs—and which however distinguishes itself from autographic systems which value the unicity of the image's substrate and of its syntactic density. The error of semiotics would have been to treat dense images such as paintings as allographic semiotic systems.

Table 4.1 Planes of language constituting the semiotic function

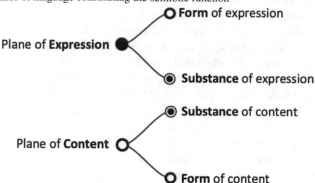

In the framework of visual semiotics, form, both of expression and of content, is described by Jean-Marie Floch as follows: "Form is the *invariant* and *purely relational* organization of a plane articulating *sensible* or *conceptual* matter, thereby entailing signification" (Floch 1985, p. 191, our translation and emphasis).

Floch's table (Table 4.2), taken from his 1985 book *Petites Mythologies de l'œil et de l'esprit: Pour une sémiotique plastique, (Eye on mind; a collection of short mythologies. Towards a theory of plastic semiotics)*, serves as a good starting point for clarifying the architecture of the form and of the substance of expression, as well as that of the form and of the substance of content.

As this table shows, the substance of content concerns the "privileged figurative universes" made relevant by each culture, whereas the form of content concerns the "types of narrative, the grammatical structures," and also, one may add, the discursive genres.

While the form and substance of the content of literary texts have been studied in semiotics since the 1970s, in the case of images, the plane of expression has been explored exclusively from the standpoint of the form of expression, and was

Table 4.2 Planes of language constituting the semiotic function according to Floch. Excerpt from Floch (1985, p. 172)

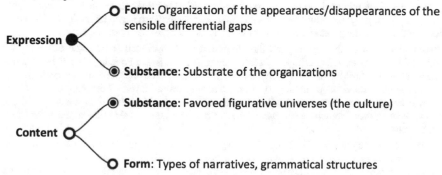

conceived of as a locus for the articulation of differences and oppositions. The theory of plastic language postulated the plane of expression to be a place articulated by eidetic and topological oppositions, as well as by any difference in potential in terms of chromatic or luminous energy. An image's form of expression is traversed by differentiational forces, by the subtraction/addition of luminous forces, by chromatic intensities, etc. While the semiotics of images studied the differential gaps in the form of expression, it only partially and recently addressed the substance of the plane of expression which, as indicated by Floch in the table above, concerns the substrate of the forms—their "consistency," to put it as such.

In other works (Basso Fossali and Dondero 2011), attention was given to the fact that Greimasian semiotics did not take into consideration the substance of the plane of expression, so as to not diverge from its structuralist orientation.[67] In a certain manner, one could say that such lack in the development of the notion of substance was programmatic, or even necessary. Yet, if semiotics avoids taking the substance of expression into account, it will then be condemned to renounce tackling works of art, but not only: It must also renounce accounting for the formation of writings, for example, as well as for any device which may be understood and explained by making relevant the adjustment between a substrate, what is applied to it, and the gestural act of inscription.

Indeed, what the semiotics of images has succeeded in accounting for was the relation between the form of expression and the form of content through the development of semi-symbolic coding which concerns the relation between categorial oppositions on the plane of expression (chromatic, eidetic, and topological categories) and oppositions on the plane of content.[68] This coding left aside the *substrates* of the images, as well as that which accompanies the inscription, that is, the gestural act of *inscribing the forms onto these substrates.*[69]

To mention only an example of this tendency, reference can be made to the analysis of Paul Klee's *Blumen-Mythos* by which Felix Thürlemann (1982) explored the relation between the forms of expression and the forms of content in a systematic manner. He relates all sensible differential gaps to semantic differential gaps while only briefly mentioning in a footnote that this painting by Paul Klee is covered in gauze. Thürlemann asserts in this respect that he cannot take into account that

[67]This lack of attention paid to the substance of expression becomes all the more understandable when considering that literature, which was the first field of study privileged by semiotics, had never been studied from the point of view of writing, or as an *act of recording markings.*

[68]Regarding semi-symbolism, beyond the aforecited work by Floch (1985), see Floch (1986) and (2005). For an excellent critique of semi-symbolism, see Basso Fossali (2018-2019): "Semi-symbolic coding sterilizes the gaps by reducing them to crystallized oppositive homologations. [...] To the contrary, the stakes pertaining to an image having several layers of meaning resides in the internal treatment of a heterogeneity in which the relations begin as events of meaning and not by the recognition of homologies between strata of a same system of semiotic organization" (our translation).

[69]Since the article by Jacques Fontanille "*Décoratif, iconicité et écriture. Geste, rythme et figurativité : à propos de la poterie berbère*" (1998)—which raises the issue of the relation between plastico-figurative markings and the markings of writing—we have called the material which makes this act of inscription possible the "application" (Basso Fossali and Dondero 2011).

which distances itself from topological, chromatic, and eidetic oppositions, that is, the organization of the form—and that the gauze cannot be studied via a system of formal oppositions.

The three aforementioned plastic categories (topological, chromatic, eidetic) which were analyzed by Thürlemann are in our view only a provisional means for shedding some light on a first oppositive organization between zones and sub-zones of the image, but they certainly cannot, by themselves, explain the consistency of these forms (their "cohesiveness"), nor their aesthetics.

Greimasian semiotics left aside the analysis of the modes by which the form of expression was constituted, as if the forms were, in the end, integrated into no substance. For example, when addressing the problem of intermediality and of the transposition of forms from one substrate to another, be it painterly or photographic,[70] the matter of the substrates of the forms could be posed in a decisive manner: In painterly and photographic images, the marking is directly linked to its substrate in the sense that the marking, as an application of writing, manifests through the substrate thanks to its *interpenetration* with the latter. Be it gauze or a wooden canvas, it makes a difference.[71]

In this sense, the substrate, such as, for example, the canvas or the photosensitive paper, is not to be confused with the *ground* of a form or of a figure[72]: The substrate is that which *embodies* the form, it is not something which detaches itself from it in order for the form to emerge, but is indeed something which *supports* the formative act.

It is true that in an image, it is difficult to distinguish the form from the substance because the form is an organization which appears as indissociable from a substrate. In their 1999 article "Sens et temps de la Gestalt (Gestalt theory: critical overview and contemporary relevance)," Rosenthal and Visetti asserted that form is the only configuration transposable to other substrates and to other substances: "the form would be the *invariant*, the product of dynamic relational schemas capable by constitution of operating upon an indefinite variety of environments" (1999, p. 181, our translation and emphasis). This conception perfectly reveals the manner in which semiotics approached the form of expression in images. But Rosenthal and Visetti add something crucial: that these forms "are *each time submitted to specific constraints*" (Rosenthal and Visetti, op. cit., p. 181, our translation and emphasis). These "specific constraints" depend on the substrates of these forms. How may they be studied?

In order to properly understand the matter of the relations between form and substance, consider an example coming from Floch and from his 1986 book *Les Formes de l'empreinte*. Floch asserts that a gouache painting by Matisse and the photograph *Nude No. 53* by Bill Brandt are based on a same aesthetics of cutting/partitioning, upon a same usage of contour lines, and upon a same stiffness and sinuosity in the manner of Egyptian decorations, despite the volumes, the

[70]See Dondero (2009a).

[71]Concerning the relation between matter and the action of the body, and notably of the hand, in the field of artistic creation from a philosophical point of view, see Parret (2018).

[72]Concerning substrates and grounds, see Le Guern (2009).

reliefs, and the compositional balance. But what about the differences between the substance of a gouache painting and of a photograph? Floch says nothing on the matter, given that any reference to the substrate would have thrown into crisis the generative trajectory of the content and consequently also the trajectory leading in the last instance to textualization.[73]

In the 1980s, indeed, visual semiotics had devoted itself to identifying similarities between the forms of expression within various types of images (painterly, sculptural, architectonic, etc.) in order to show that spatially and temporally distant visual productions may share a same underlying organization (the invariant form). This occurred following the reception of the book by Wölfflin (1917) devoted to the classical and baroque forms understood as symbolic forms exceeding temporal boundaries and mediatic distinctions.[74] But it is namely in the field of art, which was the first field of investigation for visual semiotics, that taking the substance of the expression of images into consideration may be deemed useful and necessary. In order to understand the artistic process, it is necessary to take account of the processes of material treatment involved. The "formation" of matter (purport) generates a dialog/conflict between that which organizes and that which is organized, between rules of formation and materials which are subjected to them or which accompany them. It is certainly very difficult to account for the substance because it is "hidden" between the compositional oppositions and differentiations or hidden within the markings: It is, in a certain manner, invisible because it has already been *processed,* but it is indeed the substance, with its semi-invisibility, which gives images their complexity.

At the end of the 1990s, a few works (Fontanille 1998, 2005, Klock-Fontanille 2005) enabled to open Pandora's box and to approach the image as a material object[75]—and not only as an utterance—by distinguishing between formal substrate and material substrate. One must keep in mind that the relation between these substrates is ensured by their having a form applied to them or by the gesture which informs the matter, be it painterly, photographic, or computational.

[73]We are situated within the theory of Jacques Fontanille formulated in *Soma et séma* (2004) in which the division between expression and content and the relation between form and substance depend upon the enunciative instance. This means that what is form from one standpoint can become substance from another. In other words, substance is that which is organized, form is that which organizes. But a form may be in turn organized by another form and thereby become substance from the standpoint of this new form.

[74]A lengthy critique of this transversal view of forms has already been provided in Basso Fossali and Dondero (2011).

[75]Regarding the issue of images as material objects, see one of the most important books in visual anthropology devoted to the matter: Edwards and Hart (2004), which was the object of lengthy comment in Basso Fossali and Dondero (2011).

4.1.6.2 The Relation Between Material and Formal Substrate

In order to present the notion of substrate and namely its two declensions into formal substrate and material substrate, we can look at the case of photography and in particular at the relation between photographs as utterances and photographs as objects—a distinction which corresponds to the aforementioned one between image and picture. Photographs as objects involve the more or less institutionalized practices of production and reception allowing photographs to circulate and become interpretable as utterances.

As previously outlined, the first issue to confront is the fact that the meaning of an image does not solely depend upon a relation between the form of expression and the form of content, according to semi-symbolic coding. It is necessary to address the relation which each utterance, considered to result from an act of writing and of marking (application), maintains with its substrate.[76]

This approach allows us to conceive of the visual utterance not as something already stabilized, but as a set of features which become stabilized over a receptive substrate upon which the image is recorded. It is a perspective which makes relevant the gesture linked to production, be it manual, sensorimotor, or dependent upon software and algorithms. It is only by taking into account the relations between the application of writing (the act of forming the forms) and the substrate (the locus where the forms are inscribed and from which they emerge) that it becomes possible to reconstruct and understand the hierarchy[77] established between the utterances, the objects receiving these utterances (by means of framing, for instance), and the practices which extract, transfer, and reframe them.[78]

Let's take a step to the side regarding this matter. While in semiotics, until the years 2000, utterances were deemed to constitute the only significant and relevant set, being homogeneous and bounded, the works by Fontanille on objects and practices allowed to consider among "signifying sets" not only bounded textualities, but also situations as such. According to Fontanille, a situation may be described as "a *heterogeneous segment of the natural world*, configured by an inscription at the site of an utterance" (Fontanille 2008, p. 22, our translation).

We may now consider for a moment this "*heterogeneous* segment of the natural world." The difficulty in studying utterances, for instance photographic ones, together with the devices of presentation/exposure which value them throughout various practices (museum display cases, printed mediums, screens, etc.), lies in the issue of the heterogeneity among the levels of pertinence of the analysis (the situation being located at the level of "practice" or of "practical scenes"). The schema by Fontanille

[76]See Basso Fossali and Dondero (2011).

[77]On the relation between writing interfaces and substrates, see Zinna (2015).

[78]Some works in information and communication sciences and namely Bonaccorsi (2013) appear to raise the same questions: On the one hand, the image would produce meaning and would function in an autonomous and internal manner; on the other hand, the mediatic regimes of the image's production and circulation would determine its status and value. What happens for instance when an image, following a transfer from one substrate to another or a change in medium, undergoes a change in meaning?

Table 4.3 Levels of pertinence in semiotic analysis. Excerpt from Fontanille (2008, p. 34)

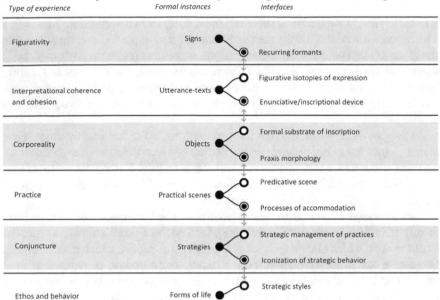

(2008) (Table 4.3) approaches the issue of heterogeneity, notably by illustrating the hierarchization of the analytical levels of text, object, and predicative scene.

Each level of pertinence may be analyzed in a homogeneous manner; the issue however lies in studying one level in relation with other levels. In other words, it is a matter of operating an *ascendant or descendent traversal between different levels*, which involves dealing with heterogeneity or with planes of immanence of which the relations must be examined.

Studying the forms of expression of a photograph (utterance) is something different from studying the functioning of its *presentational device* (object)—which may be, in the case of a photograph, a screen associated with a technology of luminous inscription—and which we could call the *material substrate of the object*, one which may be considered as an intermediate sub-level between the text and the object, and which Fontanille designates, in the preceding table, as an "enunciative/inscriptional device."

If we identify the photochemical paper or the screen as belonging to the category of material substrates, in contrast, understanding the photographic forms as resulting from acts of writing or marking entails that another mediation must also be taken into consideration, that of the *organization* of this writing, which we may call the *formal substrate*. The formal substrate is a true mediator between the application of inscriptions and their receptacle which is the material substrate, as the formal substrate concerns the *rules of inscription* which make relevant not the *technology of the screen* (deemed to constitute a "material substrate"), but another type of substrate, for example, the *format of the screen page*. The notion of formal substrate allows one

to focus on the *disposition of the inscriptions* borne by the material substrate as well as to focus on their organization into a certain size and according to a certain disposition, a certain syntax, a certain type of framing, and following certain proportions with respect to the entirety of the space available. We may therefore assert that the object level constitutes a *structure of reception of the inscriptions* composed of two sub-levels or forms of mediation, which are the formal substrate and the material substrate.

The formal substrate thus functions as a mediation between the material substrate and what is applied to it, a mediation which stems neither from the inscriptions nor from the materiality pertaining to the technology employed, but one which is to be understood as an *adjustment mechanism between the two*. The role of the formal substrate is, in a certain manner, of "domesticating" the material substrate so it may receive the inscriptions.[79] The formal substrate results from a process of *extraction of features* emanating from the material substrate: The material substrate proposes lines of force, that is, substantial tendencies among which the formal substrate sorts and selects; it occults certain properties of the material substrate and selects others.

The formal substrate is the face of the object turned towards the level of the utterance whereas the material substrate is the face of the object turned towards the level of practice. If we place ourselves at the object's level of pertinence, the two substrates, formal and material, work in the manner of form and substance: what functions as substance at the utterance level is the form at the object level and so on for the successive levels.

The case of photography in what concerns its formal substrate and material substrate having been addressed elsewhere (Basso Fossali and Dondero 2011), let's now examine in more detail the case of digital images.

4.1.6.3 Materiality in Digital Images

As already outlined in 3.5, an image understood as a "writing of forms" is subject to modifications depending upon the software and environment through which it is manifested (formal substrate), a functioning enabling it to be edited, transformed, decomposed, and enhanced.

At the initial stage of its manifestation, the digital image presents itself in the form of digital code and it is only at the moment of the code's execution that a graphical rendering is produced. Moreover, this digital code may be executed in a manner which varies in accordance with the different conditions imposed by the formal substrate.

What is common to all digital images is that they may participate in multiple modes of existence (actualized, realized, potentialized, and virtualized)[80] depending

[79]The substrate receiving the inscriptions can only be configured by means of a certain number of operations applied to the material object, operations which form part of a praxis (gesturality, technique, etc.) of which the greater or lesser sophistication is proportional to the gap which separates the material object from the inscription and from the relevant properties of the formal substrate.

[80]For a semiotic approach to the modes of existence, see Fontanille (1998) and in particular the chapter "*Énonciation.*"

on whether they are realized, in the sense of being set and printed onto paper, or actualized when displayed on a screen according to a certain refresh rate—which makes them instable and manipulable—or whether they are potentialized in the sense where their organization may integrate a reservoir of virtualities for the production of new images.

What interests us now is the mode of existence of actualization, achieved when the image is displayed upon one of its material substrates, that is, the screen constituted of a raster grid. In this respect, in his article *"Du support matériel au support formel"* (2005), Fontanille addressed the case of the digital from the standpoint of writing and of substrates. He asserts that it is not sufficient to identify the digital file as a material substrate and to distinguish it from the screen page understood as a formal substrate. The distinction is actually more subtle:

> In the case of the digital file, there is not on one side an electronic material substrate and on the other a formal visual substrate, but indeed two distinct and *complete* writing devices. On the one hand, the "internal" and imperceptible mode of existence, which comprises both a material substrate (physical and electrical) and a formal substrate (the digital coding) which governs the rules of inscription and interpretation of the signals by the machine; on the other hand, the "external" and perceptible mode of existence, through the graphical interface, comprises both a material substrate (a monitor and the technology of luminous display), and a formal substrate (that of the "screen page"). (Fontanille 2005, p. 8, our translation)

The formal substrate is the set of topological rules of orientation, of sizing, of proportion, and of segmentation which will constrain and make significant the features constituting any kind of application of writing—be it a matter of writing with light such as in photography, or of sensomotorial writing such as in painting. In the case of digital images, one may conceive of a first formal substrate, the digital code, in relation with a second formal substrate, the schematic organization of the screen page. The latter may be conceived to be the formal substrate of the visualized object, one which is regulated by the other formal substrate stratified within the digital image which is the code. It is obvious that in the case of the digital image, two formal substrates are superimposed.

Let's now consider the example of a photograph (as a writing of light) first imprinted upon a substrate made of paper (realization) and later displayed on a screen (actualization) after being digitized. Silver halide photography, for example, first takes the form of a writing of light upon a material substrate, the photochemical paper. This inscription of light is achieved thanks to the mediation of a formal substrate which may be identified as a diagrammatic schema determining the adjustment of light and dark areas, of colors, of their saturation, of their framing.

If we think about the mediatic circulation of such photograph, and consider it to be first stored on a digital memory card (virtualization) and then displayed on a screen showing a web page (actualization), it will function, in turn and in its integrality, as a simultaneous application of writing via both the material substrate which is the physical screen and another substrate, the one which determines its organization and which functions as a formal substrate: the topological disposition of the screen page. Through this passage, we see that the photograph as a complete and independent object (the writing of light onto a paper substrate) undergoes mediatic integration via another formal substrate (the screen page). Furthermore, we could assert that

the formal substrate is endowed with its own topological properties on the plane of expression and with its own praxeological properties on the plane of content.

The formal substrate indeed stems from the rules by which the photograph is stabilized as an application of writing onto a screen page in view of future usage practices, the latter being inflected by the set of selections and determinations cumulated all along the trajectory spanning from the writing of light onto the photochemical paper to the rules of the formal substrate which is the screen page. We thus find, in the mediation of these two types of substrates, on the one hand, a link with the technical specificity of each visual utterance and, on the other hand, a link with the usage practices of which the potential is contained in the formal substrate.

In the passing from the *qualities* of the material substrate to the *rules* of the formal substrate, the possible usages of these visual utterances undergo a sorting operation, one by which relevant practices are selected to the detriment of other practices that are not supported by the given substrates. It stems from this that the three actants we have identified—the inscription as an application, the formal substrate, and the material substrate—enable a multiplication of the points of view at the level of the utterance, to the point of dissolving the illusion of homogeneity and of staticity produced by the latter. The dynamics of the strata of the plane of expression which characterize each image also enable us to observe that in passing from the utterance level to the object level, a process of sorting and selection paves the way for various types of usage and interpretation practices[81]. The generative trajectory of the expression of digital images has been reinterpreted in collaboration with Everardo Reyes (Dondero and Reyes 2016) into the following schema (Table 4.4).

This table makes it possible to specify the stratification of the components of the digital image within the generative trajectory. At the object level, we suppose that the formal substrate of actualized digital images is identifiable in the grid of pixels favoring the forms managed by the computer programs. This grid is constituted by units called pixels (picture elements) and determines the visual space of the image. It is a Cartesian space where pixels are ordered along two dimensions following X and Y axes. The pixel grid constitutes the texture (what Groupe μ called in French the *macule* in 1992) of digital images, and chromatic values may be applied to it. The management of colors as well as the various actions by which the image can be manipulated will be found at another level of analysis, that of the image as utterance.[82]

Following the theorization proposed by Fontanille (2008), the formal face of the object level is associated with the material face (substance) of the utterance level. The raster grid requires a recording medium which will enable the user to manipulate the digital image. At the utterance level, the formal side is turned towards the signs and the material side towards the object.

The formal side of the utterance corresponds to the syntax of programming languages, that is, to the algorithms and data structures. The material side of the utterance, on the other hand, enables the operation of devices such as the graphical user interface and the digital code.

[81]On the relation between substance and digital practices in audiovisual domain, see D'Armenio (2017).

[82]On levels of analysis regarding to pixel and its texture, see Leone (2018).

Table 4.4 Reinterpretation of the levels of pertinence presented in the semiotic analysis by Fontanille (2008) in view of adapting them to the case of digital images. Excerpt from Dondero and Reyes (2016, p. 11)

The level of practices also constitutes an interface between the formal and material sides. On the one hand, the formal side, turned towards the object, involves the themes of the practices. In the case of digital images, the themes concern a certain variety of practices that may be simulated using a computer: drawing, designing, coloring, retouching, or simply exploring the functionalities of a piece of software. On the other hand, the material side of the practices is turned towards strategies, that is, towards the processes of accommodation or adjustment of the practices among competing groups of programmers or users.

Finally, to conclude this chapter, it must be emphasized that taking the substance of the plane of expression into consideration not only enables one to specify the

propositions made regarding the semiotic function[83], but also to account in a structured manner for current and future types of images which are inscribed within a *continuum* of technological and cultural transformations.

References

Aa.Vv.: Topologies de l'individuation et plasticité chez Deleuze et Simondon. La Part de l'œil 27–28, 138–258 (2013)

Agamben, G.: Aby Warburg and the nameless science. In: Agamben, G. (ed.) Potentialities, pp. 89–103. Stanford University Press, Stanford (1999)

Bastide, F.: Una notte con Saturno. Scritti semiotici sul discorso scientifico. In: Latour, B. (ed.), Meltemi, Rome (2001)

Bachimont, B.: La présence de l'archive: réinventer et justifier. Intellectica **53–54**, 281–309 (2010)

Barthes, R.: Image, Music, Text. Fontana/Collins, Glasgow (1977)

Barthes, R.: The Fashion System. University of California Press, Berkeley (1983)

Basso Fossali, P., Dondero, M.G.: Sémiotique de la photographie. Pulim, Limoges (2011)

Basso Fossali, P., Dondero, M.G.: Les temporalités de la photographie de mode. Infra-mince **8**, 82–95 (2013)

Basso Fossali, P.: L'image du devenir: le monde en chiffre et la passion du monitorage. Signata Annals of Semiotics 10. https://journals.openedition.org/signata/2261. (2019). Accessed 20 Sept 2019

Basso Fossali, P.: La sémiotique visuelle de Greimas entre archéologie et actualité. La Part de l'Œil 32, 309–330 (2018–2019)

Bonaccorsi, J.: Pratiquer les images en sciences de l'Information et de la communication. Sémiose, eikones, montage. Revue française des sciences de l'information et de la communication. http://journals.openedition.org/rfsic/530. (2013). Accessed 27 Jan 2018

Bordron, J.-F.: Rhétorique et économie des images. Protée **38**(1), 27–40 (2010)

Bordron, J.-F.: L'énonciation en image: quelques points de repère. In: Colas-Blaise, M. Perrin, L., Tore, G.M. (eds.) L'énonciation aujourd'hui. Un concept clé des sciences du langage, pp. 227–239. Lambert-Lucas, Limoges (2016)

Boullier, D., Crépel, M.: Biographie d'une photo numérique et pouvoir des tags. Classer/circuler. Revue d'anthropologie des connaissances **7**(4), 785–813 (2013)

Bishop, C.: Against Digital Art History. Int. J. Digital Art Hist. 3 (2018)

Caliandro, S.: Images d'images. Le métavisuel dans l'art visuel. L'Harmattan, Paris (2008)

Cardinali, M.: Digital Tools and Technical Views: The Intersection of Digital Art History and Technical Art History in a Digital Archive on the Painting Technique of Caravaggio and His Followers. Visual Resources **35**, 52–73 (2019)

Chauviré, C.: L'œil mathématique. Essai sur la philosophie mathématique de Peirce. Éditions Kimé, Paris (2008)

Coccia, E.: La norma iconica. Politica e società **1**, 61–80 (2015)

Colas-Blaise, M., Dondero, M.G.: L'événement énonciatif en sémiotique de l'image: de Roland Barthes à la sémiotique tensive. La Part de l'Œil 31, 206–217 (2017)

D'Armenio, E.: From audiovisual to intermedial editing. Film experience and enunciation put to the test of technical formats. Versus Quaderni di studi semiotici **124**, 59–74 (2017)

Didi-Hubermann, G.: Aby Warburg et l'archive des intensités. Études photographiques **10**, 144–160. http://journals.openedition.org/etudesphotographiques/268. (2001). Accessed 10 Dec 2019

Deleuze, G.: Francis Bacon: The Logic of Sensation Continuum, London (2003)

[83]For an interesting discussion on the relation between substance and semiotic function in philosophy of mathematics, see Sarti et al. (2019).

Dondero, M.G.: Le sacré dans l'image photographique. Études sémiotiques. Hermès Lavoisier, Paris (2009a)

Dondero, M.G.: Sémiotique de l'image scientifique. Signata Annals of Semiotics **1**, 111–175 (2010)

Dondero, M.G.: La totalité en sciences et en art. In: Beyaert-Geslin, A., Dondero, M.G. (eds.) Arts et sciences: approches sémiotiques et philosophiques des images, pp. 123–136. Presses universitaires de Liège, Liège (2014)

Dondero, M.G.: Voir en art, voir en sciences. Nouvelle Revue d'Esthétique **17**(1), 139–159 (2016)

Dondero, M.G.: Barthes entre sémiologie et sémiotique: le cas de la photographie. In: Bertrand, J.-P. (ed.) Roland Barthes: Continuités, pp. 365–393. Christian Bourgois, Paris (2017)

Dondero, M.G., Reyes Garcia, E.: Les supports des images: photographie et images numériques. Revue Française des Sciences de l'Information et de la Communication 9. http://rfsic.revues.org/2124. (2016). Accessed 10 May 2018

Dondero, M.G.: Diagrammatic experiment in Mathematics and in Works of Art. In: Haworth, K., Hogue, J., & Sbrocchi, L. (eds) Semiotics 2011 The Semiotics of Worldviews. Semiotics Society of America Proceedings, pp. 297–307. Legas Publishing, Ottawa. (2012c). https://www.researchgate.net/publication/299683975_Diagrammatic_Experi ement_in_Mathematics_and_in_Works_of_Art. Accessed 1 April 2020

Dondero, M.G.: The Semiotics of Design in Media Visualization: Mereology and Observation Strategies. Inf. Des. J. **23**(2), 208–218. (2017c). https://www.academia.edu/35306814/The_sem iotics_of_design_in_media_visualization._Mereology_and_observation_strategies_Informa tion_Design_Journal_2017_Farias_and_Queiroz_eds_FULL_TEXT. Accessed 10 Jan 2019

Dondero, M.G.: Visual semiotics and automatic analysis of images from the Cultural Analytics Lab: how can quantitative and qualitative analysis be combined? Semiotica **230**, 121–142. https://doi. org/10.1515/sem-2018-0104. (2019)

Dondero, M.G.: L'énonciation visuelle entre réflexivité et métalangage. In: Dondero, M.G., Beyaert-Geslin, A., Moutat, A. (eds.) Les plis du visuel. Énonciation et réflexivité dans l'image, pp. 193–206. Lambert Lucas, Limoges (2017a)

Dondero, M.G.: Les aventures du corps et de l'identité dans la photographie de mode. Actes sémiotiques Website. http://epublications.unilim.fr/revues/as/4979. (2014a). Accessed 11 Mar 2017

Dondero, M.G., Fontanille, J.: The Semiotic Challenge of Scientific Images. A Test Case for Visual Meaning. Legas Publishing, Ottawa (2014). https://www.academia.edu/19799510/The_Sem iotic_Challenge_of_Scientific_Images._A_Test_Case_for_Visual_Meaning_with_Jacques_F ontanille_FULL_TEXTE. Accessed 5 November 2018

Drucker, J.: Is There a "Digital" Art History? Visual Resources **29**(1–2), 5–13 (2013). https://doi. org/10.1080/01973762.2013.761106

Drucker, J., et al.: Digital art history: la scène américaine. Perspective [En ligne] **2**. http://perspe ctive.revues.org/6150; doi:https://doi.org/10.4000/perspective.6150 (2015)

Edwards, E., Hart, J. (eds.): Photographs Objects Histories. On the Materiality of Images. Routledge, London (2004)

Fabbri, P.: La svolta semiotica. Laterza, Rome-Bari (1998)

Floch, J.-M.: Petites mythologies de l'œil et de l'esprit. Pour une sémiotique plastique. Hadès-Benjamins, Paris-Amsterdam (1985)

Floch, J.-M.: Les formes de l'empreinte: Brandt, Cartier-Bresson, Doisneau, Stieglitz, Strandt. Fanlac, Périgueux (1986)

Floch, J.-M.: Visual Identities. Continuum, London (2005)

Focillon, H.: Foreword to Les primitifs français: La peinture clunisienne en Bourgogne à l'époque romaine, son histoire et sa technique. Fernand Mercier. Picard, Paris (1932)

Focillon, H.: The Life of Forms in Art. Zone Books, New York (1992)

Fontanille, J.: Sémiotique et littérature: essais de méthode. Presses universitaires de France, Paris (1999)

Fontanille, J.: Soma et séma. Figures du corps. Maisonneuve et Larose, Paris (2004)

Fontanille, J.: Du support matériel au support formel. In: Arabyan, M., Klock-Fontanille, I. (eds.) L'Écriture entre support et surface, pp. 183–200. L'Harmattan, Paris (2005)

Fontanille, J.: Pratiques sémiotiques. Presses universitaires de France, Paris (2008)

Fontanille, J.: Corps et sens. Presses universitaires de France, Paris (2011)

Fontanille, J.: Sans titre… ou sans contenu. Nouveaux Actes Sémiotiques 33/34/35, 77–99 (1994)

Fontanille, J.: Décoratif, iconicité et écriture. Geste, rythme et figurativité: à propos de la poterie berbère. University of Limoges Website, Visio. http://www.unilim.fr/pages_perso/jacques.fontan ille/articles_pdf/visuel/decoratifberbere.pdf. (1998). Accessed 24 Dec 2018

Greimas, A.J.: Figurative Semiotics and the Semiotics of the Plastic Arts. New Lit Hist **20**(3), 627–649 (1989)

Goodman, N.: Languages of Art. An Approach to a Theory of Symbols. Bobbs Merrill, London (1968)

Groupe μ.: Traité du signe visuel. Pour une rhétorique de l'image. Seuil, Paris (1992)

Haddad et al.: Dynamics of thymus-colonizing cells during human development. Immunity **24**(2), 217–230 (2006)

Hall, G.: Toward a Postdigital Humanities: Cultural Analytics and the Computational Turn to Data-Driven Scholarship. Am. Literature **85**(4), 781–810 (2013)

Hagelstein, M.: Mnemosyne et le Denkraum renaissant. Pratique du document visuel chez Aby Warburg. MethIS **2**, 87–111. https://popups.ulicgc.bc:443/2030-1456/index.php?id=271. (2009). Accessed 12 July 2019

Hristova, S.: Images as Data: Cultural Analytics and Aby Warburg's Mnemosyne. Int. J. Digital Art Hist. **2**. https://journals.ub.uni-heidelberg.de/index.php/dah/article/view/23489. (2016). Accessed 10 Aug 2019

Impett, L., Moretti, F.: Totentanz. Operationalizing Aby Warburg's Pathosformeln. Literary Lab Pamphlet 16. https://litlab.stanford.edu/LiteraryLabPamphlet16.pdf. (2017). Accessed 27 Feb 2020

Klee, P.: Notebooks, Volume 1: The Thinking Eye. Lund Humphries, London (1961)

Klee, P.: Notebooks, Volume 2: The Nature of Nature. Lund Humphries, London (1973)

Klinkenberg, J.-M.: Précis de sémiotique générale. Seuil, Paris (2000)

Klock-Fontanille, I.: L'écriture entre support et surface: l'exemple des sceaux et des tablettes hittites. In: Arabyan, M., Klock-Fontanille, I. (eds.) L'écriture entre support et surface, pp. 29–52. L'Harmattan, Paris (2005)

Kuhn, V., et al.: Large Scale Video Analytics. On-demand, iterative inquiry for moving image research. E-Science '12. In: Proceedings of the 2012 IEEE 8th International Conference on eScience (2012)

Lassègue, J.: Quelques remarques historiques et anthropologiques sur l'écriture informatique. In: Nicolas, F. (ed) Les mutations de l'écriture, pp. 83–103. Publications de la Sorbonne, Paris (2013)

Le Guern, O.: Le Support comme limite et les limites du support. Actes sémiotiques. http://epubli cations.unilim.fr/revues/as/3196. (2009). Accessed 10 Aug 2018

Le Cun, et al.: Deep learning. Nature **521**, 436–444. (2015). Accessed 10 July 2019

La Mantia, F.: Et la structure en came? Notes pour une diagrammatologie énonciative. In: La Mantia, F. (ed.) Pour se faire langage. Lexique de base de la théorie des opérations prédicatives et énonciatives d'Antoine Culioli. Academia, Louvain-La Neuve (2020)

Le Guern, O.: Métalangage iconique et attitude métadiscursive. Signata Annals of Semiotics 4. https://journals.openedition.org/signata/1000. (2013). Accessed 20 May 2018

Lenain, T.: The Actor's Gaze. Apropos of Giuseppe Grisoni's Portrait of Colley Cibber as Lord Foppington. In: Corpataux, J.-F. (ed.) Senses of Sight. Towards a Multisensorial Approach of the Image, pp. 245–264. L'Erma Di Bretschneifer, Rome (2015)

Leone, M.: Designing Imperfection: The Semiotics of the Pixel. Punctum **4**(1), 105–136 (2018)

Manovich, L., Douglass, J.: Timeline. 4535 Time Magazine Covers, 1923–2009. http://lab.cultur alanalytics.info/2016/04/timeline-4535-time-magazine-covers-1923.html. (2009). Accessed 23 Dec 2017

Manovich, L.: The Language of New Media. MIT Press, Cambridge (2001)

Manovich, L.: Software Takes Command. Bloomsbury Academic, New York (2013)

Manovich, L.: Data Science and Digital Art History. International Journal for Digital Art History **1**(1), 3–35 (2015)

Manovich, L.: The Science of Culture? Social Computing, Digital Humanities and Cultural Analytics. In: Schäfer, M.K., van Es, K. (eds.) The Datafied Society. Studying Culture through Data. AUP, Amsterdam (2017)

Manovich, L., et al.: The Exceptional and the Everyday: 144 Hours in Kiev. In: 2014 IEEE International Conference on Big Data. https://pdfs.semanticscholar.org/9bbe/fa7a3e0c1d39fb27770c5da4d37d7d946dd2.pdf. (2014). Accessed 23 Dec 2017

Manovich, L.: Style Space: How to compare image sets and follow their evolution. http://manovich.net/content/04-projects/073-style-space/70_article_2011.pdf. (2011). Accessed 13 Oct 2017

Marin, L.: De la représentation. Seuil, Paris (1993)

Marin, L.: Opacité de la peinture. Essais sur la représentation en Quattrocento. Éditions de l'EHESS, Paris (2006)

Masson, E., Olesen, C.: Resignification in Digitized Moving Image Archives: Algorithmic Sampling, Visualization, and the Production of Meaning. Signata Annals of Semiotics 12 (2021)

Metz, C.: Impersonal Enunciation, or the Place of Film. Columbia University Press, New York (2016)

Mitchell, W.J.T.: Picture Theory. Essays on Verbal and Visual Representation. University of Chicago Press, Chicago (1994)

Mitchell, W.J.T.: What do Pictures Want? The Lives and Loves of Images. University of Chicago Press, Chicago (2005)

Mitchell, W.J.T.: Four Fundamental Concepts of Image Science. IKON J. Iconographic Stud. 27–32 (2014)

Moretti, F.: Graphs, Maps, Trees. Abstract Models for a Literary History. Verso, New York (2005)

Moretti, F.: Distant reading. Verso, New York (2013)

Nixon, M., Aguado, A.S.: Feature Extraction & Image Processing for Computer Vision. Elsevier, London (2012)

Nova, A.: Las Meninas. Velazquez, Foucault e l'enigma della rappresentazione. Il Saggiatore, Milan (1997)

Paolucci, C.: Prothèses de la subjectivité. L'appareil formel de l'énonciation dans l'audiovisuel. In: Dondero, M.G., Beyaert-Geslin, A., Moutat, A. (eds.) Les plis du visuel. Énonciation et réflexivité dans l'image, pp. 53–68. Lambert-Lucas, Limoges (2017)

Paolucci, C.: Strutturalismo e interpretazione. Bompiani, Milan (2010)

Paolucci, C.: Persona. Philosophie de la subjectivité et sémiotique de l'énonciation. Presses universitaires de Liège, Liège (2020)

Parret, H.: La main et la matière. Hermann, Paris (2018)

Rosenthal, V., Visetti, Y.-M.: Sens et temps de la Gestalt. Intellectica 28, 147–227 (1999)

Sarti, A., Citti, G., Piotrowski, D.: Differential heterogenesis and the emergence of semiotic function. Semiotica 230, 1–34 (2019)

Seguin, B.: Making large art historical photo archives searchable, Dissertation. EPFL Scientific Publications. https://infoscience.epfl.ch/record/261212. (2018). Accessed 13 Dec 2019

Stjernfelt, F.: Diagrammatology. An Investigation on the Borderlines of Phenomenology, Ontology, and Semiotics. Synthesis Library, vol. 336. Springer, Netherlands (2007)

Stockinger, P.: The semiotic turn in digital archives and libraries. Les cahiers du Numérique 11(1), 57–83 (2015)

Stoichita, V.: Visionary Experience in the Golden Age of Spanish Art. Reaktion Books, London (1995)

Stoichita, V.: The Self-Aware Image: An Insight into Early Modern Metapainting. Harvey Miller, London (2015)

Thom, R.: Local et global dans l'œuvre d'art. Le Débat 2(24), 73–89 (1983)

Thürlemann, F.: Paul Klee. Analyse sémiotique de trois peintures. L'Âge de l'homme, Lausanne (1982)

Wildgen, W.: Thom's Theory of 'Saillance' and 'Prégnance' and Modern Evolutionary Linguistics". In: Wildgen, W., Brandt, P.A. (eds.) Semiosis and Catastrophes: René Thom's Semiotic Heritage, pp. 79–100. Peter Lang, Bern (2010)

Zinna. A.: L'interface: un espace de médiation entre support et écriture. In: Proceedings AFSLux 2015. http://afsemio.fr/wp-content/uploads/Sens-et-médiation.-A.-Zinna.pdf. (2015). Accessed 25 July 2018

Chapter 5
Conclusion

This book pursued a twofold objective: Introducing the fundamental concepts of visual semiotics and showing current advances all the while highlighting the boundaries which will need to be exceeded in the future in order to perfect the analysis of images, this with the aim of addressing the challenges introduced by the computational analysis of images and, in particular, by Lev Manovich's and the Cultural Analytics Lab's media visualization.

For each fundamental concept and for each methodological tool, we tried to associate an introductive part and a critique which were always accompanied by a few propositions for theoretical advances. We thus reviewed the specificities of the semiotic analysis of images, namely plastic analysis—which enabled to go beyond the figurative reading relying upon the model of verbal language—as well as its correlated methodological instrument, semi-symbolism. While plastic and semi-symbolic analyses remain the pillars of the semiotic method, they underwent throughout this book several reworkings with respect to the initial formulations by A. J. Greimas and J.-M. Floch. We namely tested the effectiveness of *intertextual semi-symbolism* during the analysis of "portraits of thinking" (*Soliloquy I-IX* by Sam Taylor-Johnson) as well as during our reflection on the metavisual. In this respect, we have considered the possibility of the *semi-symbolic analysis of large corpora of images*, organized beforehand by means of automatic classification via the extraction of the plastic features of the images. The comparison between the quantitative and qualitative analyses of images has recently acquired a certain scope in art history,[1] and the question of automatic corpora analysis now confronts all fields of the humanities.[2] We have sought to propose a few lines of approach in order to conceive of the complementarity

[1] See in this respect the two first issues of the *International Journal for Digital Art History*. URL: http://dah-journal.org as well as the general considerations proposed by Seguin, Striolo, di Lenardo, and Kaplan (2016).

[2] For an overview on the relationship between semiotics and quantitative analysis, see Compagno (2018).

between semiotic analysis and automatic analysis in view of a better understanding of the syntagmatics and of the semantics of image corpora.

Still in the field of plastic analysis, we made a proposition in order to make analyzable the gestural acts of inscription via the differentiation between the "plastic reading of the plastic utterance" and the "figurative reading of the plastic utterance" (Basso Fossali 2004, 2013). The latter must enable one to reconstruct the memory of the movements by which a painting was established and make it possible to justify, by analytical means, the Deleuzian assertion according to which all forms hold a force within (Deleuze 2003; Acquarelli 2015).

This had the effect of greatly renewing plastic analysis, notably by associating it with enunciative analysis which, for its part, remains underexploited as far as the study of visual corpora is concerned.

Enunciative analysis enables us to relate the image, as a finished product, to the trajectory by which it was established, but also to the perceptual and interpretative trajectories offered to the observer. It not only allows one to analyze the point of view of an image, but also to highlight the fact that in all images, there are more or less explicit conflicts between points of view. While enunciative analysis is known and conducted by a very small number of researchers, this book sought to present it to all image scientists, as well as to the disciplines adjacent to the semiotics of images, such as art history, information and communication sciences, as well as discourse analysis, which encounter syncretic, verbo-visual utterances.

Enunciative analysis naturally led to a reflection regarding the metavisual, that is, regarding the capacity of images to analyze themselves as well as other images. It was thereby not only demonstrated that images are capable of self-reflection, as has been highlighted by several theoreticians of art (Marin, Stoichita, Mitchell, etc.), but also that they are able to negate that which they nevertheless depict. This work regarding negation by and within images was anchored upon the works in visual rhetoric, and notably upon the foundations laid by Groupe μ and the developments provided by the works of Jean-François Bordron. The analysis of negation in images was also marked by the integration of the modes of existence (actualization, realization, potentialization, virtualization) within enunciative theory (Fontanille 1996; Badir and Dondero 2016), which enabled to account for the various discursive layers of which images are composed—and for the intensity of the presence of each form.

Asserting that images may be studied according to the theory and methodology of the utterance would amount to saying that what is analyzed is their actorial dimension (conflicting points of view), their spatial dimension (types of perspective) and—this being much more novel—their temporality. This means, for example, that the presence of a subject within a portrait may be conjugated in the present tense, but also in the future or past tenses. Accounting for the temporal dimension of the spatial arts such as painting and photography also led us to exploit the operational concept of spatial aspectuality, which enabled to show that even an isolated image may develop specific narrative rhythms—this having always been denied by tradition (Lessing) as well as by recent works in aesthetics (Schaeffer 2001).

Finally, we attended to the possible developments of plastic analysis, while showing the limits of an approach devoted to the analysis of the form of expression.

An attempt was made to problematize the approach to the substance of expression, that is, the characteristics one could generally call "mediatic" as regards each visual product. Taking the works of the genealogy of forms by Focillon and Warburg for foundation, the instruments which shape the gestural acts of establishment were integrated while taking account of the relation between the form and the technique establishing the work of art. The approach which values the syncretism of an image's substrate and that which is applied to it fills a gap in semiotic studies and proposes methodological tools for the material turn.

More generally, this book aimed to rethink the relation between verbal language and visual language. This amounts to tracing the divisions between the methodologies for analyzing verbal texts, with respect to which semiotics past its first test as an heir to Saussurean linguistics, and those serving the analysis of visual utterances. While plastic analysis was conceived as a methodology responding to the "needs of the image" recognizing the fact that the domain of images operates according to a different logic than does verbal language, it was then tested for the analysis of poetry as well as for other genres or regimes of visual discourse. It is important to recall this transferal between the domain of images and verbal language, because it shows that the instruments forged in the semiotics of images may have been useful for studying the plastic dimension of texts in natural language. Furthermore, the last chapter of this book, devoted to the substance of images, and more specifically to the relation between the substrate and what is applied to it, makes it possible to account for the image as an *autographic* symbolic system and to reassert the relation between forms and forces via the analysis of the techniques of the image's establishment, in an attempt to reconcile the material turn with the computational analysis of large collections of images.

Bibliography

Acquarelli, L. (ed.): Au prisme du figural. Le sens des images entre forme et force. Presses universitaires de Rennes, Rennes (2015)

Badir, S., Dondero, M.G. (eds.): L'image peut-elle nier?. Presses universitaires de Liège, Liège (2016)

Basso Fossali, P.: Il trittico 1976 di Francis Bacon. Con Note sulla semiotica della pittura. ETS, Pise (2013)

Basso Fossali, P.: Protonarratività e lettura figurativa dell'enunciazione plastica. Versus **98–99**, 163–190 (2004)

Compagno, D.: Quantitative Semiotic Analysis. Springer, Berlin (2018)

Deleuze, G.: Francis Bacon: The Logic of Sensation Continuum, London (2003)

Fontanille, J.: Le trope visuel entre présence et absence. Protée **24**(1), 47–54 (1996)

Schaeffer, J.-M.: Narration visuelle et interprétation. In: Ribière, M., Baetens, J. (eds.) Time, Narrative & The Fixed Image. Atlanta, Amsterdam (2001)

Seguin, B., Striolo, C., di Lenardo, I., Kaplan, F.: Visual Link Retrieval in a Database of Paintings. Visart Workshop, ECCV Amsterdam. https://infoscience.epfl.ch/record/223771?ln=fr. (2016). Accessed 20 June 2018

Uncited References

Arasse, D.: Vermeer. Faith in Painting. Princeton University Press, Princeton (1996)

Beyaert-Geslin, A.: Sémiotique du portrait. De Dibutade au selfie. De Boeck, Louvain-La-Neuve (2017)

Boehm, G.: Jenseits der Sprache? Anmerkungen zur Logik der Bilder. In: Maar, C., Burda, H. (eds.), Iconic Turn. Die neue Macht der Bilder, pp. 40–42. DuMont, Köln (2004)

Bordron, J.-F.: Dynamique des images. Signata Annals of Semiotics 10. https://journals.opened ition.org/signata/2267. (2019). Accessed 7 Sept 2019

Bredekamp, H.: Image Acts. A Systematic Approach to Visual Age. De Gruyter, Berlin-Boston (2017)

Colas-Blaise, M.: Questions de sémiotique visuelle. Énonciation énoncée et expérience de l'œuvre d'art. In: Dondero, M.G., Beyaert-Geslin, A., Moutat, A. (eds.) Les plis du visuel. Énonciation et réflexivité dans l'image, pp. 85–99. Limoges, Lambert-Lucas (2017)

Damisch, H., Careri, G., Vouilloux, B.: Hors cadre: entretien avec Hubert Damisch. Perspective. https://journals.openedition.org/perspective/1670. (2013). Accessed 17 Feb 2017

de Certeau, M.: The Practice of Everyday Life. University of California Press, Berkeley (2011)

De Koninck, R.: Image du désir et désir de l'image. Ou comment l'image parvient-elle à se nier. Figura. http://oic.uqam.ca/fr/system/files/garde/1646/documents/cf191-12-dekoninck-image_du_desir.pdf. (2008)

Dondero, M.G.: Rhétorique des figures visuelles et argumentation par images dans le discours scientifique. Protée 31(1), 41–53 (2010)

Dondero, M.G.: La sémiotique visuelle entre principes généraux et spécificités. À partir du Groupe μ. Actes Sémiotiques Website. http://epublications.unilim.fr/revues/as/3084. (2010c). Accessed 29 Jan 2018

Dondero, M.G., Fontanille, J.: The Semiotic Challenge of Scientific Images. A Test Case for Visual Meaning. Legas Publishing, Ottawa (2014). https://www.academia.edu/19799510/The_Sem iotic_Challenge_of_Scientific_Images._A_Test_Case_for_Visual_Meaning_with_Jacques_F ontanille_FULL_TEXTE. Accessed 5 Nov 2018

Dondero, M.G., Klinkenberg, J.-M.: Après Greimas. Des tâches pour la sémiotique visuelle. La Part de l'Œil 32, 230–235 (2018–2019)

Eco, U.: Theory of Semiotics. Indiana University Press, Bloomington (1976)

Elkins, J.: Six Histories from the End of Representation. Images in Painting, Photography, Astronomy, Microscopy, Particle Physics and Quantum Mechanics, 1980–2000. Stanford University Press, Redwood City (2008)

Floch, J.-M.: Visual Identities. Continuum, London (2005)

Greimas, A.J.: On Meaning: Selected writings in Semiotic Theory. Pinter, London (1987)

Greimas, A.J.: Figurative Semiotics and the Semiotics of the Plastic Arts. New Literary History 20(3), 627–649 (1989)

Hagelstein, M.: Mnemosyne et le Denkraum renaissant. Pratique du document visuel chez Aby Warburg. MethIS 2, 87–111. https://popups.uliege.be:443/2030-1456/index.php?id=271. (2009). Accessed 12 July 2019

Klinkenberg, J.-M.: À quelles conditions peut-on parler de négation dans l'image? In: Badir, S., Dondero, M.G. (eds.) L'image peut-elle nier?, pp. 193–212. Presses universitaires de Liège, Liège (2016)

Marin, L.: Opacité de la peinture. Essais sur la représentation en Quattrocento. Éditions de l'EHESS, Paris (2006)

Peirce, C.S.: Collected Papers of Charles Sanders Peirce, 8 vol., ed. Hartshore, Weiss et Burks. Harvard University Press, Cambridge (1931–1935)

Rastier, F.: Sémiotique et linguistique de corpus. Signata Annals of Semiotics 1. https://journals. openedition.org/signata/278. (2010). Accessed 24 Nov 2017

Sartre, J.-P.: Being and Nothingness: An Essay on Phenomenological Ontology. Routledge, London (2010)

Bibliography

Schapiro, M.: Words and Pictures: On the Literal and the Symbolic in the Illustration of Text. Mouton, The Hague-Paris (1973)

Valenti, M.: Dal figurativo all'astratto. In: Corrain, L., Valenti, M. (eds.) Leggere l'opera d'arte. Dal figurativo all'astratto, pp. 7–30. Esculapio, Bologna (1991)

Wölfflin, H.: Principles of art history. The Problem of the Development of Style in Early Modern Art. Getty Trust Publications, Los Angeles (2015)

Printed in the United States
by Baker & Taylor Publisher Services